knitting
GREEN

conversations and
PLANET-FRIENDLY PROJECTS

ANN BUDD

Editor Elaine Lipson
Technical editor Lori Gayle
Photographer Joe Hancock
Photo stylist Pamela Chavez
Hair and Makeup Kathy MacKay
Art director Liz Quan
Cover and interior design Karla Baker
Production Katherine Jackson

Interweave Press LLC
201 East Fourth Street
Loveland, CO 80537-5655 USA
Interweavestore.com

Printed in China by Asia Pacific Offset, Ltd.

Library of Congress Cataloging-in-Publication
Data

Budd, Ann, 1956-
 Knitting green : conversations and planet
friendly projects / Ann Budd.
 p. cm.
 Includes index.
 ISBN 978-1-59668-166-8 (pbk.)
 1. Knitting--Patterns. 2. Yarn. 3. Organic
living. I. Title.
 TT835.B7827 2010
 746.43'2--dc22

2009035200

10 9 8 7 6 5 4 3 2 1

ACKNOWLEDGMENTS

For all knitters, farmers, yarn companies,
and yarn stores who care for our environment.

This book would not be possible without the talented contributions of Pam Allen, Veronik Avery, Nancy Bush, Therese Chynoweth, Cecily Glowick MacDonald, Kristeen Griffin-Grimes, Carmen S. Hall, Kim Hamlin, Darlene Hayes, Katie Himmelberg, Mags Kandis, Lisa R. Myers, Deborah Newton, Kristin Nicholas, Michele Rose Orne, Clara Parkes, Amy R. Singer, Vicki Square, Kristen TenDyke, JoLene Treace, and Sandi Wiseheart. I thank you all for your dedication to good design and earth-friendly practices.

To the yarn companies who provided yarns for the projects—Blue Sky Alpacas, Buffalo Gold Premium Fibers, Cascade Yarns, Classic Elite Yarns, Green Mountain Spinnery, Hand Jive Knits, Himalaya Yarns, Jojoland International, Knitting Fever, LaLana Wools, Lanaknits Designs, Louet North America, O-Wool, Plymouth Yarn Company, Skacel, Southwest Trading Company, and Westminster Fibers—thank you for encouraging and supporting farmers, manufacturers, and distributors of earth-friendly products.

For making this book a visual treat, thanks go to Joe Hancock for his mastery of light and composition and to his assistants Jon Rose and Scott Wallace for their attention to detail and good humor; to models Devon McHenry, Nida Shaheen, and Kirsten Warner, for showing off the garments and accessories so well; to Kathy MacKay for hair and makeup artistry; to Pamela Chavez for impeccable styling of every photograph; to Karla Baker for bringing it all together in a beautiful book; and to Liz Quan for ensuring high standards every step of the way.

Thanks also to Tricia Waddell and Interweave for believing in this project, to Lori Gayle for making sure that the instructions are clear and correct, to Elaine Lipson for editing and fine tuning the words, and to Katherine Jackson for making many rounds of corrections and getting all of the pieces to the printer.

And finally, thanks to my sister, Lynn Walker, for planting the seed of inspiration for this book and to my husband, David, and our boys, Alex, Eric, and Nicholas, for indulging my passions.

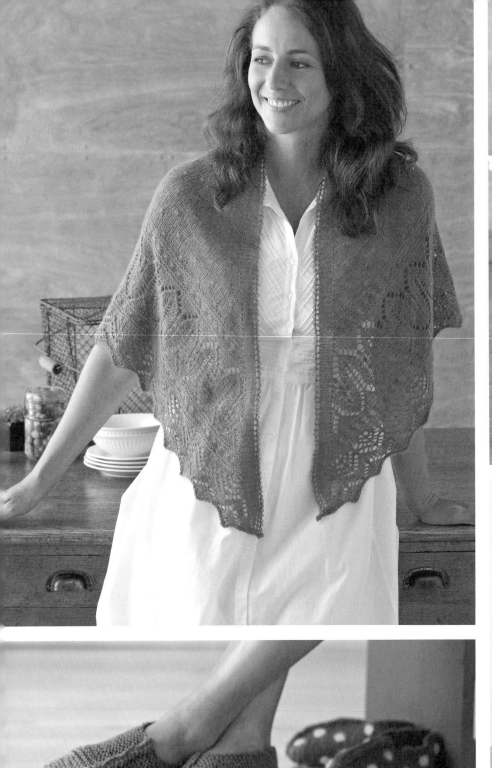
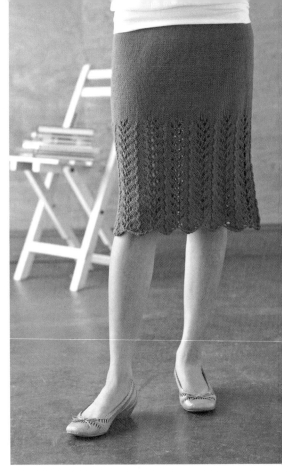
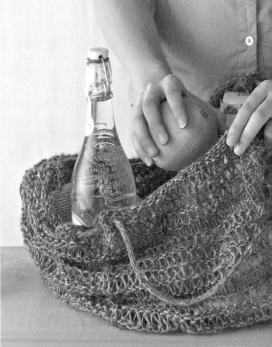
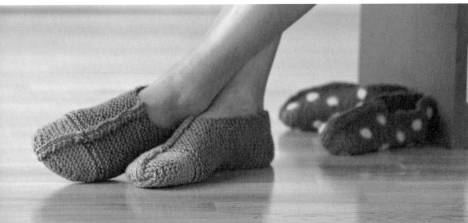

contents

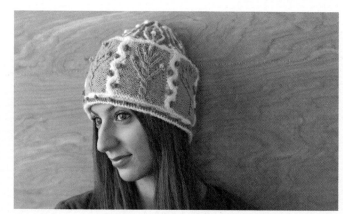

introduction

who among us is not sensitive to environmental issues—clean air, clear water, reduced waste? Beginning with the hippies of the 1970s and evolving to Al Gore's efforts to make climate change a household topic in the early 2000s, there's a worldwide movement to protect our environment. The challenges are huge and far-reaching, but if each of us takes steps to reduce, reuse, and recycle, collectively we can make a difference—even with our knitting.

This is not a book about right versus wrong—there is no one-size-fits-all solution. Instead, *Knitting Green* will help you understand the complicated issues so that you can make educated choices.

To the casual observer, knitting looks to be an earth-friendly practice that hasn't changed much over the centuries. But our ancestors raised their own sheep, and spun the fiber into yarn, and grew flax and spun it into linen, all without the use of antibiotics or pesticides. They gathered, processed, and spun the fiber by hand, dyed it with whatever was available, and hoped that there would be enough for a garment. Then they knitted by firelight after working all day to put food on the table. Although the environmental impact was small, they had just one type of yarn to knit with, and precious little of it.

The Industrial Revolution changed all that. Pesticides and antibiotics ensured healthy crops and flocks, chemicals and machines sped up the cleaning and processing steps, and planes, trains, boats, and trucks transported the goods around the globe so that today's knitter can choose from a huge variety of yarns. But progress comes at a cost—the carbon footprint grows with every aspect of large-scale production.

So, how do we enjoy our yarn choices while being mindful of our delicate planet?

It's surprisingly easy. You can choose how zealous you want to be in your practices. Whether you choose to knit a sweater so that you can turn the thermostat down a few degrees or you choose to purchase only certified organic, naturally dyed yarn from a local source, you're taking steps in the right direction.

Ann Budd

the gray of green:

Context, Conflict, and Conundrums in Green Yarns

essay by:
Clara Parkes
Editor of Knitter'sReview.com

The act of knitting is one of the greenest pastimes on the planet. It doesn't require special machines or electricity—just two sticks, two hands, and some ingenuity. It produces no emissions and runs on the ultimate renewable energy: ours. But knitting does require yarn, and not all yarns are alike—even those marketed as "green" or "eco-friendly."

The problem is that no universally agreed-upon standard exists for what "green" actually is—in food, commerce, or knitting. We hear terms such as biodegradable, renewable, sustainable, and eco-friendly, but there are no unilateral standards for these labels. While the yarn world is driven by some simple assumptions about what constitutes a green product, behind most of these assumptions lurk nuance and compromise and many gray areas.

Assumption 1:
If it comes from a plant, it's green.

While anything made from synthetic fibers will sit in landfills for hundreds of years before decomposing, fabrics made from plant fibers such as cotton, hemp, flax, and bamboo will return to the earth, given the right conditions, in a matter of months.

It's easy to view plants that grow freely and reproduce readily as renewable and sustainable resources. But we also must consider how the plant was grown, where, and by whom, and the resources required to bring the fiber from seed to skein.

Cotton cultivation, for example, accounts for more global pesticide use than any other single crop on earth when grown conventionally. Recent agricultural advances, including the use of genetically modified seed stock, have helped lower conventional cotton's carbon footprint, but it remains a highly polluting fiber, and the long-term impact of genetically modified cotton is unknown.

Fortunately, organic cotton production has risen dramatically in recent years. Organic cotton is grown without the use of toxic or persistent pesticides or synthetic fertilizers, and it cannot use genetically modified seed. Switching from conventional to organic cotton yarns is one of the simplest and most powerful ways to support positive global environmental change.

Fiber sold in the United States as organic must be grown according to U.S. Department of Agriculture (USDA) organic standards, and farmland must be certified for compliance with these standards by an accredited third-party certifier. Most organic cotton is grown abroad but must meet USDA standards if sold in the United States.

On the other side of the green spectrum are hemp and linen, both valuable fiber commodities for thousands of years. Both fibers come from plants that grow easily and quickly without pesticides; they make efficient use of water; and their stalks produce extraordinarily strong and durable fibers. Hemp cultivation is illegal in the United States, so hemp fibers must be imported for yarn and fabric produced here.

Some Assembly Required: Regenerated Cellulose Fibers

The green yarn movement also includes fibers made from regenerated cellulose harvested from trees and bamboo stalks and leaves. These woody plants are made into yarn and sold as bamboo, rayon, Modal, or lyocell, which is marketed in the United States as Tencel. Seaweed is also being ground into microscopic granules and added to the wood cellulose solution to create SeaCell fiber. Similar manufacturing processes have been developed to convert cellulose proteins, such as corn and milk, into spinnable fibers for yarn.

While these fibers are biodegradable and do come from renewable resources (especially bamboo, one of the fastest-growing plants on earth), the conversion from raw material to soft yarn requires so much energy and chemical intervention that many believe their carbon footprint is too heavy to justify the term "green." Sodium hydroxide, used in the conversion process, is a harsh alkaline chemical, and carbon disulfide has been linked to significant neural disorders in workers at the plants where these fibers are manufactured. Treatments with chlorine bleach also produce dioxin toxins.

Most bamboo grown for fiber comes from China, where there's a lack of transparency in the supply chain. Many mixed forests have been clear-cut to make way for bamboo forests, and while the Chinese government has launched efforts to restore biodiversity, it is difficult to know the growing conditions for bamboo or the degree to which toxic manufacturing waste was properly recovered, recycled, and disposed.

Seaweed

Bamboo

Does this make regenerated cellulose fibers bad? Certainly not. Among regenerated fibers, the greenest manufacturing process is that of lyocell/Tencel; the spinning process recovers and recycles some 99 percent of solvents. Regenerated cellulose fibers such as bamboo and Tencel represent a significant step forward from synthetic fibers manufactured from crude oil or liquefied petroleum gas, such as nylon, polyester, and acrylic. Better manufacturing oversight and transparency in the supply chain will continue to move regenerated cellulose fibers further into greener pastures.

Assumption 2:
If it comes from an animal, it's green.

After seeing all the work that goes into creating regenerated cellulose fibers, protein fibers from animals might seem like a walk in the park. Protein fibers—wool, angora, alpaca, mohair, cashmere, qiviut, you name it—are innately green. They are biodegradable, and they come from renewable, sustainable, not to mention cute, four-legged resources. They provide incredible insulation and moisture management, keeping us warm even in the coldest, dampest of conditions, and they lend themselves beautifully to the structure of knitted fabric. But even in this realm we find nuance.

When allowed to roam freely in large, sufficiently green pastures, sheep have healthy immune systems that require little human intervention. But as the pastures grow smaller and concentrations of animals increase, as with large-scale commercial sheep farms, sheep become more susceptible to both external and internal parasites. Most commercial wool growers protect their flocks by dunking them regularly in tubs of pesticides. While effective, these pesticides are con-

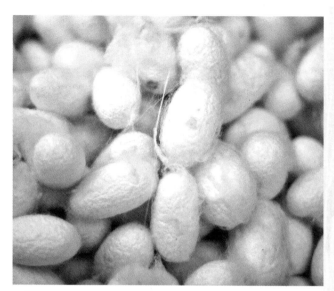
Silkworm cocoons

Use your senses when evaluating yarn advertised as minimally processed. Yarn doesn't lie: If a skein looks and feels minimally processed, with a rich lanolin scent and occasional flecks of grass and straw still in the fibers, it's safe to assume it was minimally processed.

The Silk Situation

Not all living creatures are as lucky as sheep. While most protein fibers are shorn or brushed from living animals, conventionally produced silk is extruded by moth caterpillars whose pupae are killed immediately before the fiber is harvested. About 2,600 silkworms are killed to produce one pound of fine silk. This may not be an issue for folks who swat flies without batting an eye, but for others it presents a heavy karmic weight.

Some silk fabrics are made from cocoons in which the pupae are allowed to emerge as moths and fly free; you may see these labeled as wild silk, Ahimsa silk, Muga silk, peace silk, or true raw silk. This fiber isn't as "silky" as what we normally consider silk. Its shorter staple length more often closely resembles cotton, and the underlying fibers have a slightly earthy hue.

But remember that the common mulberry silkworm (bombyx mori) has been so selectively raised in captivity over the centuries that its quality of life was long ago diminished. It can no longer see or fly, and its average lifespan is just seventy days—ten days more than if the pupa is killed while still in the cocoon stage. The pay and treatment of silk workers, as well as chemical runoff during the dyeing process, is a broader concern.

Undyed wild silk yarn remains the greenest option, followed by those silk yarns dyed with low-impact fiber reactive dyes or vegetable dyes without any finishes.

Assumption 3:
If it's naturally dyed, it's green.

The dyeing process involves energy, water, and soluble compounds of varying degrees of toxicity. How much water is used, how the waste water is handled, and how

sistently linked with nervous system damage among exposed workers.

For several years now, organic wool has been available to handknitters, made from animals that graze on land that receives no pesticide applications, and the sheep are never dipped in pesticides or given growth hormones or antibiotics. Like organic cotton, organic wool must come from land and livestock cultivated and raised according to USDA organic standards and certified by a USDA-accredited agency. While federal organic standards do not cover fiber processing, voluntary standards have been developed with detailed guidance for finished organic textile products, such as the Global Organic Textile Standards (GOTS), the best-known worldwide voluntary standard.

Labels other than organic fall into the "sustainable" category and are not backed by the same force of law that organic standards have. Some allow restricted use of chemical compounds, with a focus on using biodegradable cleansing agents and water-soluble spinning oils. Look for third-party certifications that are not funded by the companies they certify.

much unabsorbed dye remains in that waste water can have a significant environmental impact.

The commercial yarn market uses synthetic dyes, made from chemicals and occasionally containing heavy metals, to give yarns deep, strong, long-lasting color. Low-impact fiber-reactive dyes are synthetic but have a higher fiber fixation rate (up to 70 percent), resulting in less toxic waste. Acid dyes, popular among hand-dyers, are relatively easily neutralized and can be poured down the kitchen sink without worry.

Natural dyeing, which uses dyes derived from natural sources, such as plants, earth, and even bugs, has a somewhat tarnished reputation because of the heavy metals (including aluminum, iron, and copper) required to help the dye adhere permanently to the fiber. When used in a dissolved form, these metals may create a semi-toxic dyebath that must be properly disposed. However, these mordant materials can also take the simpler form of things such as pennies or iron vitamin supplements. When evaluating a natural yarn, ask the dyer which type of mordant was used.

Where does that leave us?

Most of us swim in contradiction-filled waters and make a point of trying to do better. Because the notion of "green" encompasses so many areas of our lives, from fiscal to spiritual, each person's vision of eco-friendly fibers looks slightly different.

For some, "going green" may simply involve not buying any new yarn and only using what they have. For others, it's purging stashes and making different purchasing decisions going forward. And some folks may see no need to make any changes whatsoever.

I'm reminded of a classic Bloom County cartoon in which one of the strip's main characters decides to become a vegetarian. At first he simply gives up meat, but with each advancing frame he realizes yet another way in which he is harming other living organisms—until the last frame when, dangling naked and upside down from the ceiling, he realizes with horror that he's still breathing air.

How far you take the green pursuit is up to you. There is no black-and-white answer to the green question, only a collective move in a positive direction.

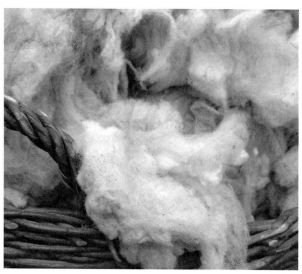
Raw wool

Natural yarns

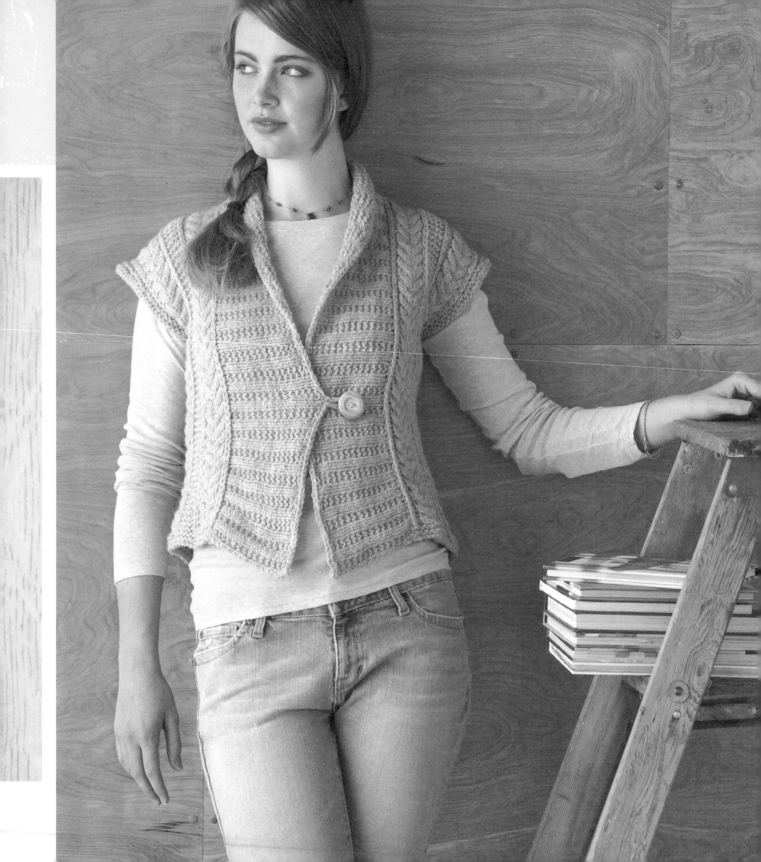

eco VEST

designed by:
Katie Himmelberg

The *eco* in Eco Wool means that this yarn is neither dyed nor chemically processed, but instead of having the raw feeling of many minimally processed yarns, Eco Wool is surprisingly smooth and clean. **Katie Himmelberg** used this earth-friendly yarn to knit an unstructured vest that can transition from fall to spring. Katie knitted the vest in a single piece to the armholes, then worked the back and fronts separately to the shoulders. The shaping is achieved through cable stitches rather than increases and decreases.

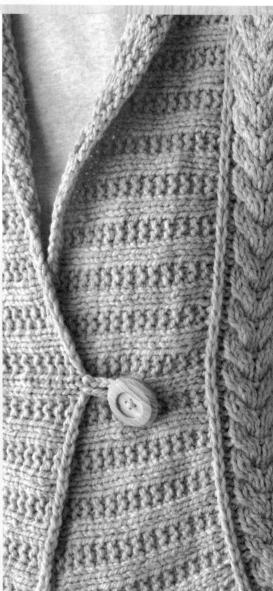

Finished Size

About 35 (42, 49)" (89 [106.5, 124.5] cm) bust circumference. Vest shown measures 35" (89 cm).

Yarn

Worsted weight (#4 Medium).

SHOWN HERE: Cascade Eco Wool (100% wool; 478 yd [437 m]/250 g): #8015 oatmeal, 2 (2, 3) skeins.

Needles

Size U.S. 10½ (6.5 mm): 16" and 32" (40 and 80 cm) circular (cir). Adjust needle size if necessary to obtain the correct gauge.

Notions

Cable needle (cn); stitch holders or waste yarn; marker (m); tapestry needle, one 1⅜" (3.5 cm) button; size K/10½ (6.5 mm) crochet hook.

Gauge

32 stitches and 32 rows (2 repeats wide and 8 repeats high) measure about 7" (18 cm) wide and 5¼" (13.5 cm) high in cable and garter pattern; 16 stitches and 24 rows = 4" (10 cm) in garter rib pattern.

STITCH GUIDE

Cable and Garter Pattern
(multiple of 16 sts + 14)

SET-UP ROW: (WS) K1, *p1, k1, p8, k1, p1, k4; rep from * to last 13 sts, p1, k1, p8, k1, p1, k1.

ROW 1: (RS) K1, *sl 1 as if to purl with yarn in back (pwise wyb), p1, sl 2 sts onto cn and hold in back, k2, k2 from cn, sl next 2 sts onto cn and hold in front, k2, k2 from cn, p1, sl 1, k4; rep from * to last 13 sts, sl 1 pwise wyb, p1, sl 2 sts onto cn and hold in back, k2, k2 from cn, sl next 2 sts onto cn and hold in front, k2, k2 from cn, p1, sl 1 pwise wyb, k1.

ROWS 2 AND 4: (WS) K1, *p1, k1, p8, k1, p1, k4; rep from * to last 13 sts, p1, k1, p8, k1, p1, k1.

ROW 3: K1, *sl 1 pwise wyb, p1, k8, p1, sl 1 pwise wyb, k4; rep from * to last 13 sts, sl 1 pwise wyb, p1, k8, p1, sl 1 pwise wyb, k1.

Repeat Rows 1–4 for pattern; do not rep the set-up row.

Garter Rib (multiple of 4 sts + 2)

ROW 1: (WS) *P2, k2; rep from * to last 2 sts, p2.

ROW 2: (RS) Knit.

Repeat Rows 1 and 2 for pattern.

NOTE

• The lower body of the vest is worked back and forth in rows in one piece to the underarms, then the fronts and back are divided and worked separately to the shoulders.

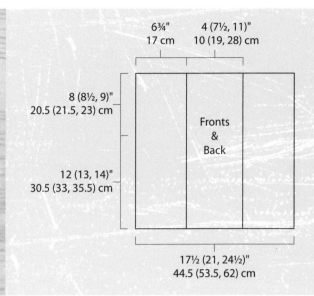

Lower Body

With longer cir needle, CO 124 (138, 152) sts. Do not join. Knit 4 rows, ending with a WS row.

INC ROW: (RS) K1,*sl 1 as if to purl with yarn in back (pwise wyb), p1, [k2, M1 (see Glossary)] 2 times, k2, p1, sl 1 pwise wyb, k4; rep from * to last 11 sts, sl 1 pwise wyb, p1, [k2, M1] 2 times, k2, p1, sl 1 pwise wyb, k1—142 (158, 174) sts.

Beg with the WS Set-up row, work in Cable and Garter patt (see Stitch Guide) until piece measures about 12 (13, 14)" (30.5 [33, 35.5] cm) from CO, ending with Row 2 of patt.

DIVIDING ROW: (RS; Row 3 of patt) Work 31 right front sts in patt for all sizes, place next 80 (96, 112) sts on holder or waste yarn for back, then place rem 31 sts on separate holder for left front—31 right front sts rem on needle. The fronts and back divide in the center of a 4-st garter panel at each underarm, leaving 2 garter selvedge sts at the armhole edge(s) of each piece.

Right Front

Cont in established patt on 31 right front sts until armhole measures about 8 (8½, 9)" (20.5 [21.5, 23] cm), ending with Row 2 of patt.

NEXT ROW: (RS; Row 3 of patt) Cont in patt, working each 8-st cable panel as k1, k2tog, k2, k2tog, k1—2 sts dec'd from each of 2 cable panels; 27 sts rem for all sizes.

Place sts on holder or waste yarn.

Back

Return 80 (96, 112) held back sts to needle and rejoin yarn with RS facing.

NEXT ROW: (RS; Row 3 of patt) K2, work to end in established patt, ending last rep with k2 instead of k4.

Cont in patt until armholes measure about 8 (8½, 9)" (20.5 [21.5, 23] cm), ending with Row 2 of patt.

NEXT ROW: (RS; Row 3 of patt) Cont in patt, working each 8-st cable panel as k1, k2tog, k2, k2tog, k1—2 sts dec'd from each of 5 (6, 7) cable panels; 70 (84, 98) sts rem.

Place sts on holder or waste yarn.

Left Front

Return 31 held left front sts to needle and rejoin yarn with RS facing.

NEXT ROW: (RS; Row 3 of patt) K2, work to end in established patt.

Cont in patt until armhole measures about 8 (8½, 9)" (20.5 [21.5, 23] cm), ending with Row 2 of patt.

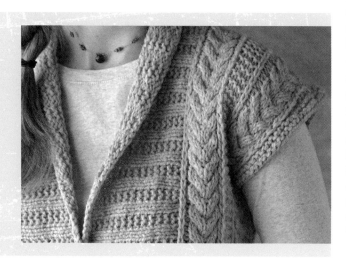

NEXT ROW: (RS; Row 3 of patt) Cont in patt, working each 8-st cable panel as k1, k2tog, k2, k2tog, k1—2 sts dec'd from each of 2 cable panels; 27 sts rem for all sizes.

Place sts on holder or waste yarn.

Finishing

Block to measurements.

Join Shoulders

Place right shoulder sts of back and front on separate cir needles. Hold needles tog with RS touching and WS facing outward. Using three-needle method (see Glossary) to join shoulder sts tog. Place held left shoulder sts on separate cir needles and join in the same manner—16 (30, 44) sts rem on holder at center back neck.

With crochet hook and RS facing, rejoin yarn to back neck sts, and use slip-stitch crochet (see Glossary) to BO center back sts.

Front Band

With RS facing, longer cir needle, and beg at lower right front CO edge, pick up and knit 79 (84, 91) sts long right front edge, 16 (30, 44) sts across back neck, and 79 (84, 91) sts along left front edge—174 (198, 226) sts total. Work in garter rib (see Stitch Guide) for about 4 (6, 8)" (10 [15, 20.5] cm), ending with a WS row. Loosely BO all sts on next RS row.

Armhole Edgings

With RS facing, shorter cir needle, and beg at base of armhole, pick up and knit 60 (64, 68) sts evenly around armhole opening. Place marker (pm) and join for working in rnds. Purl 1 rnd, knit 1 rnd, purl 1 rnd. BO all sts loosely knitwise on next rnd. Rep for other armhole.

Try on vest with right front lapped over left and determine the most flattering position for button closure at about waist height. Mark the button position on the left front and the button loop position on the BO edge of right front band; for the vest shown, the button and loop are about 7" (18 cm) up from the CO edge and the button is 2" (5 cm) from the front band pick-up row. Sew button in place on left front. Join yarn to marked loop position on right front edge, work a crochet chain (see Glossary) long enough to fit around button, join into a loop with a slip stitch in the base of the chain, then fasten off last st. Weave in loose ends.

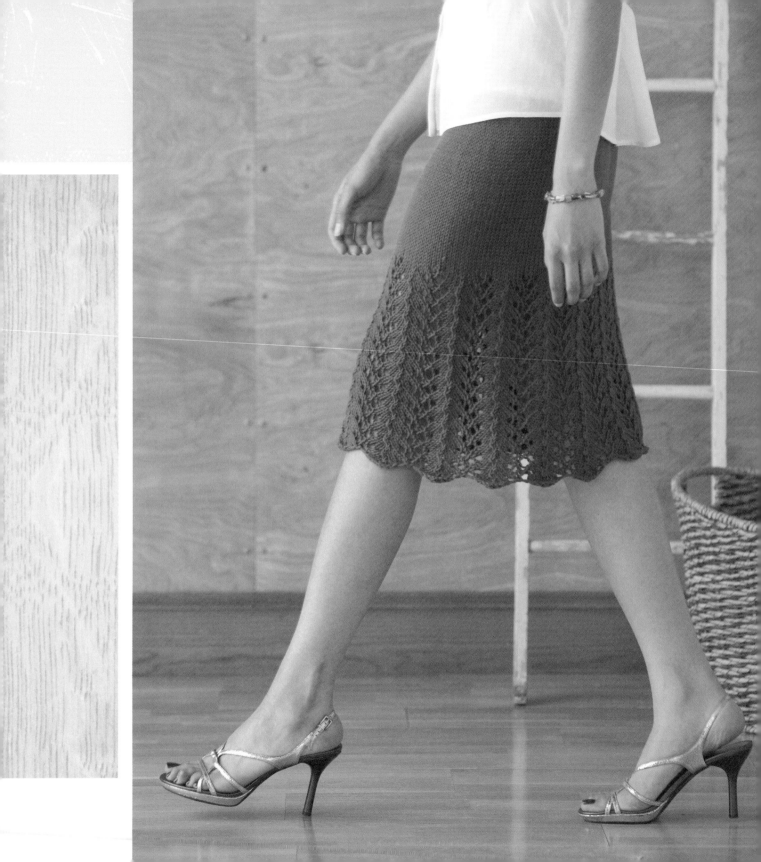

solstice
SKIRT

designed by:
Cecily Glowik
MacDonald

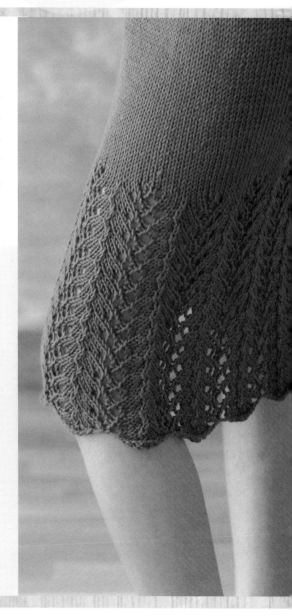

Cecily Glowik MacDonald used Solstice, a yarn that blends earth-friendly organic cotton with the softest merino, to knit a skirt that has both a conscience and memory. The cotton provides cool comfort, and the merino provides resilience (no droopy seat here). Cecily worked the skirt in the round from the scalloped lace pattern at the hem to the casing for elastic at the waist. She cleverly tapered the skirt by changing to progressively smaller needles along the way—there are no decreases to interrupt the lace pattern on the lower skirt.

Finished Size

About 29½ (34, 38½, 42¾, 47¼)" (75 [86.5, 98, 108.5, 120] cm) waistband circumference, 34¾ (39¼, 44, 48½, 53¼)" (88.5 [99.5, 112, 123, 135.5] cm) hip circumference about 8" (20.5 cm) below waist, and 20½" (52 cm) long from lower edge of waistband for all sizes.

Skirt shown measures 29½" (75 cm) at waistband.

Yarn

Worsted weight (#4 Medium).

SHOWN HERE: Classic Elite Solstice (70% organic cotton, 30% merino; 100 yd [91 m]/50 g): #2349 Calais (blue), 7 (8, 9, 9, 10) skeins.

Needles

Sizes U.S. 9, 8, 7, 6, and 5 (5.5, 5, 4.5, 4, and 3.75 mm): 32" (80 cm) circular (cir). Adjust needle size if necessary to obtain the correct gauge.

Notions

Marker (m); tapestry needle; 1" (2.5 cm) wide elastic to fit around waist plus 1" (2.5 cm) overlap; sharp-point sewing needle and thread.

Gauge

20 stitches and 26 rounds = 4" (10 cm) in stockinette stitch on size 6 (4 mm) needles, worked in rounds; 19 stitches and 25 rounds = 4" (10 cm) in stockinette stitch on size 7 (4.5 mm) needles, worked in rounds; 22 sts (two patt reps) of lace pattern measure about 5½" (14 cm) wide on largest needle, worked in rounds.

STITCH GUIDE

Lace Pattern (mult of 11 sts)

RND 1: *P1, k1, yo, k3, sl 1, k2tog, psso, k3, yo; rep from * around.

RND 2: *P1, k10; rep from * around.

RND 3: *P1, yo, k3, k3tog, k3, yo, k1; rep from * around.

RND 4: Rep Rnd 2.

Repeat Rnds 1–4 for pattern.

NOTE

• The skirt begins at the lower edge with the lace pattern worked on the largest needle. The skirt is shaped by changing to progressively smaller needles to the ribbed waist, which is worked on the smallest needle.

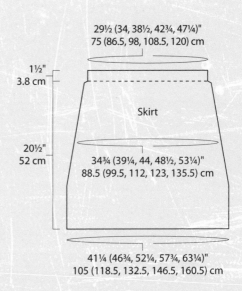

29½ (34, 38½, 42¾, 47¼)"
75 (86.5, 98, 108.5, 120) cm

1½"
3.8 cm

Skirt

20½"
52 cm

34¾ (39¼, 44, 48½, 53¼)"
88.5 (99.5, 112, 123, 135.5) cm

41¼ (46¾, 52¼, 57¾, 63¼)"
105 (118.5, 132.5, 146.5, 160.5) cm

Skirt

With size 9 (5.5 mm) needle, CO 165 (187, 209, 231, 253) sts. Place marker and join for working in rnds, being careful not to twist sts. Work lace patt (see Stitch Guide) until piece measures 6″ (15 cm) from CO. Change to size 8 (5 mm) needle and work even as established until piece measures 11″ (28 cm) from CO. Change to size 7 (4.5 mm) needle and work in St st (knit every rnd) until piece measures 17½″ (44.5 cm) from CO, or 3″ (7.5 cm) less than desired length to base of waistband. Change to size 6 (4 mm) needle and work even until piece measures 20½″ (52 cm) from CO or desired length.

Waistband and Facing

Change to size 5 (3.75 mm) needle.

NEXT RND: K2tog, *p1, k1; rep from *—164 (186, 208, 230, 252) sts rem.

NEXT RND: *K1, p1; rep from *.

Rep the last rnd until rib section measures 1½″ (3.8 cm).

TURNING RND: P4 (10, 0, 6, 12), [p2tog, p8 (9, 11, 12, 13)] 16 times—148 (170, 192, 214, 236) sts rem. Remove end-of-

rnd marker and work St st (knit RS rows; purl WS rows) back and forth in rows until facing measures 1½" (3.8 cm) from turning rnd.

Loosely BO all sts.

Finishing

Block to measurements (the facing is not shown on the schematic). Fold facing to WS along turning rnd and, with yarn threaded on a tapestry needle, sew BO edge of facing to first rnd of ribbing to form casing for elastic. Thread elastic through casing, overlap ends as necessary to achieve the correct fit. Sew the overlapped ends of the elastic together with sharp-point sewing needle and thread. With yarn threaded on a tapestry needle, sew selvedges of facing tog to close opening in casing. Weave in loose ends. Block again, if desired.

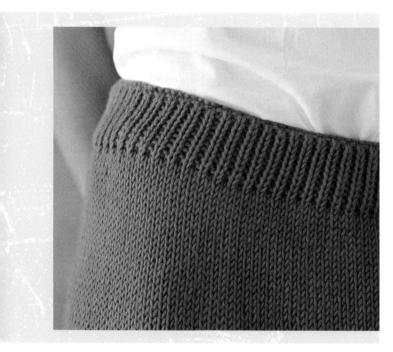

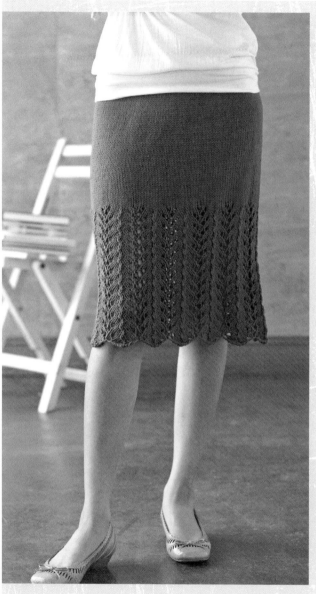

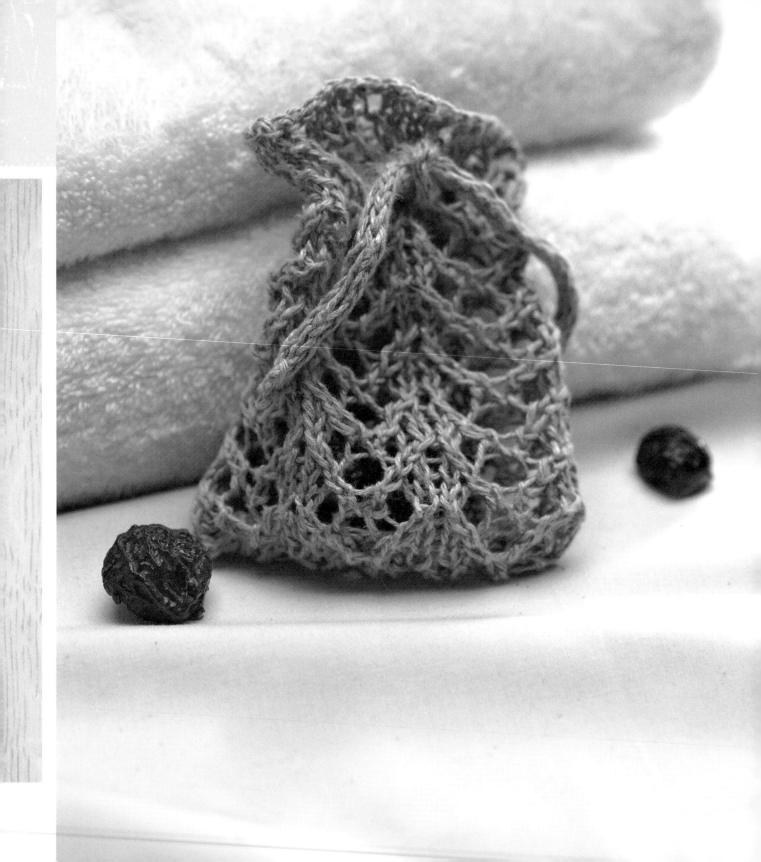

soap nut
VESSELS

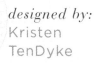

designed by:
Kristen
TenDyke

Instead of using laundry detergent, **Kristen TenDyke** throws a few soap nuts in her washing machine. Soap nuts are the shells of berries that grow on trees in India and Nepal. The shells contain a large quantity of saponin that acts as a gentle detergent when agitated in water. Simply place a porous bag containing four or five soap nuts in the washer and enjoy three or four loads of clean clothes without chemicals, perfumes, or dyes. Kristen improved on the look (and made it easier to find the bag in a load of whites) by knitting her own lacy patterns with renewable hemp yarn.

Finished Size
About 3¼" (8.5 cm) wide and 4¼" (11 cm) tall.

Yarn
Fingering weight (#1 Super Fine).
SHOWN HERE: Lanaknits #101 Allhemp3 (100% long-fiber hemp; 165 yd [150 m]/50 g): #013 foggy (light gray), 1 skein.

note: One skein will make about 4 or 5 bags.

Needles
Size U.S. 2 (2.75 mm): straight and 2 double-pointed (dpn).

Notions
Tapestry needle; soap nuts (available online from various sources).

Gauge
About 12 stitches and 15 rows = 2" (5 cm) in stitch pattern. Exact gauge is not critical for this project.

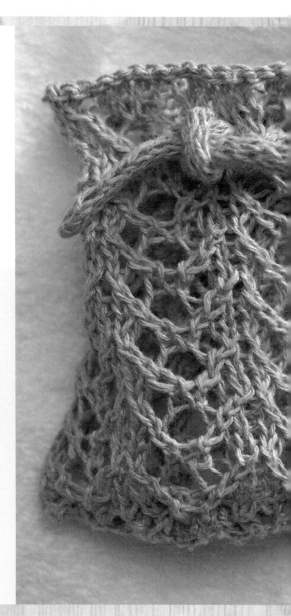

STITCH GUIDE

Sk2p

Slip 1 st knitwise, k2tog, pass the slipped st over the st made by the k2tog (2 sts decreased).

Pattern A (multiple of 6 sts + 2)

ROW 1: (RS) K1, *k2tog, yo, k2, yo, ssk; rep from * to last st, k1.

ROW 2: Purl.

ROW 3: K2, *k2tog, [yo] 2 times, ssk, k2; rep from * to end.

ROW 4: P2, *p1, work (p1, p1tbl) in the double yo of previous row, p3; rep from * to end.

Rep Rows 1–4 for pattern.

Pattern B (multiple of 6 sts + 2)

ROW 1: (RS) K1, *ssk, yo, k1, yo, k2tog, k1; rep from * to last st, k1.

ROWS 2 AND 4: Purl.

ROW 3: K1, *yo, k2tog, k1, ssk, yo, k1; rep from * to last st, k1.

Rep Rows 1–4 for pattern.

Pattern C (multiple of 6 sts + 2)

ROWS 1 AND 3: (RS) K1, *yo, k1, sk2p, k1, yo, k1; rep from * to last st, k1.

ROWS 2 AND 4: Purl.

Rep Rows 1–4 for pattern.

Bag

CO 38 sts. Purl 1 (WS) row. Working in your choice of Pattern A, B, or C (see Stitch Guide) rep Rows 1–4 of patt 6 times, then work Rows 1–2 once more—26 rows total. Knit 1 RS row, then purl 1 WS row. For all patts, work Rows 3 and 4 as for Pattern A to create eyelet holes for drawstring.

Shape Top

(RS) K1, *[k2, yo] 2 times, k2; rep from * to last st, k1—50 sts. Purl 1 WS row.

NEXT ROW: (RS) K1, *k2, yo, k4, yo, k2; rep from * to last st, k1—62 sts.

With WS facing, BO all sts knitwise, leaving a long tail for seaming.

Finishing

Block pieces to about 6½" (16.5 cm) wide below the flared top edge and 4¼" (11 cm) tall, allowing top edge to ruffle gently. Fold in half vertically. With yarn threaded on a tapestry needle, sew side and bottom seams. Weave in loose ends.

I-Cord Tie

With dpn, CO 4 sts. Work 4-st I-cord (see Glossary) until piece measures about 8½" (21.5 cm) from CO. BO all sts. Weave in CO and BO tails into the center of the cord.

Thread cord through eyelet holes, fill bag with 4 or 5 soap nuts, and tie in a square knot to secure.

the meaning of organic

essay by:
Pam Allen
Knitwear Designer

The tag "organic" is everywhere these days, but one woman's organic is another's "not quite." In the food realm, the emphasis is on the dirt a plant grows in and what's sprayed on the leaves—whether we're eating the plant directly or through an organic animal destined for the grocery store. In either case, the focus is on the farming processes. However, in the world of textiles, formal certification is a two-part process that hinges at the farmyard gate. For a yarn to be organic, the entire production cycle after harvest is also an issue—carding, retting, scouring, bleaching, spinning, dyeing, and finishing—all processes that involve water and chemicals.

In the United States, the National Organic Program (NOP), the organic division of the USDA, oversees the federal organic standards, which were mandated by the Organic Foods Production Act of 1990 and finalized in 2001. These legally binding standards dictate what constitutes organic methods for crops and animals raised in the United States, and products sold as organic must abide by them. The law also requires that all imports labeled organic comply with the same standards. USDA-accredited third-party certifiers, often local agencies, monitor the specifics of how the plants or animals are raised to ensure compliance with the law.

The goal in organic farming practice for plants and animals is to use methods that have minimal impact on the environment. Crop rotation and organic matter take the place of synthetic fertilizers that feed a plant but do little to refurbish soil quality or fertility. Geneti-

cally modified seeds are banned, as are toxic chemicals that might contaminate local environments, create a risk for the people handling them, or leave harmful residues on leaves. This isn't to say that no pesticides can be used—certain treatments are allowed. For example, approved pesticides are especially important for cotton plants vulnerable to boll weevil. Given that the pesticides traditionally used on cotton are among the most toxic on earth, switching to less harmful products has been a huge environmental improvement. Farmers

Cotton

are also experimenting with other kinds of pest control such as pheromone lures that entice bugs away from host plants.

Wool fiber is certified organic if it's taken from an animal that has been in an organic system from the last third of its gestation period. Organic sheep must graze on organic pasture, have access to the outdoors and adequate shelter, and be free of antibiotics. Organic or not, pests and disease are part of raising sheep. The challenge for any organic farmer or shepherd is to find ways to keep plants and animals healthy without resorting to products that are potentially lethal in the long-term. It's important to note, however, that the health of an animal is paramount. If a sick animal risks dying, it's taken out of the organic system and treated with antibiotics as needed. But once out of the organic Eden, it can't return to the herd.

In theory, as far as animals go, humane treatment is part of organic practice. The controversial practice of mulesing—slicing off a sheep's hind skin in order to promote pest-resistant scar tissue—isn't an accepted organic practice. On large farms, however, it's an effective way to combat flystrike, a disease in which parasites set up housekeeping in the warm, damp hindquarters of Merino sheep. Eventually, the fly larvae bore through the host sheep's skin, a situation that usually results in the sheep's death through blood poisoning.

Organically minded farmers are finding other, less brutal, ways to combat flystrike. They avoid introducing infected sheep into a noninfected herd; rotate grazing areas between sheep, cattle, and goats; breed sheep for less wool in the susceptible area; and finally, they shear the sheep more than once a year—a costly procedure.

After the raw material—plant or animal fiber—has been certified by a local agency, organic certification of the final product is the mandate of the voluntary Global Textile Standard (GOTS), an international certification program launched in 2006. The GOTS certifier looks at the production, processing, manu-

facturing, packaging, labeling, and distribution of textile products. Because GOTS standards are the result of collaboration among many countries with different farming and textile methods and cultures, the standards are as stringent as they can be, given the practical realities of varying material resources and what can be realistically verified. The stated aim of GOTS certification is to: Define worldwide recognized requirements that ensure organic status of textiles from harvesting of the raw materials, through environmentally and socially responsible manufacturing up to labeling in order to provide a credible assurance to the end consumer.

To earn GOTS status, a processing plant or spinning mill must ensure strict separation of organic and nonorganic materials and equipment to prevent contamination. For example, a mill can't spin organic and nonorganic fiber on the same equipment. Residues from nonorganic substances used in conventional farming linger on machinery and in storage facilities.

Material used in the process—soaps, chemicals, dyes—must be on an approved list. They must be non-toxic and biodegradable. Organic doesn't mean that chemicals are never used; certain ones, such as formaldehyde are prohibited, but others such as certain optical brighteners—used by Wal-Mart in dyeing its organic clothing line—pass muster.

Processes used in scouring and dyeing must be earth-friendly and sustainable. Given that clean water is a scarce resource in many parts of the world, processing plants are encouraged to find ways of reusing it. When wastewater can't be recovered, it needs to be disposed of in a way that doesn't pollute the local environment or water supply. Two solutions often used to solve the waste-product problem are artificial wetlands or lagoons for storage and filters that collect solids for composting.

As might be expected, people who work in processing, spinning, and dyeing plants need to be trained in certain environmentally sustaining practices—how to conserve water and energy, how to use chemicals conservatively and safely, and how to dispose of them correctly.

It's interesting to note that the GOTS standards include social responsibility as a criterion for organic certification (a criterion not included in U.S. NOP standards). Fair wages and safe working conditions—determined by local standards—are GOTS requirements. Children can't be used in the production of the product, nor any kind of forced or bonded labor.

Finally, all of the above must be documented so that inspectors have a transparent and thorough trail to follow.

Given that organic practices are often more expensive and labor intensive than conventional ones, it behooves businesses that make the effort to produce an organic product to apply for certification—even at their own expense. As consumers, we encourage organic practice by asking for products that are certified. In this way, we hold accountable manufacturers who use the word "organic" on their labels.

Flax

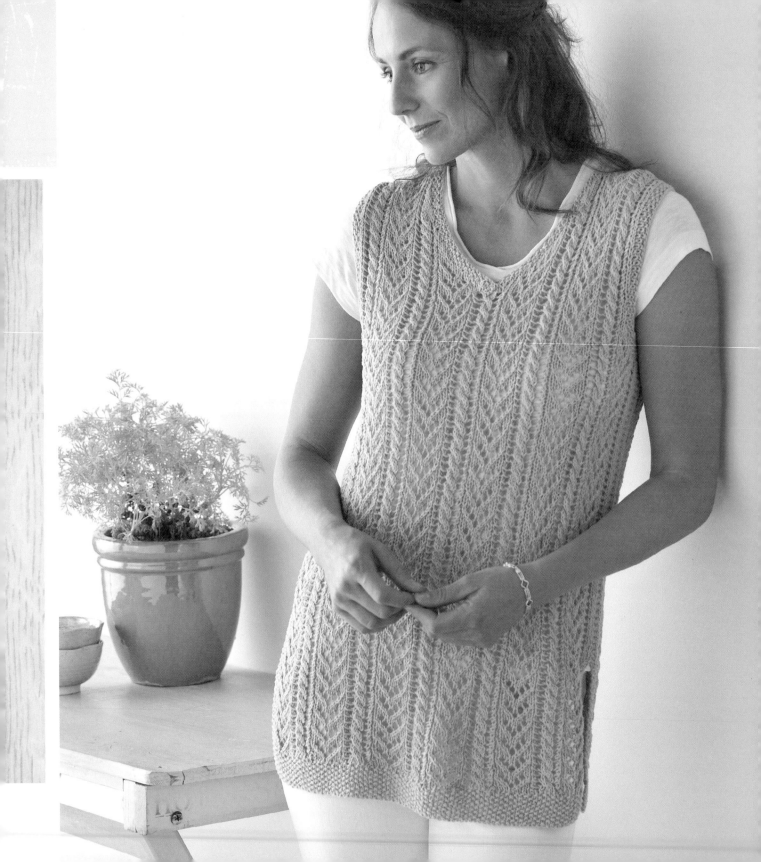

allegoro lace
TUNIC

designed by:
Therese Chynoweth

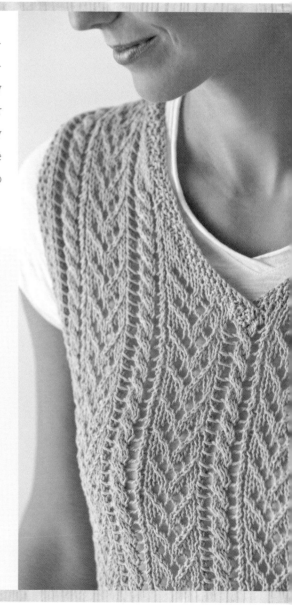

Therese Chynoweth's lace tunic is made with an organic-cotton-and-linen yarn named for Al Gore, who made global warming a household term. The two fibers are blended into a yarn that is comfortably breathable and has crisp stitch definition—perfect for a lacy summer top. Therese began by working the back and front separately for a few inches, then joined them together and worked in the round to the armholes, at which point she worked the back and front separately to the shoulders, shaping the armholes and V-neck along the way.

Finished Size

About 30¼ (33¾, 38¾, 43, 46¼, 49¾, 54)" (77 [85.5, 98.5, 109, 117.5, 126.5, 137] cm) bust circumference.

Tunic shown measures 38¾" (98.5 cm).

Yarn

DK weight (#3 Light).

SHOWN HERE: Classic Elite Allegoro (70% organic cotton, 30% linen; 152 yd [139 m]/50 g): #5619 lupine pink, 5 (5, 6, 7, 7, 8, 8) skeins.

Needles

BODY: size U.S. 6 (4 mm): 24" and 32" (60 and 80 cm) circular (cir) and set of 4 double-pointed (dpn). EDGING: size U.S. 5 (3.75 mm): 24" and 32" (60 and 80 cm) cir. Adjust needle size if necessary to obtain the correct gauge.

Notions

Cable needle (cn); markers (m); stitch holders; tapestry needle.

Gauge

19 stitches and 32 rows = 4" (10 cm) in cable and lace pattern from chart on larger needles.

Lower Back

With shorter cir needle in smaller size, CO 72 (80, 92, 102, 110, 118, 128) sts. Do not join. Work all sts in seed st (see Stitch Guide) for 13 rows, ending with a RS row—piece measures about 1¼" (3.2 cm) from CO. Change to shorter cir needle in larger size.

NEXT ROW: (WS) Work 6 (6, 5, 6, 6, 5, 6) sts in seed st as established, place marker (pm), p60 (68, 82, 90, 98, 108, 116), pm, work rem 6 (6, 5, 6, 6, 5, 6) sts in seed st as established.

SET-UP ROW: (RS) Work 6 (6, 5, 6, 6, 5, 6) sts in seed st, establish patt from Row 1 of Cable & Lace chart (see page 32) for your size by working 2 (6, 13, 2, 6, 11, 15) sts before patt rep box once (see Notes), rep 15-st patt 3 (3, 3, 5, 5, 5, 5) times, work 13 (17, 24, 13, 17, 22, 26) sts after patt rep box once, work rem 6 (6, 5, 6, 6, 5, 6) sts in seed st.

Working the sts outside the markers in seed st as established, cont in patt until 42 (42, 46, 46, 46, 50, 50) chart rows have been completed, ending with WS Row 6 (6, 10, 10, 10, 2, 2) of chart—piece measures about 6½ (6½, 7, 7, 7, 7½, 7½)" (16.5 [16.5, 18, 18, 18, 19, 19] cm) from CO. Cut yarn and set aside.

Lower Front

Work same as back, using longer cir needles in smaller and larger sizes as indicated. After last row, leave sts on needle and do not cut yarn.

Body

note: On joining rnd, remove m on each side of chart patts as you come to them and place new m to indicate the right side "seam" and end-of-rnd.

JOINING RND: With larger, longer cir needle holding front sts and RS facing, *k2 (1, 1, 2, 1, 1, 0), establish patt from Row 7 (7, 11, 11, 11, 3, 3) of Cable & Lace chart for your size by working 6 (11, 2, 6, 11, 15, 6) sts before patt rep box once, rep 15-st patt 3 (3, 5, 5, 5, 5, 7) times, work 17 (22, 13, 17, 22, 26, 17) sts after patt rep box once, k2 (1, 1, 2, 1, 1, 0)*, pm for right side, return held back sts to needle; rep from * to * over back sts, pm for end-of-rnd, and join for working in rnds—144 (160, 184, 204, 220, 236, 256) sts.

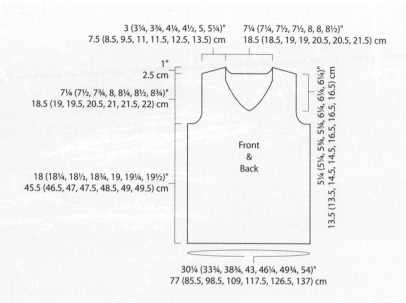

3 (3¼, 3¾, 4¼, 4½, 5, 5¼)"
7.5 (8.5, 9.5, 11, 11.5, 12.5, 13.5) cm

7¼ (7¼, 7½, 7½, 8, 8, 8½)"
18.5 (18.5, 19, 19, 20.5, 20.5, 21.5) cm

1"
2.5 cm

7¼ (7½, 7¾, 8, 8¼, 8½, 8¾)"
18.5 (19, 19.5, 20.5, 21, 21.5, 22) cm

5¼ (5¼, 5¾, 5¾, 6¼, 6¼, 6¼)"
13.5 (13.5, 14.5, 14.5, 16.5, 16.5, 16.5) cm

Front & Back

18 (18¼, 18½, 18¾, 19, 19¼, 19½)"
45.5 (46.5, 47, 47.5, 48.5, 49, 49.5) cm

30¼ (33¾, 38¾, 43, 46¼, 49¾, 54)"
77 (85.5, 98.5, 109, 117.5, 126.5, 137) cm

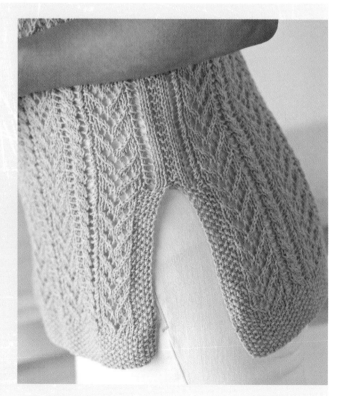

NEXT RND: *P2 (1, 1, 2, 1, 1, 0), cont chart patt in the rnd over 68 (78, 90, 98, 108, 116, 128) sts, p2 (1, 1, 2, 1, 1, 0); rep from * once more.

Working 2 (1, 1, 2, 1, 1, 0) st(s) at each end of both front and back in established garter st (knit 1 rnd, purl 1 rnd), cont patt in the rnd until piece measures 18 (18¼, 18½, 18¾, 19, 19¼, 19½)" (45.5 [46.5, 47, 47.5, 48.5, 49, 49.5] cm) from CO, ending with an even-numbered rnd and ending the last rnd 2 (3, 4, 4, 5, 5, 5) sts before end-of-rnd m.

DIVIDING RND: *BO 4 (6, 8, 8, 10, 10, 10) sts for armhole, removing m in center of BO sts as you come to it, work in established patt until there are 68 (74, 84, 94, 100, 108, 118) sts on needle after BO gap, join a second ball of yarn; rep from *—68 (74, 84, 94, 100, 108, 118) sts each for front and back.

Shape Front Armholes

note: Back sts may be placed on a holder or allowed to rest on the needle while working the front sts back and forth in rows.

Cont in patt on front sts only, BO 0 (0, 0, 3, 3, 3, 3) sts at beg of next 0 (0, 0, 2, 2, 2, 2) rows, then BO 2 sts at beg of foll 2 (2, 4, 4, 4, 4, 6) rows, then BO 1 st at beg of next 2 (4, 4, 4, 6, 8, 10) rows—62 (66, 72, 76, 80, 86, 90) sts

Cable and Lace

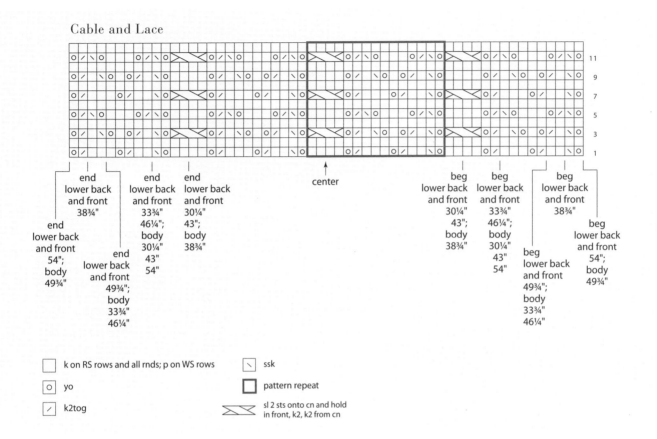

k on RS rows and all rnds; p on WS rows		ssk	
o	yo		pattern repeat
/	k2tog		sl 2 sts onto cn and hold in front, k2, k2 from cn

rem. Work even in patt until armholes measure 2 (2¼, 2, 2¼, 2, 2¼, 2½)" (5 [5.5, 5, 5.5, 5, 5.5, 6.5] cm), ending with a WS row.

Shape Front Neck and Shoulders

(RS) Work 31 (33, 36, 38, 40, 43, 45) sts in patt, join a second ball of yarn and work in patt to end—31 (33, 36, 38, 40, 43, 45) sts each side. Working each side separately, dec 1 st at each neck edge on the next 12 (12, 12, 12, 13, 13, 15) RS rows, then every 3rd row 5 (5, 6, 6, 6, 6, 5) times—14 (16, 18, 20, 21, 24, 25) sts rem each side. Work even until armholes measure 7¼ (7½, 7¾, 8, 8¼, 8½, 8¾)" (18.5 [19, 19.5, 20.5, 21, 21.5, 22] cm), ending with a WS row. Shape shoulders separately using short-rows (see Glossary) as foll.

Left Front Shoulder

SHORT-ROWS 1, 3, 5, AND 7: (RS) Work in patt to neck edge.

SHORT-ROW 2: (WS) Work in patt to last 3 (4, 4, 5, 5, 6, 6) sts, wrap next st, turn.

SHORT-ROW 4: Work in patt to last 6 (8, 8, 10, 10, 12, 12) sts, wrap next st, turn.

SHORT-ROW 6: Work in patt to last 10 (12, 13, 15, 15, 18, 18) sts, wrap next st, turn.

SHORT-ROW 8: Work in patt to end, working wrapped sts tog with their wraps as you come to them.

Place sts on holder.

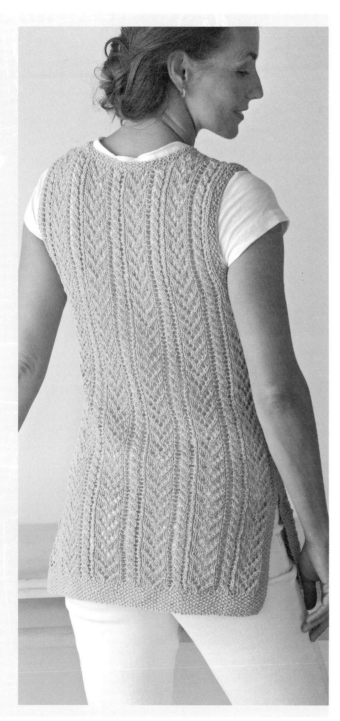

Right Front Shoulder

Resume working on 14 (16, 18, 20, 21, 24, 25) right front shoulder sts.

SHORT-ROW 1: (RS) Work in patt to last 3 (4, 4, 5, 5, 6, 6) sts, wrap next st, turn.

SHORT-ROWS 2, 4, AND 6: (WS) Work in patt to neck edge.

SHORT-ROW 3: Work in patt to last 6 (8, 8, 10, 10, 12, 12) sts, wrap next st, turn.

SHORT-ROW 5: Work in patt to last 10 (12, 13, 15, 15, 18, 18) sts, wrap next st, turn.

SHORT-ROW 7: Work in patt to end, working wrapped sts tog with their wraps as you come to them.

SHORT-ROW 8: Work in patt across all sts to end with a WS row. Place sts on holder.

Shape Back Armholes

Return 68 (74, 84, 94, 100, 108, 118) back sts to larger cir needle if they are not already on the needle. Work armhole shaping as for front—62 (66, 72, 76, 80, 86, 90) sts rem. Work even in patt until armholes measure 7¼ (7½, 7¾, 8, 8¼, 8½, 8¾)" (18.5 [19, 19.5, 20.5, 21, 21.5, 22] cm), ending with a WS row. Shape back neck and work shoulder short-rows at the same time as foll.

Left Back Neck and Shoulder

DIVIDING ROW: (RS) Work 19 (21, 23, 25, 26, 29, 30) sts in patt for right back shoulder and place these sts on holder or allow them to rest on needle while working left shoulder as desired, join a second ball of yarn and BO center 24 (24, 26, 26, 28, 28, 30) sts—1 st rem on right needle after BO gap; 18 (20, 22, 24, 25, 28, 29) unworked sts for a total of 19 (21, 23, 25, 26, 29, 30) left shoulder sts.

With RS still facing, cont on left shoulder sts as foll:

SHORT-ROW 1: (RS) Work in patt to last 3 (4, 4, 5, 5, 6, 6) sts, wrap next st, turn.

SHORT-ROWS 2, 4, AND 6: (WS) Work in patt to neck edge.

SHORT-ROW 3: BO 3 sts, work in patt to last 6 (8, 8, 10, 10, 12, 12) sts, wrap next st, turn—16 (18, 20, 22, 23, 26, 27) sts rem.

SHORT-ROW 5: BO 2 sts, work in patt to last 10 (12, 13, 15, 15, 18, 18) sts, wrap next st, turn—14 (16, 18, 20, 21, 24, 25) sts rem.

SHORT-ROW 7: Work in patt to end, working wrapped sts tog with their wraps as you come to them.

SHORT-ROW 8: Work in patt across all sts to end with a WS row.

Place sts on holder.

Right Back Neck and Shoulder

Return 19 (21, 23, 25, 26, 29, 30) right shoulder sts to larger cir needle with WS facing if they are not already on the needle.

SHORT-ROW 1: (WS) BO 3 sts, work in patt to last 3 (4, 4, 5, 5, 6, 6) sts, wrap next st, turn—16 (18, 20, 22, 23, 26, 27) sts.

SHORT-ROWS 2, 4, AND 6: (RS) Work in patt to neck edge.

SHORT-ROW 3: BO 2 sts, work in patt to last 6 (8, 8, 10, 10, 12, 12) sts, wrap next st, turn—14 (16, 18, 20, 21, 24, 25) sts.

SHORT-ROW 5: Work in patt to last 10 (12, 13, 15, 15, 18, 18) sts, wrap next st, turn.

SHORT-ROW 7: Work in patt to end, working wrapped sts tog with their wraps as you come to them.

Leave sts on needle and do not break yarn.

note: The RS dividing row worked across these sts at the start of the back neck shaping counts as 1 row, so this shoulder also contains 8 rows total.

Finishing

Join Shoulders

Return held right front shoulder sts to separate cir needle, then hold back and front right shoulder sts tog with RS touching and WS facing outward. Using larger needle tip and yarn attached to armhole edge of right back, use the three-needle method (see Glossary) to join shoulder sts tog. Place held sts of back and front left shoulders on separate needles, rejoin yarn to one armhole edge, and join left shoulder in the same manner.

Armhole Edging

With RS facing and smaller, shorter cir needle, join yarn to center of BO sts at base of armhole, then pick up and knit 76 (82, 88, 98, 104, 110, 116) evenly spaced around

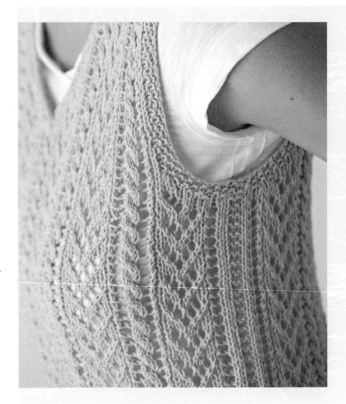

armhole to end at center of BO sts again. Pm and join for working in rnds.

RND 1: *K1, p1; rep from *.

RND 2: *P1, k1; rep from *.

Rep Rnds 1 and 2, then work Rnd 1 once more—5 rnds total. BO all sts in patt. Rep for other armhole.

Neck Edging

With smaller, shorter cir needle, RS facing, and beg at point of V-neck, pick up and knit 36 (36, 40, 40, 44, 44, 48) sts along right front neck, 33 (33, 35, 35, 37, 37, 39) sts across back neck, and 36 (36, 40, 40, 44, 44, 48) sts along left front neck—105 (105, 115, 115, 125, 125, 135) sts total. Do not join. Work seed st back and forth in rows for 5 rows, beg and ending with a WS row. BO all sts in patt. Lap ends of neck edging right over left, and sew short selvedges at ends of edging to shaped neck edges as shown.

Weave in loose ends. Block to measurements.

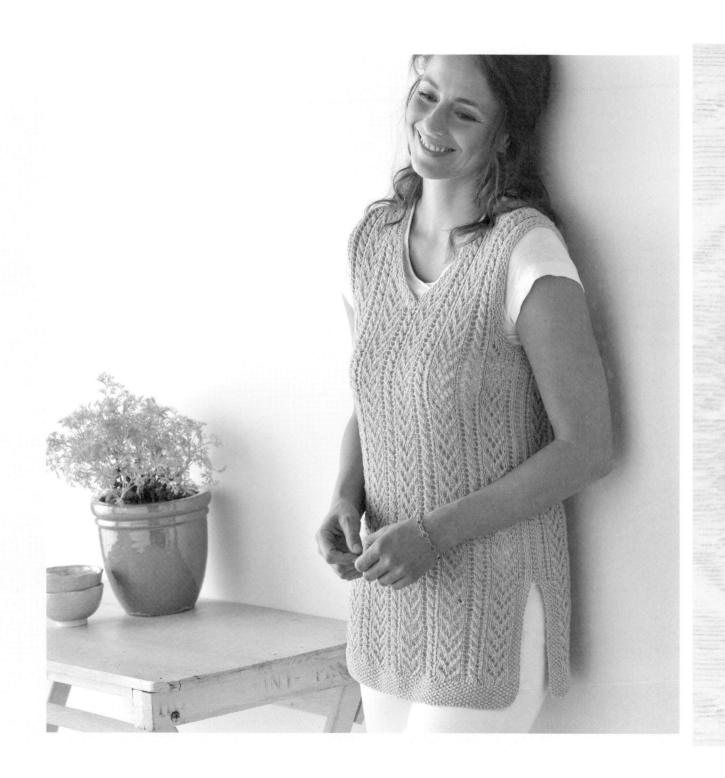

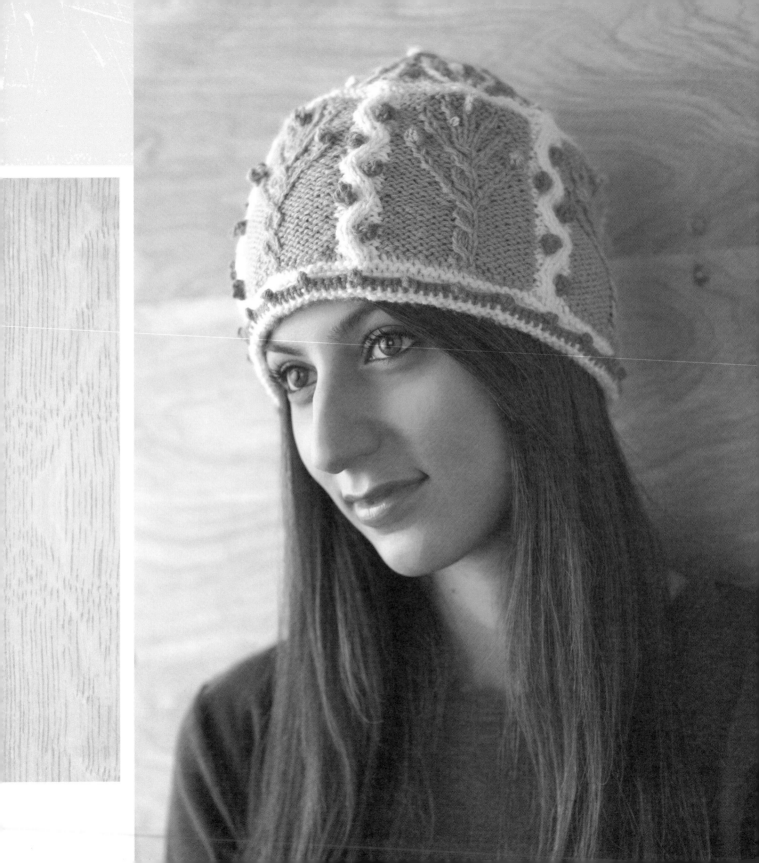

back-to-nature
HAT

designed by:
Michele Rose
Orne

The good folks at O-Wool spin knitting yarns from 100 percent certified-organic fibers and process them in accordance with the Organic Trade Association's Fiber Processing Standards. **Michele Rose Orne** used their DK weight organic merino to knit a hat that includes several elements of nature—trees, waves, stones, and snowflakes. Michele knitted the hat from the brim to the center of the crown in a combination stockinette stitch worked in rounds and intarsia worked back and forth in rows. She worked the bobble "stones" separately and sewed them in place.

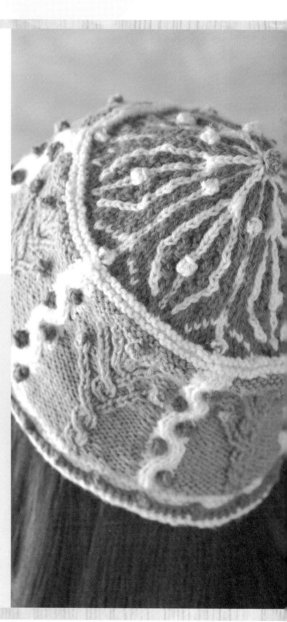

Finished Size

About 21" (53.5 cm) in circumference and 8¾" (22 cm) high. To fit a woman.

Yarn

DK weight (#3 Light).

SHOWN HERE: O-Wool Legacy DK (100% organic wool; 305 yd [279 m]/100 g): #1000 natural (A), #6041 olive (B), and #5624 storm (blue, C), 1 skein each.

Needles

Size U.S. 6 (4 mm): 16" (40 cm) circular (cir) and set of 5 double-pointed (dpn). Adjust needle size if necessary to obtain the correct gauge.

Notions

Markers (m); bobbins (optional); cable needle (cn); tapestry needle; size E/4 (3.5 mm) crochet hook.

Gauge

20 stitches (1 patt rep wide) and 38 rows of Tree and Cable chart measure about 3½" (9 cm) wide and 4" (10 cm) high.

STITCH GUIDE

Small Bobble

BOBBLE WORKED SEPARATELY: CO 1 st, leaving a 3″ (7.5 cm) tail. Work (k1, yo, k1) all in same st—3 sts. Turn, p3, turn, k1, k2tog, pass the knit st over the k2tog—1 st rem. Cut yarn, leaving a 3″ (7.5 cm) tail, and fasten off last st.

BOBBLE WORKED AS YOU GO: Work (k1, p1, k1) all in same st—3 sts. Turn, p3, turn, k1, k2tog, pass the knit st over the k2tog—1 st rem.

Large Bobble

CO 1 st, leaving a 3″ (7.5 cm) tail. Work ([k1, yo] 2 times, k1) all in same st—5 sts. Turn, [k5, turn] 3 times. Sl 1, k4tog, psso—1 st rem. Cut yarn, leaving a 3″ (7.5 cm) tail. Fasten off last st.

Wrap

Bring yarn to front between needles, sl the next st to right-hand needle, bring yarn to back between needles, return slipped st to left-hand needle, then turn the work so the opposite side is facing you.

Joining Ends of Intarsia Rows

ROW 1: (RS) Work in patt to end of row, wrap next st (first st worked at beg of this row), turn work so WS is facing.

ALL WS ROWS: Work in patt to last st of row (wrapped st), then work the wrapped st tog with its wrap as k2tog, making sure that the wrap color is concealed underneath the charted color on the RS. Wrap next st (first st worked at beg of this row), turn work so RS is facing.

ALL RS ROWS EXCEPT ROW 1: Work in patt to last st of row (wrapped st), then work the wrapped st tog with its wrap as p2tog, making sure that the wrap color is concealed underneath the charted color. Wrap next st (first st worked at beg of this row), turn work so WS is facing.

NOTES

- The hat is worked from the brim to the center of the crown.

- The first eight rounds of the brim are worked in the round, then the Tree and Cable chart is worked back and forth in rows on the same short circular needle using the intarsia method. Read the even-numbered chart rows from left to right as WS rows. Use a separate strand of yarn for each vertical section, crossing the yarns at the color changes to prevent leaving holes. To avoid having to seam this part of the hat, the ends of the rows are joined using wraps (see Stitch Guide).

- After finishing the intarsia section, the rest of the hat is worked in the round using two-color stranded knitting for the Crown chart.

- Because the bobbles of the Tree and Cable chart are located on even-numbered WS rows, purl the stitch for each bobble symbol with the background color, then work separate bobbles and attach them at these positions later. Because the Crown chart is worked in the round, its bobbles can be worked as you come to them or knitted separately and sewn in place during finishing, if you prefer.

- Before beginning Rnd 7 of the Crown chart, temporarily remove the end-of-round marker, slip the first stitch purlwise to the right-hand needle, and replace the marker. Doing so will allow both stitches for the last k2tog at the end of the round to be on the same side of the marker.

Hat

Brim

With A and cir needle, CO 120 sts. Place marker (pm) and join for working in rnds, being careful not to twist sts. Knit 4 rnds, [purl 1 rnd, knit 1 rnd] 2 times. Prepare 12 butterflies or bobbins, 6 each with A and B. Work Tree and Cable chart as foll.

NEXT ROW: (RS; Row 1 of chart) Using the intarsia method and a separate strand for each color section, *[P1, k2, p2] with A, [p6, k3, p6] with B; rep from * to end, then wrap next st (see Stitch Guide).

NEXT ROW: (WS; Row 2 of chart) With WS facing, work Row 2 of chart to last st, work wrapped st tog with its wrap, then wrap the foll st.

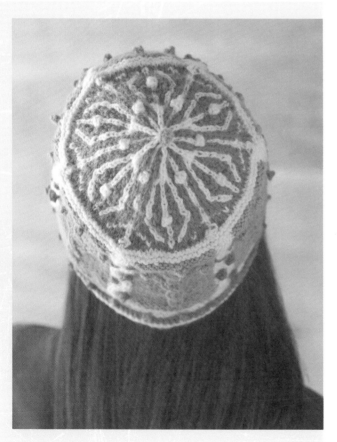

Cont working in this manner, joining the ends of the rows with wraps (see Stitch Guide), until Row 38 of chart has been completed. With RS facing, rejoin for working in rnds. With A, [knit 1 rnd, purl 1 rnd] 2 times, working last wrapped st tog with its wrap as you come to it in the first rnd.

Crown

Change to dpn and redistribute sts evenly on 4 needles—30 sts on each needle. With A and C, work Rnds 1–27 of Crown chart—12 sts rem. Cut yarn, thread tail through rem sts, pull tight to close hole, and fasten off on WS.

Finishing

Bobbles

Make 48 separate small bobbles for Tree and Cable chart; 18 with B and 30 with C. Sew bobbles in place on RS at positions shown on chart. If you chose to work the Crown chart bobbles separately, make 18 bobbles with A and attach them to the positions shown. With B, make a large bobble (see Stitch Guide) and sew to top of crown.

Edging

With C, crochet hook, and beg at start of rnd aligned with "seam" of intarsia, join edging along CO edge as foll: *Work 1 single crochet (sc; see Glossary for crochet instructions) in each of next 5 CO sts, chain (ch) 3, work a slip stitch into sc at base of ch to form a picot; rep from * around, then end by working a slip stitch into first sc of rnd. Cut yarn and fasten off last st.

Weave in loose ends. Steam-block lightly as needed.

Tree and Cable

Crown

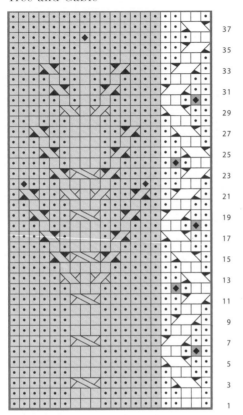

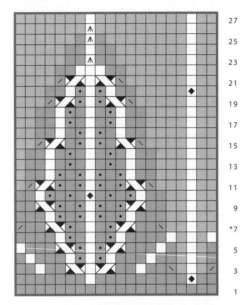

*See Notes.

Work stitches with colors shown on charts.

☐	knit on RS rows and all rnds; purl on WS rows
•	purl on RS rows and all rnds; knit on WS rows
⁄	k2tog
\	ssk
ʌ	sl 2 as if to k2tog, k1, pass 2 slipped sts over
◆	small bobble (see Stitch Guide and Notes)
▨	no stitch

☐	pattern repeat
⤢	sl 1 st onto cn, hold in back, k1, k1 from cn
⤡	sl 1 st onto cn, hold in front, k1, k1 from cn
◣	sl 1 st onto cn, hold in back, k1, p1 from cn
◢	sl 1 st onto cn, hold in front, p1, k1 from cn
◤	sl 1 st onto cn, hold in back, k2, p1 from cn
◥	sl 2 sts onto cn, hold in front, p1, k2 from cn
⤢	sl 1 st onto cn, hold in front, k2, k1 from cn

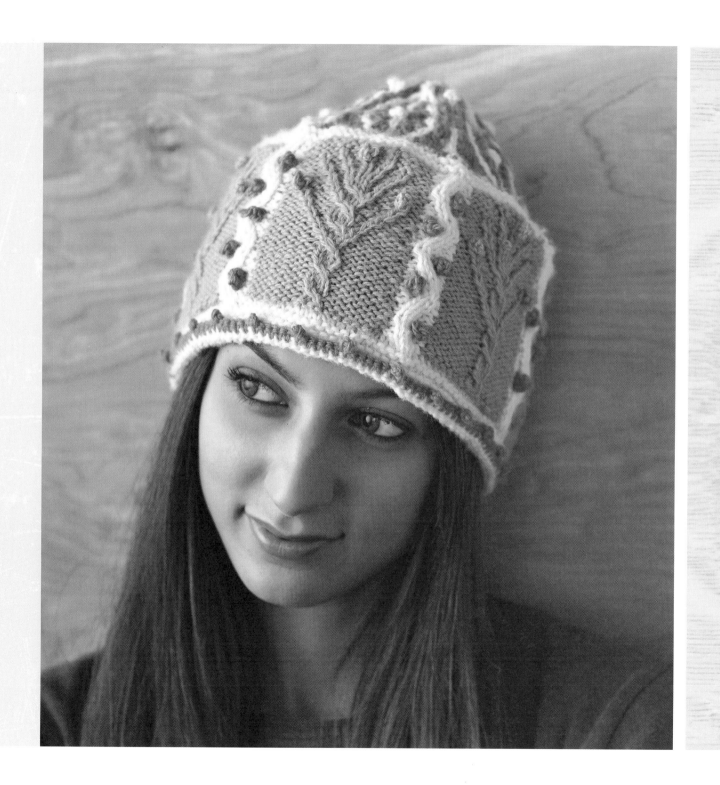

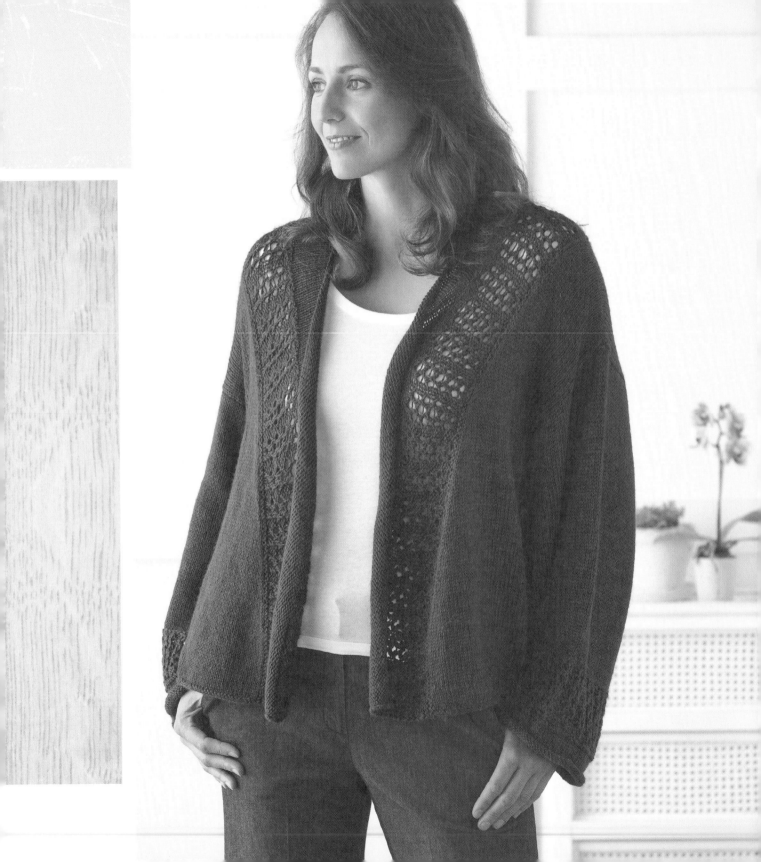

soy-silk
KIMONO

designed by:
Vicki
Square

It turns out that soybeans are so much more than a meat substitute. As a fiber, soy protein boasts the softness of silk and the warmth of cashmere. **Vicki Square** capitalized on the soft gentle drape in a kimono that transcends the seasons. She worked the body and sleeves in pieces from the lower edges to the shoulders, then picked up stitches around the neck and fronts to work the lace edging perpendicular to the garment fronts. Fasten the kimono with a stick pin or let it hang open naturally.

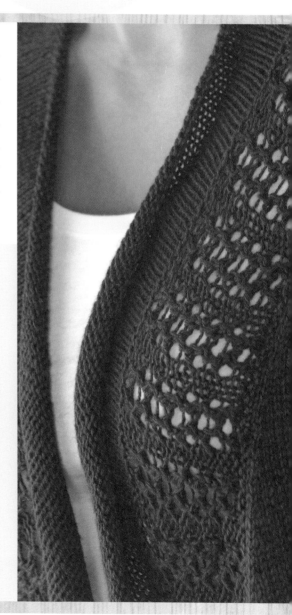

Finished Size

36½ (40, 43½, 47½, 51)" (92.5 [101.5, 110.5, 120.5, 129.5] cm) bust circumference.

Kimono shown measures 43½" (110.5 cm).

Yarn

DK weight (#3 Light).

SHOWN HERE: Southwest Trading Company Pure (100% soysilk; 164 yd [150 m]/50 g): #027 cabernet, 8 (9, 10, 10, 11) balls.

Needles

Size U.S. 6 (4 mm): 24" and 32" (60 and 80 cm) circular (cir). Adjust needle size if necessary to obtain correct gauge.

Notions

Markers (m); stitch holders; size F/5 (3.75 mm) crochet hook; tapestry needle.

Gauge

22 stitches and 30 rows = 4" (10 cm) in stockinette stitch.

Back

With longer cir needle and using the Old Norwegian method (see Glossary), CO 100 (110, 120, 130, 140) sts. Knit 1 WS row. Change to St st and work even until piece measures 8½ (9, 9, 9, 9)" (21.5 [23, 23, 23, 23] cm) from CO, ending with a WS row.

Shape Armholes

BO 2 sts at beg of next 2 rows—96 (106, 116, 126, 136) sts rem.

DEC ROW: (RS) *K1, k2tog, knit to last 3 sts, ssk, k1—2 sts dec'd.

Purl 1 WS row. Rep the last 0 (2, 2, 2, 2) rows 0 (1, 1, 2, 3) more time(s)—94 (102, 112, 120, 128) sts rem. Work even until armholes measure 7¾ (7¾, 8¼, 8½, 8¾)" (19.5 [19.5, 21, 21.5, 22] cm), ending with a WS row.

Shape Neck

K35 (38, 42, 45, 48), join a second ball of yarn and BO center 24 (26, 28, 30, 32) sts, knit to end—35 (38, 42, 45, 48) sts at each side. Working each side separately, at each neck edge BO 7 sts once, then BO 3 sts once, then BO 2 sts 3 times, then dec 1 st every RS row 4 times—15 (18, 22, 25, 28) sts rem each side. Work even until armholes measure 11½ (11½, 12, 12¼, 12½)" (29 [29, 30.5, 31, 31.5] cm) and piece measures 20 (20½, 21, 21¼, 21½)" (51 [52, 53.5, 54, 54.5] cm) from CO. Place sts on separate holder for each shoulder.

Right Front

With shorter cir needle and using the old Norwegian method, CO 45 (50, 55, 60, 65) sts. Do not join. Knit 1 WS row. Change to St st and work even until piece measures 4" (10 cm) from CO for all sizes.

Shape Neck and Armhole

note: Armhole shaping is introduced while neck shaping is in progress; read the following sections before proceeding.

NECK DEC ROW: (RS) K1, ssk, knit to end—1 st dec'd at neck edge.

For neck shaping, dec 1 st at neck edge in this manner every foll 4th row 26 (27, 28, 29, 30) more times—27 (28, 29, 30, 31) sts total removed at neck edge. *At the same time* when the piece measures 8½ (9, 9, 9, 9)" (21.5 [23, 23, 23, 23] cm) from CO, shape armhole by BO 2 sts at beg of next WS row, then dec 1 st at armhole edge as for back at end of next 1 (2, 2, 3, 4) RS row(s)—3 (4, 4, 5, 6) sts removed at armhole edge; 15 (18, 22, 25, 28) sts rem when all shaping has been completed. Work even in St st until armhole measures 11½ (11½, 12, 12¼, 12½)" (29 [29, 30.5, 31, 31.5] cm) and piece measures 20 (20½, 21, 21¼, 21½)" (51 [52, 53.5, 54, 54.5] cm) from CO. Place sts on holder.

Left Front

With shorter cir needle and using the old Norwegian method, CO 45 (50, 55, 60, 65) sts. Do not join. Knit 1 WS row. Change to St st and work even until piece measures 4" (10 cm) from CO for all sizes.

Shape Neck and Armhole

note: As for right front, neck and armhole shaping are worked at the same time; read the following sections before proceeding.

NECK DEC ROW: (RS) Knit to last 3 sts, k2tog, k1—1 st dec'd at neck edge.

For neck shaping, dec 1 st at neck edge in this manner every foll 4th row 26 (27, 28, 29, 30) more times—27 (28, 29, 30, 31) sts total removed at neck edge. *At the same time* when the piece measures 8½ (9, 9, 9, 9)" (21.5 [23, 23, 23, 23] cm) from CO, shape armhole by BO 2 sts at beg of next RS row, then dec 1 st at armhole edge as for back at beg of next 1 (2, 2, 3, 4) RS row(s)—3 (4, 4, 5, 6) sts removed at armhole edge; 15 (18, 22, 25, 28) sts rem when

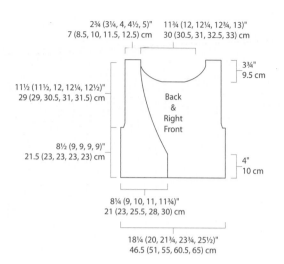

2¾ (3¼, 4, 4½, 5)"
7 (8.5, 10, 11.5, 12.5) cm

11¾ (12, 12¼, 12¾, 13)"
30 (30.5, 31, 32.5, 33) cm

3¾"
9.5 cm

11½ (11½, 12, 12¼, 12½)"
29 (29, 30.5, 31, 31.5) cm

Back
&
Right
Front

8½ (9, 9, 9, 9)"
21.5 (23, 23, 23, 23) cm

4"
10 cm

8¼ (9, 10, 11, 11¾)"
21 (23, 25.5, 28, 30) cm

18¼ (20, 21¾, 23¾, 25½)"
46.5 (51, 55, 60.5, 65) cm

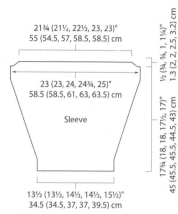

21¾ (21½, 22½, 23, 23)"
55 (54.5, 57, 58.5, 58.5) cm

½ (¾, ¾, 1, 1¼)"
1.3 (2, 2, 2.5, 3.2) cm

23 (23, 24, 24¾, 25)"
58.5 (58.5, 61, 63, 63.5) cm

Sleeve

17¾ (18, 18, 17½, 17)"
45 (45.5, 45.5, 44.5, 43) cm

13½ (13½, 14½, 14½, 15½)"
34.5 (34.5, 37, 37, 39.5) cm

all shaping has been completed. Work even in St st until armhole measures 11½ (11½, 12, 12¼, 12½)" (29 [29, 30.5, 31, 31.5] cm) and piece measures 20 (20½ 21, 21¼, 21½)" (51 [52, 53.5, 54, 54.5] cm) from CO. Place sts on holder.

Sleeves

With shorter cir needle and using the long-tail method (see Glossary), CO 74 (74, 80, 80, 86) sts. Do not join. Beg and ending with a WS row, work even in St st until piece measures 2" (5 cm) from CO. Purl 1 RS row for garter ridge. Work set-up row of Lace patt (see Stitch Guide) on next WS row. Rep Rows 1–4 of Lace patt 5 times and *at the same time* inc 1 st at each side of Row 3 in all 5 vertical reps by working p1, p1f&b (see Glossary) in first 2 sts of row and working p1f&b, p1 in last 2 sts of row, working new sts in rev St st (purl on RS rows; knit on WS rows)— 84 (84, 90, 90, 96) sts. Purl 2 rows for garter ridge, ending with a WS row—piece measures about 5½" (14 cm) from CO. Cont in St st, use the backward-loop method (see Glossary) to inc 1 st at each end of needle every 4th row 16 (16, 17, 13, 13) times, then every other row 5 (5, 4, 10, 8) times, working new sts in St st—126 (126, 132, 136, 138) sts. Work even in St st until piece measures 17¾ (18, 18, 17½, 17)" (45 [45.5, 45.5, 44.5, 43] cm) from CO with lower edge unrolled and measured flat, ending with a

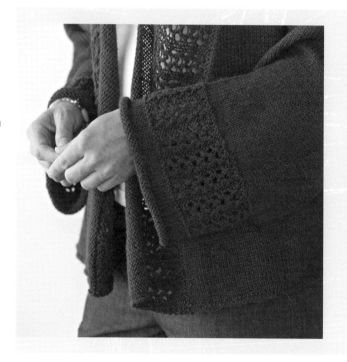

Lace Border Neckband

Row numbers (right side): 17, 15, 13, 11, 9, 7, 5, 3, 1

set-up

└ work ┘
16 (17,17, 17, 17)
times
left front

└ work ┘
9 (9, 9, 10, 10)
times
back

└ work ┘
16 (17, 17, 17, 17)
times
right front

Legend:

☐ k on RS; p on WS
• p on RS; k on WS
○ yo
╱ k2tog
╲ ssk

⅄ p2tog on RS; k2tog on WS
▨ no stitch
☐ pattern repeat
| marker position

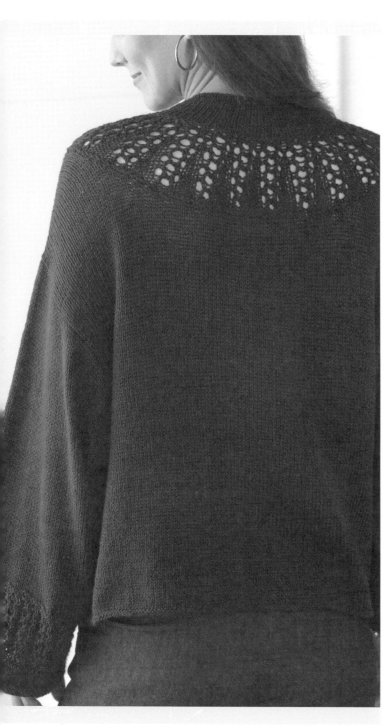

WS row. **note:** The larger sizes have increasingly wider upper bodies, so they have shorter sleeves to prevent the cuff-to-cuff "wingspan" of the kimono from becoming too wide.

Shape Cap

BO 2 sts at beg of next 2 rows—122 (122, 128, 132, 134) sts rem.

DEC ROW: (RS) *K1, k2tog, knit to last 3 sts, ssk, k1—2 sts dec'd.

Purl 1 WS row. Rep the last 0 (2, 2, 2, 2) rows 0 (1, 1, 2, 3) more time(s)—120 (118, 124, 126, 126) sts rem. BO all sts.

Finishing

Join Shoulders

Place held sts of back and front right shoulders on separate cir needles and hold pieces tog with RS touching and WS facing outward. Use the three-needle method (see Glossary) and the tip of one of the cir needles to join shoulder sts tog. Place held sts of back and front left shoulders on separate needles and join left shoulder in the same manner.

Lace Border Neckband

Lightly steam-block shoulder seams. With WS facing, lightly steam front and neck edges to uncurl them and make it easier to pick up sts along neck edge. With longer cir needle, RS facing, and beg at CO edge of right front, pick up and knit 2 sts along garter ridge, 104 (110, 110, 110, 110) sts along right front to shoulder seam, place marker (pm), 80 (80, 80, 88, 88) sts along back neck to next shoulder seam, pm, 104 (110, 110, 110, 110) sts along left front to garter ridge, and 2 sts along garter ridge to end at CO edge of left front—292 (304, 304, 312, 312) sts total. Knit 2 rows, ending with a RS row. Establish patt from set-up row of Lace Border Neckband chart as foll: (WS) K2 (garter edge sts), k2, work 6-st patt rep 16 (17, 17, 17, 17) times, p4, k2, sl m, k2, p4, work 8-st patt rep 9 (9, 9, 10, 10) times, k2, sl m, k2, p4, work 6-st patt rep 16 (17, 17, 17, 17) times, k2, k2 (garter edge sts). Cont as established, work Rows 1–18 of chart. **note:** On Rows 5 and 10 you will need to temporarily remove the shoulder m in order to work the sts on each side of the m tog; replace the m in the positions shown on chart after working these decs.

When Row 18 has been completed—259 (271, 271, 276, 276) sts rem; 105 (111, 111, 111, 111) right front sts; 50 (50, 50, 55, 55) back sts; 104 (110, 110, 110, 110) left front sts.

NEXT ROW: (RS) K2, p1, p1f&b, [ssk, k2tog, (p1f&b) twice] 16 (17, 17, 17, 17) times, ssk, k2tog, p1, sl m, [ssk, k2tog, p1] 10 (10, 10, 11, 11) times, sl m, [ssk, k2tog, (p1f&b) twice] 16 (17, 17, 17, 17) times, ssk, k2tog, p1f&b, p1, k2—237 (249, 249, 252, 252) sts rem; 104 (110, 110, 110, 110) right front sts; 30 (30, 30, 33, 33) back sts; 103 (109, 109, 109, 109) left front sts.

Knit 1 WS row for garter ridge. Work even in St st for 2½" (6.5 cm)—neckband measures about 6½" (16.5 cm) from pick-up row. BO all sts.

With yarn threaded on a tapestry needle, use the mattress st with ½-st seam allowance (see Glossary) to sew sleeve and side seams. Insert sleeve caps into armholes with RS touching and WS facing outward, matching center of each sleeve cap to shoulder join. With WS facing you, use slip-stitch crochet (see Glossary) to join sleeves to body. Weave in loose ends. Lightly steam-block St st sections of garment on WS, taking care to avoid lace borders and rolled St st edges of cuffs and neckband. Turn kimono right side out and lay flat to dry.

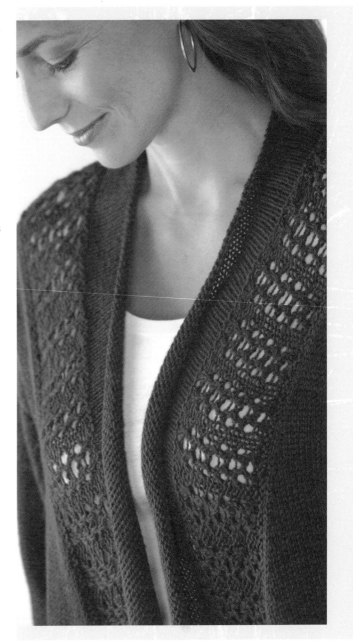

a shop owner's dilemma

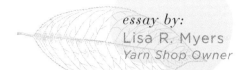
essay by:
Lisa R. Myers
Yarn Shop Owner

Being an environmentally conscious retailer looks a lot like being an environmentally conscious individual at home: you recycle, replace incandescent lightbulbs with compact fluorescents, and install a thermostat with a timer.

At work, though, it can be tricky to be a model of green retailing and also meet customer expectations for convenience and comfort. Without customer participation, a retailer's green efforts can quickly come to naught. In this new era of conservation, here are a few suggestions for knitters to work with yarn retailers for a greener knitting community.

Can one ever be too cool?

I like to run the air-conditioner only when it's absolutely necessary, but what's absolutely necessary? Selling yarn in July is an uphill battle, especially when it's 80 degrees Fahrenheit. I want you to come into the shop and spend time browsing, dreaming, exploring, talking, and yes, buying, but I hope you'll be understanding when the store is a comfortable 72 degrees instead of an arctic 66 degrees.

Timing is everything.

Give it time. I'd like to save on shipping charges and fuel by placing fewer, larger orders with suppliers. But I don't have much storage space (it's the rare shop that does). In the spirit of green living, I hope my customers can sometimes order in advance or help me consolidate orders by being willing to wait a few more days or weeks for an order.

Make an intentional green purchase.

I'm delighted at the green yarn options I can offer to my customers, from undyed to naturally dyed to organically grown fibers. I stock a bunch of them, and they're a pleasure to knit with—they're well crafted and wonderfully soft, and come in beautiful subtle colors. Sometimes, though, they don't sell all that well, for a variety of reasons.

For one, it's difficult for a display of natural browns and grays to get attention. Even naturally dyed colors, which look beautiful together and could create a visual haven if they were the only yarns in the place, sometimes look dull next to conventionally dyed fibers. If you're willing now and then to forego the "eye candy" for a more subdued but sustainable option, you'll find it has an enduring beauty.

Then there's price.

On the whole, environmentally conscious yarns are more expensive than conventional yarns. I understand that it can be difficult to pay the price—for the knitter as well as the shop owner who orders an expensive inventory of organic cotton that gets marked down at the end of the season.

Yet even a small purchase of organic yarn, locally produced yarn, or other sustainable choice helps to build the market. Vote with your dollars! I buy green yarn because it's great yarn, and everyone tells me how much they care about the environment, and I love helping my customers make a conscious choice to invest in a green knitting project. Ask your yarn retailer to do the same.

We're all pioneers in the world of green knitting, and at this stage, being environmentally engaged often takes more time and costs more money. Retailers and knitters who want to create with conscious environmental awareness can work together to support our shared values. You'll have the pleasure of a wonderful green knitting experience, and we'll be able to stay in business and keep expanding our green choices and initiatives.

all-(north)american
HOODIE

designed by:
Véronik Avery

In addition to designing great knitwear, **Véronik Avery** has spearhead-
ed a new line of yarn with a small carbon footprint. Called St-Denis
after her maternal surname, this sportweight yarn is entirely grown,
harvested, processed, and distributed in North America—no trans-
oceanic transportation involved. Véronik doubled the yarn to make
the casual hooded pullover shown here ideal for cold climates. She
worked the body in the round from the lower edge to the armholes,
then worked the back and front separately to the shoulders. A simple
texture pattern at the yoke sets off the V-neck shaping.

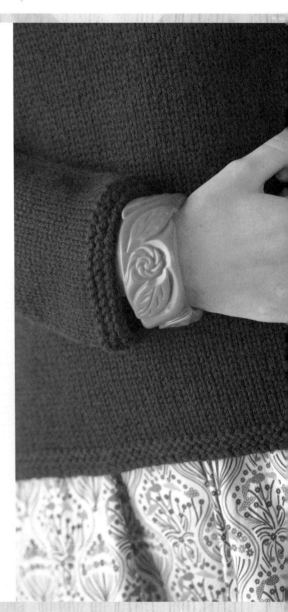

Finished Size

33 (36¾, 40½, 44¼, 48, 51¾)" (84
[93.5, 103, 112.5, 122, 131.5] cm) bust
circumference.
Sweater shown measures 36¾"
(93.5 cm).

Yarn

Sportweight (#2 Fine).

SHOWN HERE: St-Denis Nordique (100%
wool; 150 yd [137 m]/50 g): #5838
espresso, 14 (15, 17, 19, 21, 24) balls.

Needles

Size U.S. 10 (6 mm): 16" and 24" (40
and 60 cm) circular (cir) and set of
4 or 5 double-pointed (dpn). Adjust
needle size if necessary to obtain the
correct gauge.

Notions

Markers (one in contrasting color for
beg of rnd); coilless safety pins or
removable markers; stitch holders;
tapestry needle.

Gauge

17 stitches and 25 rows/rounds = 4"
(10 cm) in stockinette stitch with
yarn doubled.

NOTES

- Yarn is used double throughout.
- The lower body is worked in the round to the underarms, then divided for working the fronts and back separately, back and forth in rows. The sleeves are worked in the round to the beginning of the sleeve cap, then the cap shaping is worked back and forth in rows.
- Although the lower part of the sleeve is worked in the round, the sleeve is drawn opened out flat on the schematic to show the shape of the sleeve cap.

Body

With longer cir needle and two strands of yarn held tog, CO 152 (168, 184, 200, 216, 232) sts. Place marker (pm) and join for working in rnds, being careful not to twist sts; rnd beg at left side at start of front sts. Work in garter st (purl 1 rnd, knit 1 rnd) for 6 rnds—piece measures about ¾" (2 cm). Change to St st (knit every rnd) and work even until piece measures 1¼" (3.2 cm) from CO.

NEXT RND: K76 (84, 92, 100, 108, 116), pm for right side, knit to end—76 (84, 92, 100, 108, 116) sts each for front and back.

DEC RND: *Ssk, knit to 2 sts before m, k2tog, slip marker (sl m); rep from * once more—4 sts dec'd, 2 sts each from front and back.

Rep dec rnd every 8th rnd 2 more times, then every 6th rnd 4 times—124 (140, 156, 172, 188, 204) sts rem. Work even until piece measures 9½ (9½, 9½, 10, 10, 10)" (24 [24, 24, 25.5, 25.5, 25.5] cm) from CO.

INC RND: *K1, M1 (see Glossary), knit to 1 st before m, M1, k1, sl m; rep from * once more—4 sts inc'd, 2 sts each for front and back.

Rep inc rnd every 10th rnd 3 more times—140 (156, 172, 188, 204, 220) sts. Work even until piece measures 15¾ (16, 16½, 17, 17¼, 17¾)" (40 [40.5, 42, 43, 44, 45] cm) from CO, ending 2 (3, 4, 5, 6, 7) sts before end of rnd.

DIVIDING RND: Removing m as you come to them, BO last 2 (3, 4, 5, 6, 7) sts of previous rnd and first 2 (3, 4, 5, 6, 7) sts of next rnd, knit until there are 66 (72, 78, 84, 90, 96) sts on needle after BO gap and place these sts on holder for front, BO 4 (6, 8, 10, 12, 14) sts, knit to end for back—66 (72, 78, 84, 90, 96) back sts rem on needle.

Back

Working back and forth in rows, purl 1 WS row. Cont in St st, dec 1 st at each end of needle on the next 4 (5, 6, 7, 7, 7) RS rows, ending with a RS dec row—58 (62, 66, 70, 76, 82) sts; armholes measure about 1½ (1¾, 2, 2½, 2½, 2½)" (3.8 [4.5, 5, 6.5, 6.5, 6.5] cm).

Sizes 33 (36¾, 40½)" only

Cont even in St st until armholes measure 2½" (6.5 cm) for all three sizes, ending with a RS row.

All sizes

Establish yoke patt as foll:

ROWS 1 AND 3: (WS) Knit.

ROW 2: (RS) Purl, dec 0 (0, 0, 0, 1, 1) st at each end of needle—58 (62, 66, 70, 74, 80) sts rem.

ROW 4: Work according to your size as foll.

Sizes 33 (36¾, 40½, 44¼, 48)" only

K1 (selvedge st; work in St st), *k1, p1; rep from * to last st, k1 (selvedge st; work in St st).

Size 51¾" only

K1 (selvedge st; work in St st), k2tog, p1, *k1, p1; rep from * to last 4 sts, k1, ssp, k1 (selvedge st; work in St st)—78 sts.

All sizes

Cont in patt as foll:

ROW 5: P1, *k1, p1; rep from * to last st, p1.

ROW 6: K1, *p1, k1; rep from * to last st, k1.

ROW 7: P1, *p1, k1; rep from * to last st, p1.

ROW 8: K1, *k1, p1; rep from * to last st, k1.

Rep Rows 5–8 until armholes measure about 6½ (7, 7¼, 8, 8¾, 9¼)" (16.5 [18, 18.5, 20.5, 22, 23.5] cm), ending with WS Row 8—58 (62, 66, 70, 74, 78) sts rem.

Shape Shoulders

Cont in yoke patt, BO 6 (6, 7, 7, 8, 8) sts at beg of next 4 rows, then BO 6 (7, 6, 8, 7, 9) sts at beg of foll 2 rows—22 (24, 26, 26, 28, 28) sts rem. Place sts on holder.

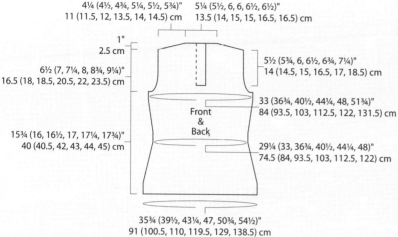

4¼ (4½, 4¾, 5¼, 5½, 5¾)"
11 (11.5, 12, 13.5, 14, 14.5) cm

5¼ (5½, 6, 6, 6½, 6½)"
13.5 (14, 15, 15, 16.5, 16.5) cm

1"
2.5 cm

6½ (7, 7¼, 8, 8¾, 9¼)"
16.5 (18, 18.5, 20.5, 22, 23.5) cm

5½ (5¾, 6, 6½, 6¾, 7¼)"
14 (14.5, 15, 16.5, 17, 18.5) cm

33 (36¾, 40½, 44¼, 48, 51¾)"
84 (93.5, 103, 112.5, 122, 131.5) cm

Front
&
Back

15¾ (16, 16½, 17, 17¼, 17¾)"
40 (40.5, 42, 43, 44, 45) cm

29¼ (33, 36¾, 40½, 44¼, 48)"
74.5 (84, 93.5, 103, 112.5, 122) cm

35¾ (39½, 43¼, 47, 50¾, 54½)"
91 (100.5, 110, 119.5, 129, 138.5) cm

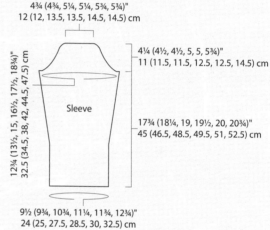

4¾ (4¾, 5¼, 5¼, 5¾, 5¾)"
12 (12, 13.5, 13.5, 14.5, 14.5) cm

4¼ (4½, 4½, 5, 5, 5¾)"
11 (11.5, 11.5, 12.5, 12.5, 14.5) cm

12¾ (13¾, 15, 16½, 17½, 18¾)"
32.5 (34.5, 38, 42, 44.5, 47.5) cm

Sleeve

17¾ (18¼, 19, 19½, 20, 20¾)"
45 (46.5, 48.5, 49.5, 51, 52.5) cm

9½ (9¾, 10¾, 11¼, 11¾, 12¾)"
24 (25, 27.5, 28.5, 30, 32.5) cm

Front

Return 66 (72, 78, 84, 90, 96) held front sts to longer cir needle and rejoin yarn with WS facing. Working back and forth in rows, purl 1 WS row. Cont in St st, dec 1 st at each end of needle on the next 2 (3, 3, 4, 5, 5) RS rows, then work 1 WS row even—62 (66, 72, 76, 80, 86) sts; armholes measure about 1 (1¼, 1¼, 1½, 2, 2)" (2.5 [3.2, 3.2, 3.8, 5, 5] cm).

Shape Neck

Mark center 6 front sts with removable markers or safety pins—28 (30, 33, 35, 37, 40) sts on each side of marked sts.

NEXT ROW: (RS) Dec 1 st at armhole edge as established, knit to m, sl m, k6, remove next m, join a second ball of yarn and use the cable method (see Glossary) to CO 6 sts at beg of second group of sts, pm, knit to end, dec 1 st at armhole edge as established—33 (35, 38, 40, 42, 45) sts at each side; 6 marked garter sts at neck edge of each group.

NEXT ROW: (WS) Working each side separately, for first group purl to m, sl m, k6; for second group, k6, sl m, purl to end.

Cont in St st with 6 garter sts at each neck edge, work 1 (1, 3, 3, 1, 1) row(s), dec 1 st at each armhole edge on next

1 (1, 2, 2, 1, 1) RS row(s), ending with a RS dec row—32 (34, 36, 38, 41, 44) sts at each side; armholes measure about 1½ (1¾, 2, 2½, 2½, 2½)" (3.8 [4.5, 5, 6.5, 6.5, 6.5] cm).

Sizes 33 (36¾, 40½)" only

Cont even in St st with 6 garter sts at each neck edge until armholes measure 2½" (6.5 cm) for all three sizes, ending with a RS row.

All sizes

Establish yoke patt as foll:

ROWS 1 AND 3: (WS) Knit.

ROW 2: (RS) For first group, dec 0 (0, 0, 0, 1, 1) st at armhole edge, purl to marked sts, k6; for second group, k6,

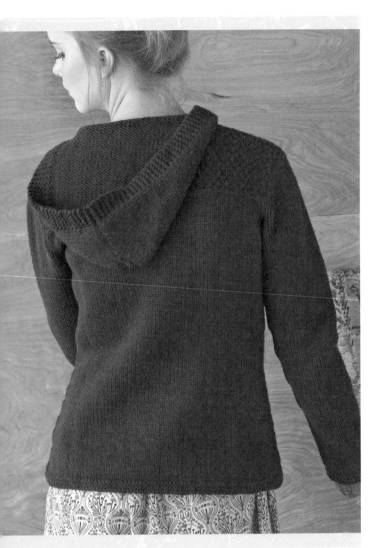

purl to end dec 0 (0, 0, 0, 1, 1) st at armhole edge—32 (34, 36, 38, 40, 43) sts.

ROW 4: Work according to your size as foll.

Sizes 33 (36¼, 40½, 44¼, 48)" only

For first group of sts, k1 (selvedge st; work in St st), *k1, p1; rep from * to 1 st before m, k1, sl m, k6; for second group of sts, k6, sl m, k1, **p1, k1; rep from ** to last st, k1 (selvedge st; work in St st).

Size 51¾" only

For first group of sts, k1 (selvedge st; work in St st), k2tog, p1, *k1, p1; rep from * to 1 st before m, k1, sl m, k6; for second group of sts, k6, sl m, k1, **p1, k1; rep from ** to last 4 sts, p1, ssk, k1 (selvedge st; work in St st)—42 sts at each side.

All sizes

Cont in patt as foll:

ROW 5: P1, *p1, k1; rep from * to 1 st before m, p1, sl m, k6; for second group of sts, k6, sl m, p1, **k1, p1; rep from ** to last st, p1.

ROW 6: K1, *p1, k1; rep from * to 1 st before m, p1, sl m, k6; for second group of sts, k6, sl m, p1, **k1, p1; rep from ** to last st, k1.

ROW 7: P1, *k1, p1; rep from * to 1 st before m, k1, sl m, k6; for second group of sts, k6, sl m, k1, **p1, k1; rep from ** to last st, p1.

ROW 8: K1, *k1, p1; rep from * to 1 st before m, k1, sl m, k6; for second group of sts, k6, sl m, k1, **p1, k1; rep from ** to last st, k1.

Rep Rows 5–8 until armholes measure about 6½ (7, 7¼, 8, 8¾, 9¼)" (16.5 [18, 18.5, 20.5, 22, 23.5] cm, ending with WS Row 8—32 (34, 36, 38, 40, 42) sts at each side.

Shape Shoulders

Cont in yoke patt, at each armhole edge BO 6 (6, 7, 7, 8, 8) sts 2 times, then BO 6 (7, 6, 8, 7, 9) sts once—14 (15, 16, 16, 17, 17) sts rem at each side. Place sts on separate holders.

Sleeves

With dpn and two strands of yarn held tog, CO 40 (42, 46, 48, 50, 54) sts. Pm and join for working in rnds, being careful not to twist sts. Work in garter st for 6 rnds as for lower body. Change to St st and work even until piece measures 6½ (5½, 4½, 5½, 4¾, 4¼)" (16.5 [14, 11.5, 14, 12, 11] cm) from CO.

INC RND: K1, M1, knit to last st, M1, k1—2 sts inc'd.

Knit 9 (9, 9, 7, 7, 7) rnds. Rep the last 10 (10, 10, 8, 8, 8) rnds 6 (7, 8, 10, 11, 12) more times, changing to shorter cir needle when there are too many sts to fit on dpn, and ending last rnd 2 (3, 4, 5, 6, 7) sts before m—54 (58, 64,

70, 74, 80) sts; piece measures about 17¾ (18¼, 19, 19½, 20, 20¾)" (45 [46.5, 48.5, 49.5, 51, 52.5] cm) from CO.

Shape Cap

NEXT RND: Removing end-of-rnd m as you come to it, BO last 2 (3, 4, 5, 6, 7) sts of previous rnd and first 2 (3, 4, 5, 6, 7) sts of next rnd, knit to end—50 (52, 56, 60, 62, 66) sts rem.

Working back and forth in rows, purl 1 WS row. Cont in St st, BO 2 (2, 3, 3, 3, 3) sts at beg of next 2 rows—46 (48, 50, 54, 56, 60) sts rem.

DEC ROW: (RS) K2, k2tog, knit to last 4 sts, ssk, k2—2 sts dec'd.

Work 1 WS row even. Rep the last 2 rows 8 (9, 9, 11, 11, 13) more times—28 (28, 30, 30, 32, 32) sts rem. BO 2 sts at beg of next 4 rows—20 (20, 22, 22, 24, 24) sts rem. BO all sts.

Finishing

Block to measurements (see Notes). With a single strand of yarn threaded on a tapestry needle, sew front to back at shoulders. Lap right front garter edging over left front edging at base of neck opening and, with yarn threaded on a tapestry needle, sew CO sts of right edging to front of garment.

Hood

Place held sts of right front, back neck, and left front on cir needle, and rejoin yarn with RS facing to beg of right front sts.

NEXT ROW: (RS) K14 (15, 16, 16, 17, 17) right front sts, pick up and knit 1 st from shoulder seam, k22 (24, 26, 26, 28, 28) back neck sts, pick up and knit 1 st from shoulder seam, k14 (15, 16, 16, 17, 17) left front sts—52 (56, 60, 60, 64, 64) sts.

Do not join. Working back and forth in rows with 6 sts at each end of needle in garter st as established, work rem sts in St st until hood measures 10¼ (11, 11¾, 12¼, 13, 13½)" (26 [28, 30, 31, 33, 34.5] cm). Shape top as foll:

ROW 1: (RS) K24 (26, 28, 28, 30, 30), k2tog, pm in center, ssk, k24 (26, 28, 28, 30, 30)—2 sts dec'd, 1 st on each side of center m.

ROW 2: (WS) K6, purl to 2 sts before m, ssp (see Glos-sary), sl m, p2tog, purl to last 6 sts, k6—2 sts dec'd.

ROW 3: Knit to 2 sts before m, k2tog, sl m, ssk, knit to end—2 sts dec'd.

Rep Rows 2 and 3 three more times, ending with RS Row 3—34 (38, 42, 42, 46, 46) sts rem; 17 (19, 21, 21, 23, 23) sts on each side of center m; hood measures about 11¾ (12½, 13¼, 13¾, 14½, 15)" (30 [31.5, 33.5, 35, 37, 38] cm). Fold sts on cir needle in half at center m so that RS of halves touch and WS face outward. Use the three-needle method (see Glossary) to BO the two halves tog.

With a single strand of yarn threaded on a tapestry needle, sew sleeve caps into armholes. Weave in loose ends. Block again, including hood, if desired.

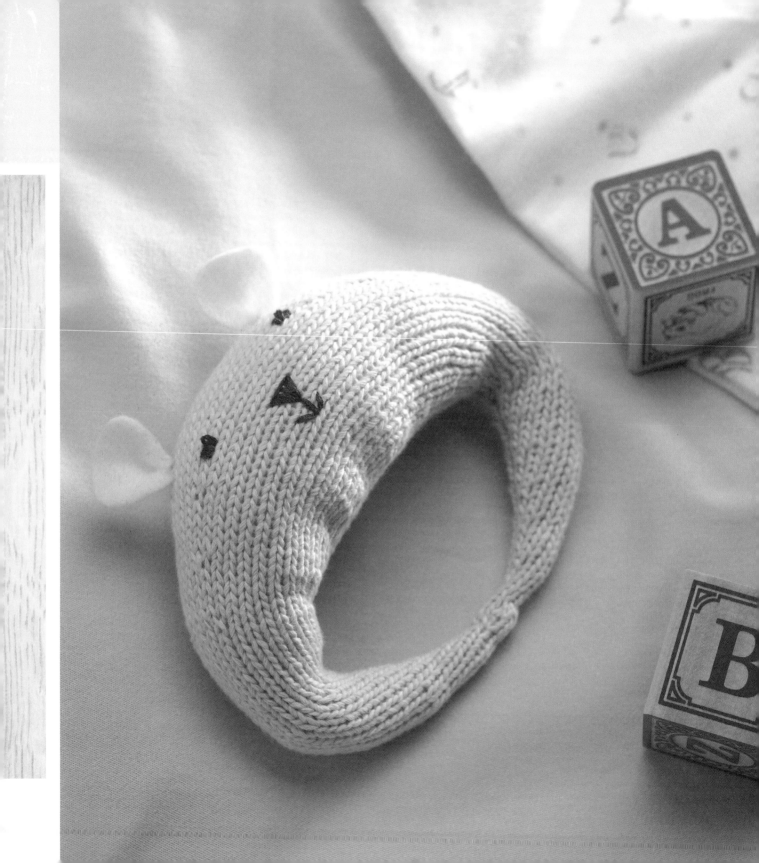

better
BABY RATTLE

designed by:
Katie
Himmelberg

Nonallergenic cotton has long been a favorite fiber for clothing and toys made for infants and children. **Katie Himmelberg** went a step further by using 100 percent organic cotton for this adorable baby rattle—no pesticides, chemicals, or dyes involved. Even better, a knitted rattle has no hard edges to cause inadvertent bruises. Katie's rattle is knitted from one short end to the other and shaped with short-rows along the way. She tucked a jingle bell inside the stuffing—organic roving for the diehard—and added a couple of felt ears and embroidery for character.

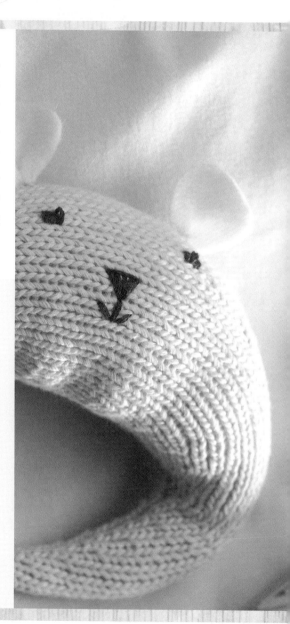

Finished Size

About 6½" (16.5 cm) wide and 5" (12.5 cm) high after stuffing and finishing, not including ears.

Yarn

Sportweight (#2 Fine).

SHOWN HERE: Plymouth Oceanside Organic (100% organic cotton; 109 yd [100 m]/50 g): #2 natural light green, 1 ball.

Needles

Size U.S. 4 (3.5 mm).

Notions

Markers (m); tapestry needle; polyester or organic roving for stuffing; jingle bell enclosed in fabric scrap or commercial rattle small enough to fit inside knitted piece (optional); embroidery floss; small piece of felt for ears.

Gauge

About 12 stitches and 16½ rows = 2" (5 cm) in stockinette stitch. Exact gauge is not critical for this project.

Rattle

CO 6 sts.

ROWS 1 (RS)–ROW 4 (WS): Work in St st.

ROW 5: (RS) K1, M1 (see Glossary), knit to last st, M1, k1—2 sts inc'd.

ROWS 6-8: Work in St st.

ROWS 9-20: Rep the Rows 5-8 three more times—14 sts.

ROW 21: Rep Row 5—16 sts.

ROW 22: Purl.

ROWS 23-26: Rep the last 2 rows 2 times—20 sts.

Cont as foll; some rows will be worked as short-rows (see Glossary) to shape curve of rattle handle:

ROW 27: (RS) Knit to last 3 sts, wrap next st, turn.

ROW 28: (WS) Purl to last 3 sts, wrap next st, turn.

ROW 29: Knit to 2 sts before previous wrapped st, wrap next st, turn.

ROW 30: Purl to 2 sts before previous wrapped st, wrap next st, turn.

ROW 31: Knit to end, working wrapped sts tog with their wraps as you come to them.

ROW 32: Purl across all sts, working rem wrapped sts tog with their wraps.

ROW 33: Rep Row 5—22 sts.

ROW 34: Purl.

ROW 35: Knit to last 3 sts, wrap next st, turn.

ROW 36: Purl to last 3 sts, wrap next st, turn.

ROWS 37-40: Rep Rows 31-34—24 sts.

ROWS 41-46: Rep Rows 35-40—26 sts.

ROW 47: K1, M1, k10, M1, place marker (pm), k4, pm, M1, k10, M1, k1—30 sts.

ROW 48: Purl.

ROW 49: Knit to last 4 sts, wrap next st, turn.

ROW 50: Purl to last 4 sts, wrap next st, turn.

ROWS 51 AND 52: Work each row to end, working wrapped sts tog with their wraps.

ROW 53: K1, M1, knit to marker (m), M1, slip marker (sl m), k4, sl m, M1, knit to last st, M1, k1—4 sts inc'd.

ROW 54: Purl.

ROW 55: Knit to last 4 sts, wrap next st, turn.

ROW 56: Purl to last 4 sts, wrap next st, turn.

ROWS 57 AND 58: Work each row to end, working wrapped sts tog with their wraps.

ROWS 59-64: Rep Rows 53-58 once more—38 sts.

ROWS 65-66: Work in St st.

ROWS 67-70: Rep Rows 55-58.

ROWS 71-82: Rep Rows 65-70 two times.

ROW 83: K1, k2tog, knit to 2 sts before m, k2tog, sl m, k4, sl m, ssk, knit to last 3 sts, ssk, k1—4 sts dec'd.

ROW 84: Purl.

ROWS 85-88: Rep Rows 55-58.

ROWS 89-94: Rep Rows 83-88—30 sts rem.

ROWS 95 AND 96: Rep Rows 83 and 84—26 sts rem.

ROW 97: K1, k2tog, knit to last 3 sts, ssk, k1—2 sts dec'd.

ROW 98: Purl.

ROW 99: Knit to last 3 sts, wrap next st, turn.

ROW 100: Purl to last 3 sts, wrap next st, turn.

ROWS 101 AND 102: Work each row to end, working wrapped sts tog with their wraps.

ROWS 103-114: Rep Rows 97-102 two times—20 sts rem.

ROW 115: Rep Row 97—2 sts dec'd.

ROW 116: Purl.

ROWS 117-120: Rep Rows 115 and 116 two times—14 sts rem.

ROW 121: Rep Row 97—2 sts dec'd.

ROWS 122-124: Work in St st.

ROWS 125-138: Rep Rows 121-124 three times, then work 2 rows St st to end with a WS row—6 sts rem.

BO all sts. Break yarn, leaving a 16" (40.5 cm) tail.

Finishing

note: If using a jingle bell, sew a small scrap of felt into a pouch to contain bell before inserting it into rattle.

With tail threaded on tapestry needle, sew selvedges tog, stuffing as you go and placing optional rattle or covered jingle bell in the middle of the stuffing at the widest part of rattle. Overlap CO and BO ends about ½″ (1.3 cm) and sew tog securely through all layers. Weave in loose ends.

Face and Ears

With embroidery floss threaded on a tapestry needle, embroider face using closely spaced stitches for eyes and nose, and small straight stitches for mouth in center of one side as shown in photograph; the rattle shown has eyes about 1¾″ (4.5 cm) apart and aligned with a stitch column at one side of the 4-st section between the incs and decs in center of toy. Cut two pieces of felt in ear shapes as shown. Pinch lower edges of ear tog and sew ears to toy about 2″ (5 cm) apart, slightly farther back on the head than the face; the rattle shown has ears aligned with the stitch column on the other side of the 4-st section between incs and decs in center of toy.

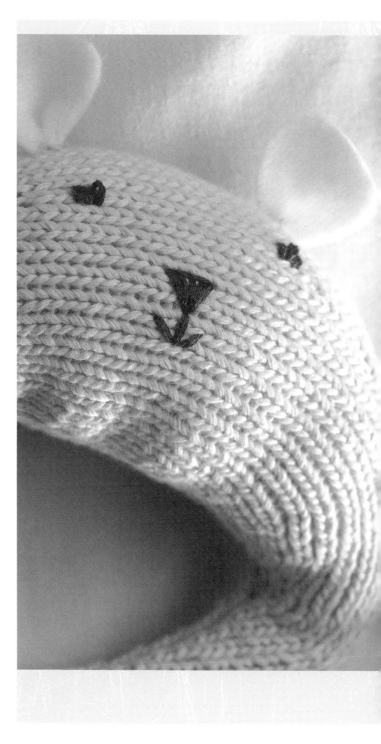

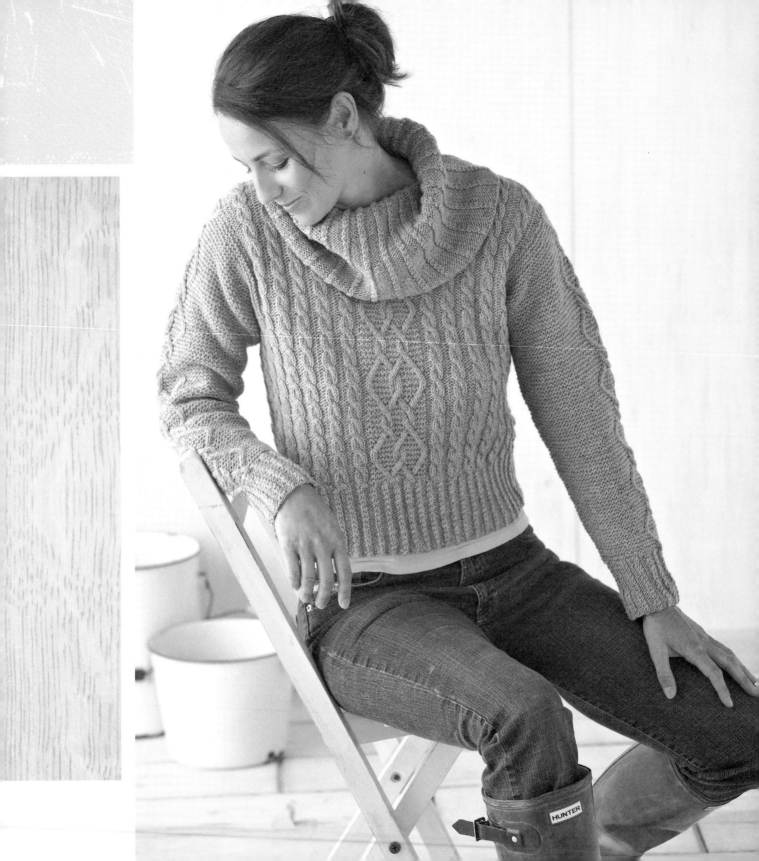

tree-hugger
PULLOVER

designed by:
Therese
Chynoweth

Green Mountain Spinnery·Sylvan Spirit is a lovely blend of fine wool and Tencel, a fiber derived from wood pulp harvested from Southern oak and gum trees grown on land that's unsuitable for grazing. The subtle sheen and gentle drape of this yarn are evident in the cables and cowl collar in **Therese Chynoweth's** pullover. Therese worked the body in the round to the armholes, then worked the back and front separately to the shoulders. She picked up stitches for the collar around the neckline and worked a series of increases to produce a generous flare.

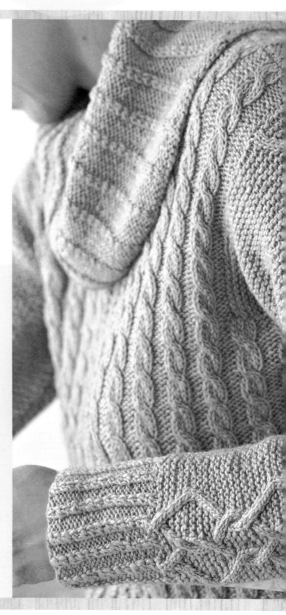

Finished Size

About 36 (40½, 45, 49¼, 53¾)" (91.5 [103, 114.5, 125, 136.5] cm) bust circumference.

Sweater shown measures 40½" (103 cm) in the cropped version.

Yarn

DK weight (#3 Light).

SHOWN HERE: Green Mountain Spinnery Sylvan Spirit (50% wool, 50% Tencel; 180 yd [164 m]/2 oz [56.7 g]): antique brass, 10 (10, 11, 12, 13) skeins for cropped version; 10 (11, 12, 13, 15) skeins for longer version.

Needles

Sizes U.S. 6 and 7 (4 and 4.5 mm): 16" and 32" (40 and 80 cm) circular (cir) and set of 4 or 5 double-pointed (dpn). Adjust needle size if necessary to obtain the correct gauge.

Notions

Markers (m); cable needle (cn); stitch holder; tapestry needle.

Gauge

25 stitches and 29 rows/rounds = 4" (10 cm) in side cable pattern on larger needles; 21 stitches and 38 rows/rounds = 4" (10 cm) in garter stitch on larger needles; 20 stitches of Lattice Cable chart measure about 3¼" (8.5 cm) wide on larger needles.

Body

With longer cir needle in smaller size, CO 200 (232, 260, 288, 320) sts. Place marker (pm) and join for working in rnds, being careful not to twist sts. Work in twisted rib patt (see Stitch Guide) until piece measures about 3½ (4, 4, 4½, 4½)" (9 [10, 10, 11.5, 11.5] cm) from CO, ending with Rnd 2 of patt. Work Rnd 1 of patt once more, inc 24 (20, 20, 20, 16) sts evenly spaced—224 (252, 280, 308, 336) sts. Change to longer cir in larger size.

NEXT RND: *Work Set-up rnd of side cable patt (see Stitch Guide) over 92 (106, 120, 134, 148) sts, pm, work Set-up rnd of Lattice Cable chart (see page 64) over next 20 sts, pm; rep from * once more, omitting last pm because end-of-rnd m is already in place—rnd begs at left back (after the center back cable panel).

Cont in established patts (do not rep the set-up rnds) until piece measures 12 (12¼, 12½, 12¾, 13)" (30.5 [31, 31.5, 32.5, 33] cm) from CO for cropped version or 15 (15¼, 15½, 15¾, 16)" (38 [38.5, 39.5, 40, 40.5] cm) for longer version, ending with an even-numbered, non-cable-crossing rnd. Break yarn. Sl the next 37 (37, 44, 44, 51) sts pwise without working any sts—the last 3 slipped sts should be a 3-st purl column. Rejoin yarn—first 4 sts at new beg of rnd should be a 4-st cable column.

DIVIDING RND: (odd-numbered rnd) *BO 18 (32, 32, 46, 46) sts for left armhole, working each 4-st cable column as [k1, k2tog, k1] as you BO instead of crossing the cables, cont in established patts until there are 94 (94, 108, 108, 122) front sts on needle after BO gap; rep from * once more for right armhole and back—sts at each end of both armhole BO should be 4-st cable columns; sts rem at each side of both front and back should be 3-st purl columns. Place front sts on holder.

Back

Working back and forth in rows with 1 selvedge st at each side in garter st (knit every row), cont in patt on 94 (94, 108, 108, 122) back sts until armholes measure 6½ (6¾, 7, 7¼, 7½)" (16.5 [17, 18, 18.5, 19] cm), ending with a WS row.

Shape Back Neck

(RS) Work 27 (27, 34, 34, 39) sts in patt, join second ball of yarn and BO center 40 (40, 40, 40, 44) sts working each 4-st cable column as [k1, k2tog, k1] as you BO, work in patt

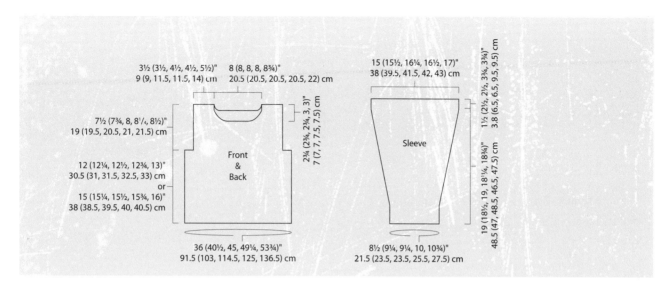

to end—27 (27, 34, 34, 39) sts rem each side. Working each side separately (see Notes), at each neck edge BO 2 sts 2 times, then BO 1 st once—22 (22, 29, 29, 34) sts rem each side. Work even if necessary until armholes measure 7½ (7¾, 8, 8¼, 8½)" (19 [19.5, 20.5, 21, 21.5] cm). BO all sts, working rem 4-st cables as [k1, k2tog, k1] in BO row.

Front

Return 94 (94, 108, 108, 122) held front sts to longer cir needle in larger size and rejoin yarn with WS facing. Working back and forth in rows with 1 selvedge st at each side in garter st, cont in patt until armholes measure 4¾ (5, 5¼, 5¼, 5½)" (12 [12.5, 13.5, 13.5, 14] cm), ending with a WS row.

Shape Front Neck

NEXT ROW: (RS) Work 37 (37, 44, 44, 49) sts in patt, join second ball of yarn and BO center 20 (20, 20, 20, 24) sts working each 4-st cable column as [k1, k2tog, k1] as you BO, work in patt to end—37 (37, 44, 44, 49) sts rem each side.

Working each side separately, at each neck edge BO 5 sts once, then BO 3 sts once, then BO 2 sts 2 times, then BO 1 st 3 times—22 (22, 29, 29, 34) sts rem each side. Work even until armholes measure 7½ (7¾, 8, 8¼, 8½)" (19 [19.5, 20.5, 21, 21.5] cm). BO all sts, working rem 4-st cables as [k1, k2tog, k1] in BO row.

Sleeves

With smaller dpn, CO 48 (52, 52, 56, 60) sts. Pm and join for working in rnds, being careful not to twist sts. Work in Twisted Rib patt for 24 (26, 26, 28, 28) rnds, ending with Rnd 2 of patt—cuff measures about 3 (3¼, 3¼, 3½, 3½)" (7.5 [8.5, 8.5, 9, 9] cm) from CO. Change to larger dpn.

NEXT RND: P14 (16, 16, 18, 20), pm, work Set-up rnd of Lattice Cable chart over center 20 sts, p14 (16, 16, 18, 20).

Keeping sts on each side of marked chart section in garter st (knit odd-numbered rnds, purl even-numbered rnds), work in established patts and *at the same time* inc 1 st at each end of rnd every 8th rnd 13 (12, 18, 17, 12) times, then every 10th rnd 4 (4, 0, 0, 4) times, working new sts in garter st and changing to shorter cir in larger size when there are too many sts to fit on dpn—82 (84, 88, 90, 92) sts. Cont in established patts until piece measures 19 (18½, 19, 18¼, 18¾)" (48.5 [47, 48.5, 46.5, 47.5] cm) from CO, ending with an even-numbered rnd.

Shape Cap

Working back and forth in rows, cont in established patts (garter sts at each side will be knit on WS rows) for 1½ (2½, 2½, 3¾, 3¾)" (3.8 [6.5, 6.5, 9.5, 9.5] cm), ending with a WS row—piece measures 20½ (21, 21½, 22, 22½)" (52 [53.5, 54.5, 56, 57] cm) from CO. BO all sts, working any 4-st cables as [k1, k2tog, k1] in BO row.

Lattice Cable

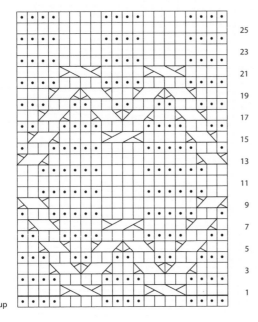

knit on all rnds and RS rows; purl on WS rows

· purl on all rnds and RS rows; knit on WS rows

sl 2 sts onto cn and hold in front, k1, k2 from cn

sl 1 st onto cn and hold in back, k2, k1 from cn

sl 2 sts onto cn and hold in front, k2, k2 from cn

sl 2 sts onto cn and hold in back, k2, k2 from cn

Finishing

Block pieces to measurements. With yarn threaded on a tapestry needle, sew shoulder seams.

Collar

With shorter cir in smaller size, RS facing, and beg at right shoulder seam, pick up and knit 48 (48, 48, 52, 52) sts across back neck and 56 (56, 56, 60, 60) sts across front neck—104 (104, 104, 112, 112) sts total. Turn piece inside out so WS of body is facing—RS of collar is worked with WS of body facing so RS of collar will show on outside when collar is folded down. Pm and join for working in rnds.

NEXT RND: *P2, k2; rep from *.

Rep the last rnd until piece measures 1" (2.5 cm) from pick-up rnd. Work in twisted rib until piece measures 2" (5 cm). Change to shorter cir in larger size. Cont in patt until piece measures 2¾" (7 cm), ending with Rnd 2 of patt.

INC RND: *P1, M1P (see Glossary), p1, k2, p2, k2; rep from *—117 (117, 117, 126, 126) sts.

NEXT RND: *P3, RT, p2, RT; rep from *.

NEXT RND: *P3, k2, p2, k2; rep from *.

Rep the last 2 rnds until piece measures 4" (10 cm), ending with a RT rnd.

INC RND: *P3, k2, p1, M1P, p1, k2; rep from *—130 (130, 130, 140, 140) sts.

NEXT RND: *P3, RT; rep from *.

NEXT RND: *P3, k2; rep from *.

Rep the last 2 rnds until piece measures 5¼" (13.5 cm), ending with a RT rnd.

INC RND: *P2, M1P, p1, k2, p3, k2; rep from *—143 (143, 143, 154, 154) sts.

NEXT RND: *P4, RT, p3, RT; rep from *.

NEXT RND: *P4, k2, p3, k2; rep from *.

Rep the last 2 rnds until piece measures 6½" (16.5 cm), ending with a RT rnd.

INC RND: *P4, k2, p2, M1P, p1, k2; rep from *—156 (156, 156, 168, 168) sts.

NEXT RND: *P4, RT; rep from *.

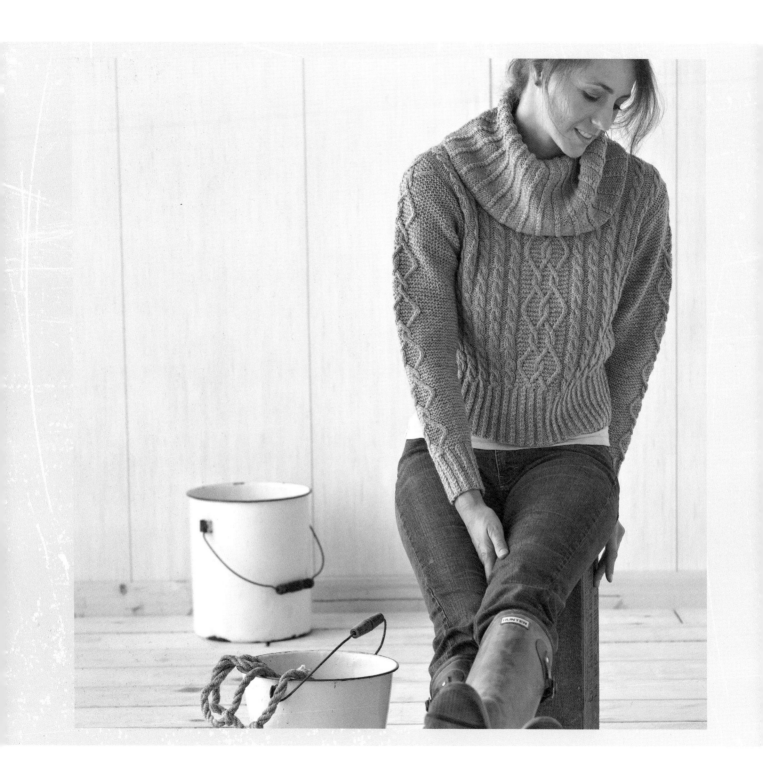

NEXT RND: *P4, k2; rep from *.

Rep the last 2 rnds until piece measures 8″ (20.5 cm), ending with a RT rnd.

INC RND: *P2, M1P, p2, k2, p4, k2; rep from *—169 (169, 169, 182, 182) sts.

NEXT RND: *P5, RT, p4, RT; rep from *.

NEXT RND: *P5, k2, p4, k2; rep from *.

Rep the last 2 rnds until piece measures 9½″ (24 cm), ending with a RT rnd.

INC RND: *P5, k2, p2, M1P, p2, k2; rep from *—182 (182, 182, 196, 196) sts.

NEXT RND: *P5, RT; rep from *.

NEXT RND: *P5, k2; rep from *.

Rep the last 2 rnds until piece measures 11 (11, 12, 12½, 12½)″ (28 [28, 30.5, 31.5, 31.5] cm) from pick-up rnd, ending with a RT rnd. BO all sts loosely in p5, k2 rib.

With yarn threaded on a tapestry needle, sew BO edges of sleeves to armhole selvedges. Sew selvedges of section worked back and forth in rows at top of each sleeve to BO sts at base of armholes. Weave in loose ends.

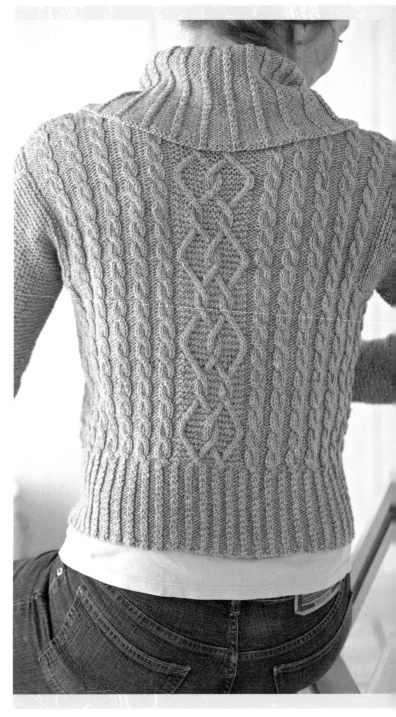

it's not easy
knitting green

essay by:
Sandi Wiseheart
Former editor of
KnittingDaily.com

I'm as passionate about the planet as the next gal. I choose nontoxic ant deterrents; my laundry soap is bio-everything-it-should-be; I recycle, reuse, and compost. But how on earth does a planet-loving knitter go green and simultaneously support a serious yarn habit?

I use my friend Google to educate myself about knitting green, but quickly get bogged down in regulations that vary from one country to the next and from one part of the process to the next—maybe the sheep were raised organically, but the mills processed the yarn with Yucky Stuff, or the dyes might BE Yucky Stuff. How's a knitter to know?

The idea is that the label will tell me—it may say "certified organic," for example. But exactly what has been certified organic—the sheep, the wool, the yarn label? Then there is the yarn's carbon footprint. How much oil and gasoline was burned in processing and transporting it? Was it packaged in dangerous-to-wildlife plastic bags? Was the truck driver eating yellow arches hamburgers along the way?

There's a whole dyepot of dilemmas right there, and the worst part is, there is no way to figure that all out while standing at a display of luscious wool at the local yarn shop.

Speaking of local yarn shops, I've noticed that a good selection of organic yarns is often hard to come by. I like to support my local community. But I've begun to realize that buying local takes on a whole new meaning in this age of *Ravelry*, blogs, podcasts, and Internet meet-ups.

When I ask who my real knitting community is, it's a complicated matrix. I live 50 kilometers away from the Toronto shop that I consider to be my "local" yarn shop. I have close ties to a shop in Michigan, so it, too, is part of my community. I chat daily with knitters and spinners all over the world; if they sell yarn or fiber, I buy from their online shops. That, too, is supporting my knitting family. I buy local to support the village that supports me; it just happens to be spread out over several thousand miles.

So put me on the spot. Do I buy organic? Do I knit green? I support my knitting community by supporting them. I avoid over-processed yarns whose origin and impacts on the earth are suspect. I buy as many natural fibers as I can. I bring my own shopping bag to the yarn shop.

I don't buy only certified organic yarns—the selection is too limited for someone whose passion and profession is knitting. I try to choose wisely, which is tough to do when the issues are so tangled. We're all going to have to figure this out together, because knitting green is a whole lot more complicated than I thought it would be.

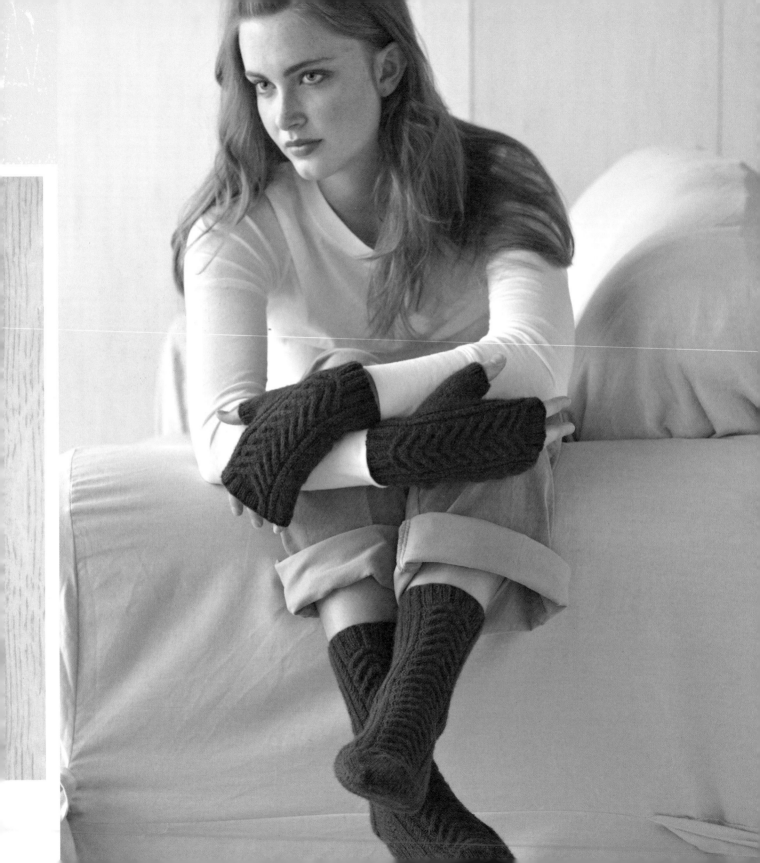

honor-the-buffalo
SOCKS AND MITTS

designed by:
Ann Budd

Instead of letting the hides of buffalo raised for meat go to waste, the folks at Buffalo Gold retrieve the down undercoat and spin it into pure luxury. Despite the rough, shaggy nature of the bison's outer mantle, the down rivals cashmere and qiviut for softness and warmth. A labor-intensive combing and collection process makes the yarn somewhat pricy, but ideal for small projects such as **Ann Budd's** cabled socks and fingerless mitts. Both are worked from the cuff to the tip and feature a relatively simple cable pattern.

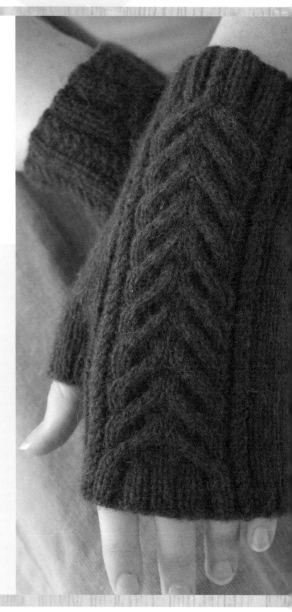

Finished Size

SOCKS About 7¼ (7¾, 8½)" (18.5 [19.5, 21.5] cm) foot circumference, 8¾ (9¼, 10)" (22 [23.5, 25.5] cm) leg length from CO to end of heel flap, and 9½ (9¾, 10¼)" (24 [25, 26] cm) foot length from back of heel to tip of toe. To fit U.S. shoe sizes women's 7½–8½ (women's 8½–9½, men's 9½–10½).

FINGERLESS MITTS About 7 (7½, 8)" (18 [19, 20.5] cm) hand circumference and 7½ (7½, 8¾)" (19 [19, 22] cm) length. To fit women's S (women's M–L, man's M).

Yarn

Sportweight (#2 Fine).

SHOWN HERE: Buffalo Gold #3 Sportweight (90% bison down, 10% nylon; 200 yd [183 m]/62 g): brown, 2 (2, 3) skeins for socks, 1 (1, 1) skein for fingerless mitts.

Needles

Size U.S. 3 (3.25 mm): set of 4 double-pointed (dpn). Adjust needle size if necessary to obtain the correct gauge.

Notions

Marker (m); cable needle (cn); waste yarn or small stitch holders for mitts; tapestry needle.

Gauge

13 stitches and 20 rounds = 2" (5 cm) in stockinette stitch, worked in rounds; 28 marked chevron cable stitches of Buffalo chart measure about 3½" (9 cm) wide.

STITCH GUIDE

Right Twist (RT)

K2tog, but do not slip sts from left needle; insert right needle tip between 2 sts just worked and knit the first st again; slip both sts off needle.

SOCKS

Using the Old Norwegian method (see Glossary), CO 56 (56, 62) sts. Divide sts on three dpn so there are 15 (15, 18) sts on Needle 1, 28 sts on Needle 2, and 13 (13, 16) sts on Needle 3. Place marker (pm) and join for working in rnds.

Leg

Beg and ending each needle where indicated for its number of sts, rep Rnds Rib 1 and Rib 2 of Buffalo chart 5 times for cuff—10 rnds total; piece measures about 1" (2.5 cm). Rep Rnds 1–6 of chart 9 (10, 11) times or to desired length to top of heel, ending with Rnd 6 of chart—piece measures about 6½ (7, 7½)" (16.5 [18, 19] cm) from CO.

Heel

With RS facing, work Row 1 of patt across 15 (15, 18) sts of Needle 1, turn work so WS is facing, sl 1, p27 (27, 33) and *at the same time* dec 0 (0, 2) sts evenly spaced—28 (28, 32) heel sts on one needle. Divide rem 28 sts of chevron cable on 2 needles to work later for instep.

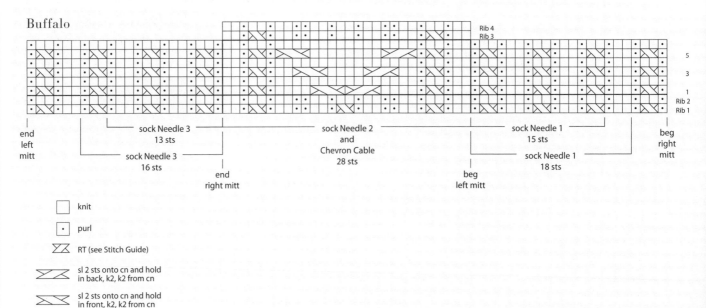

Buffalo

knit

· purl

RT (see Stitch Guide)

sl 2 sts onto cn and hold in back, k2, k2 from cn

sl 2 sts onto cn and hold in front, k2, k2 from cn

Heel Flap

Work 28 (28, 32) heel sts back as forth in rows as foll:

ROW 1: (RS) *Sl 1 purlwise with yarn in back (pwise wyb), k1; rep from *.

ROW 2: (WS) Sl 1 purlwise with yarn in front (pwise wyf), purl to end.

Rep these 2 rows until a total of 28 (28, 32) rows have been worked or desired length for heel flap, ending with a WS row—14 (14, 16) chain edge sts at each selvedge edge; heel flap measures about 2¼ (2¼, 2½)" (5.5 [5.5, 6.5] cm).

Turn Heel

Work short-rows to shape heel as foll:

ROW 1: (RS) K16 (16, 18), ssk, k1, turn work.

ROW 2: (WS) Sl 1 pwise wyf, p5, p2tog, p1, turn.

ROW 3: Sl 1 pwise wyb, knit to 1 st before gap formed on previous row, ssk (1 st each side of gap), k1, turn.

ROW 4: Sl 1 pwise wyf, purl to 1 st before gap formed on previous row, p2tog (1 st each side of gap), p1, turn.

Rep Rows 3 and 4 until all heel sts have been worked, omitting the final k1 on the last rep of Row 3 and the final p1 on the last rep of Row 4—16 (16, 18) heel sts rem.

Shape Gussets

Rejoin for working in rnds as foll:

RND 1: With Needle 1, sl 1 pwise wyb, k15 (15, 17) heel sts, pick up and knit 15 (15, 17) sts along selvedge edge of heel flap (1 st in each chain edge st plus 1 st at the base of the heel flap); with Needle 2, resume working 28-st chevron cable as established with Rnd 1 of chart; with Needle 3, pick up and knit 15 (15, 17) sts along other selvedge edge of heel flap (1 st at base of flap plus 1 st in each chain edge st), then knit the first 8 (8, 9) sts from Needle 1 onto the end of Needle 3—74 (74, 80) sts total; 23 (23, 26) sts on Needle 1, 28 sts on Needle 2, 23 (23, 26) sts on Needle 3. Rnd begs at back of heel.

RND 2: Knit sts on Needles 1 and 3, cont in established patt on Needle 2.

RND 3: On Needle 1, knit to last 2 sts, k2tog; on Needle 2, cont in established patt; on Needle 3, ssk, knit to end—2 sts dec'd.

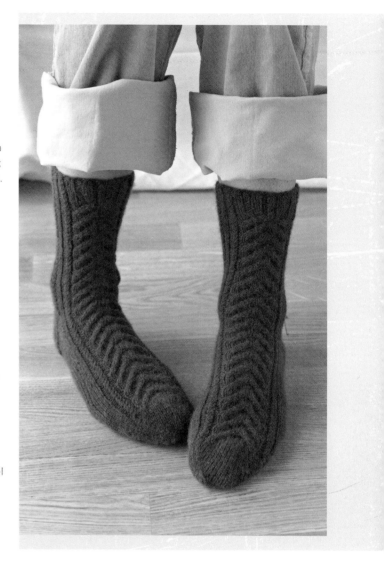

Rep Rnds 2 and 3 ten (eight, nine) more times—52 (56, 60) sts rem; 12 (14, 16) sts each on Needles 1 and 3, 28 sts on Needle 2.

Foot

Cont even as established (knit the sts on Needles 1 and 3; cont in patt on Needle 2) until piece measures 7½ (7¾, 8)" (19 [19.5, 20.5] cm) from back of heel, or about 2 (2, 2¼)" (5 [5, 5.5] cm) less than desired total length.

Toe

Smallest size only

Transfer the first st on Needle 2 to the end of Needle 1, then transfer the last st on Needle 2 to the beg of Needle 3—13 sts on each on Needles 1 and 3, 26 sts on Needle 2.

Largest size only

Transfer the last on Needle 1 to the beg of Needle 2, then transfer the first st on Needle 3 to the end of Needle 2—15 sts each on Needles 1 and 3, 30 sts on Needle 2.

All sizes

Dec for toe as foll:

RND 1: On Needle 1, knit to last 3 sts, k2tog, k1; on Needle 2, k1, ssk, knit to last 3 sts, k2tog, k1; on Needle 3, k1, ssk, knit to end—4 sts dec'd.

RND 2: Knit.

Rep Rnds 1 and 2 (dec every other rnd) 6 (6, 7) more times—24 (28, 28) sts rem; 6 (7, 7) sts each on Needles 1 and 3, 12 (14, 14) sts on Needle 2.

Rep Rnd 1 (dec every rnd) 3 (4, 4) times—12 sts rem for all sizes; 3 sts each on Needles 1 and 3, 6 sts on Needle 2. Knit the sts on Needle 1 onto the end of Needle 3—6 sts each on 2 needles.

Finishing

Cut yarn, leaving an 8" (20.5 cm) tail. Thread tail on a tapestry needle and use the Kitchener st (see Glossary) to graft the rem sts tog. Weave in loose ends. Block lightly.

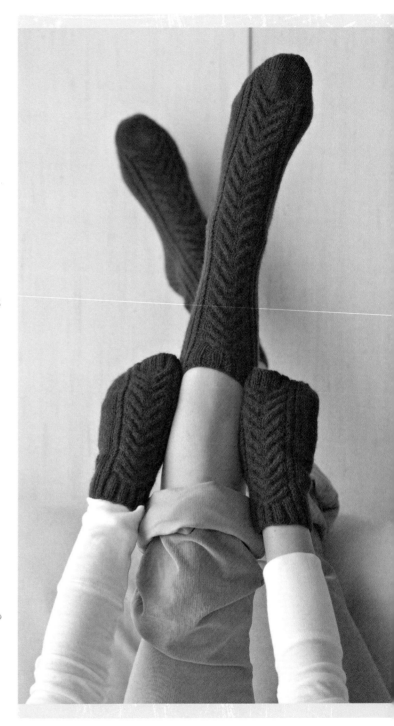

FINGERLESS MITTS
LEFT MITT

Cuff

Using the Old Norwegian method (see Glossary), CO 50 sts for all sizes. Divide sts as evenly as possible on 3 dpn, place marker (pm), and join for working rnds. Rnd begs at thumb side of hand. Beg and end as indicated for left mitt, rep Rnds Rib 1 and Rib 2 of Buffalo chart (see page 70) 5 times—10 rnds total; piece measures about 1" (2.5 cm) from CO. Rep Rnds 1–6 of chart 2 (2, 3) times, ending with Rnd 6 of chart—piece measures about 2¼ (2¼, 2¾)" (5.5 [5.5, 7] cm) from CO.

Shape Thumb Gusset

RND 1: Work first 28 sts in established chevron cable patt, k21, pm, M1 (see Glossary), pm, k1—51 sts; 1 gusset st bet markers.

RNDS 2 AND 3: Cont chevron patt on first 28 sts, knit to end.

RND 4: Cont chevron patt on first 28 sts, k21, slip marker (sl m), M1, knit to next m, M1, sl m, k1—2 sts inc'd inside gusset markers.

Cont in established patts, rep Rnds 2–4 eight (eight, ten) more times, then work Rnds 2 and 3 once more—69 (69, 73) sts total; 19 (19, 23) sts between gusset markers; 30 (30, 36) rnds in gusset; last chart rnd completed is Rnd 6; piece measures about 5¼ (5¼, 6¼)" (13.5 [13.5, 16] cm) from CO.

Hand

(Rnd 1 of chart) Work 28 sts in established chevron cable, removing gusset markers as you come to them, k21 (21, 22), place next 19 (19, 21) sts on waste yarn or holder (for largest size this will be the center 21 gusset sts), use the backward-loop method (see Glossary) to CO 1 (3, 5) st(s) over gap, k1 (1, 2)—51 (53, 57) sts.

Working sts outside chevron cable in St st, work Rnds 2–6 of chart once, then rep Rnds 1–6 two more times or until piece measures ½ (½, ¾)" (1.3 [1.3, 2] cm) less than desired total length and *at the same time* dec 1 (0, 1) st in knit section of last rnd—50 (53, 56) sts rem; piece measures about 1¾" (4.5 cm) from where thumb sts were put on holder and about 7 (7, 8)" (18 [18, 20.5] cm) from CO.

Work rib patt at top of hand as foll:

RND 1: Work Rnd Rib 3 of chart over 28 sts, [p1, k2] 7 (8, 9) times, p1.

RND 2: Work Rnd Rib 4 of chart over 28 sts, [p1, k2] 7 (8, 9) times, p1.

Rep Rnds 1 and 2 one (one, two) time(s), then work Rnd 1 once more. BO all sts in patt, working k2tog at the top of each RT column of chevron cable in BO rnd.

Thumb

Place 19 (19, 21) gusset sts on dpn and rejoin yarn to beg of sts with RS facing. K19 (19, 21), pick up and knit 2 (4, 6) sts from base of sts CO at top of thumb gap, pm, and join for working in rnds—21 (23, 27) sts. Redistribute sts as evenly as possible on 3 dpn. Knit 4 (4, 6) rnds and *at the same time* inc 0 (1, 0) st in last rnd—21 (24, 27) sts.

NEXT RND: *K2, p1; rep from *.

Rep the last rnd 3 more times. BO all sts in rib patt.

Finishing

Weave in loose ends. Block lightly.

RIGHT MITT

Cuff

Using the Old Norwegian method, CO 50 sts as for left mitt. Rnd beg at thumb side of hand. Beg and ending where indicated for right mitt, rep Rnds Rib 1 and Rib 2 of Buffalo chart 5 times—10 rnds total; piece measures about 1" (2.5 cm). Rep Rnds 1–6 of chart 2 (2, 3) times, ending with Rnd 6 of chart—piece measures about 2¼ (2¼, 2¾)" (5.5 [5.5, 7] cm) from CO.

Shape Gusset

RND 1: K1, pm, M1, pm, k21, work last 28 sts in established chevron cable patt—51 sts; 1 gusset st bet markers.

RNDS 2 AND 3: Knit to last 28 sts, cont chevron cable on last 28 sts.

RND 4: K1, sl m, M1, knit to next m, M1, sl m, k21, cont chevron cable on last 28 sts—2 sts inc'd inside gusset markers.

Cont in established patts, rep Rnds 2–4 eight (eight, ten) more times, then work Rnds 2 and 3 once more—69 (69,

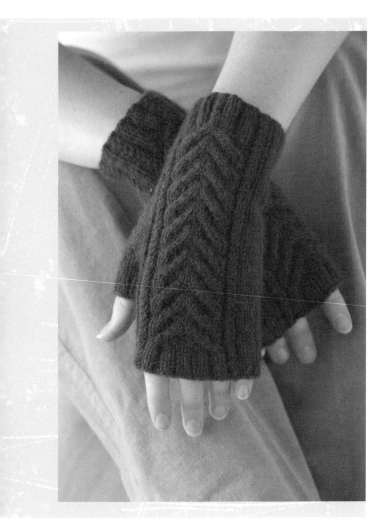

73) sts total; 19 (19, 23) sts between gusset markers; 30 (30, 36) rnds in gusset; last chart rnd completed is Rnd 6; piece measures about 5¼ (5¼, 6¼)" (13.5 [13.5, 16] cm) from CO.

Hand

(Rnd 1 of chart) Removing gusset markers as you come to them, k1 (1, 2), place next 19 (19, 21) sts on waste yarn or holder (for largest size this will be the center 21 gusset sts), use the backward-loop method to CO 1 (3, 5) st(s) over gap, k21 (21, 22), work 28 sts in established chevron cable—51 (53, 57) sts.

Working sts outside chevron cable in St st, work Rnds 2–6 of chart once, then rep Rnds 1–6 two more times or until piece measures ½ (½, ¾)" (1.3 [1.3, 2] cm) less than desired total length and *at the same time* dec 1 (0, 1) st in St st section in last rnd—50 (53, 56) sts rem; piece measures about 1¾" (4.5 cm) from where thumb sts were put on holder and about 7 (7, 8)" (18 [18, 20.5] cm) from CO.

Work rib patt at top of hand as foll:

RND 1: P1, [k2, p1] 7 (8, 9) times, work Rnd Rib 3 of chart over 28 sts.

RND 2: P1, [k2, p1] 7 (8, 9) times, work Rnd Rib 4 of chart over 28 sts.

Rep Rnds 1 and 2 one (one, two) time(s), then work Rnd 1 once more. BO all sts in patt, working k2tog at the top of each RT column of chevron cable in BO rnd.

Thumb and Finishing

Work as for left mitt.

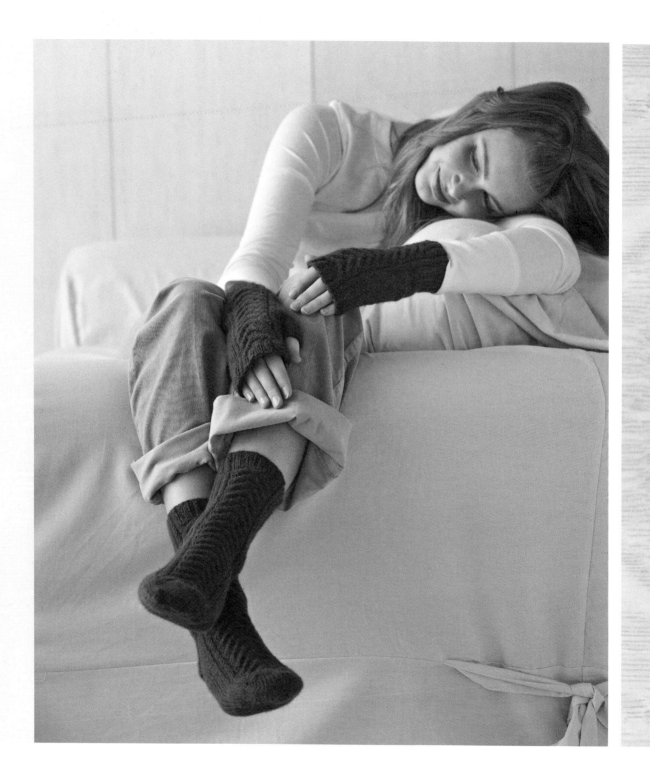

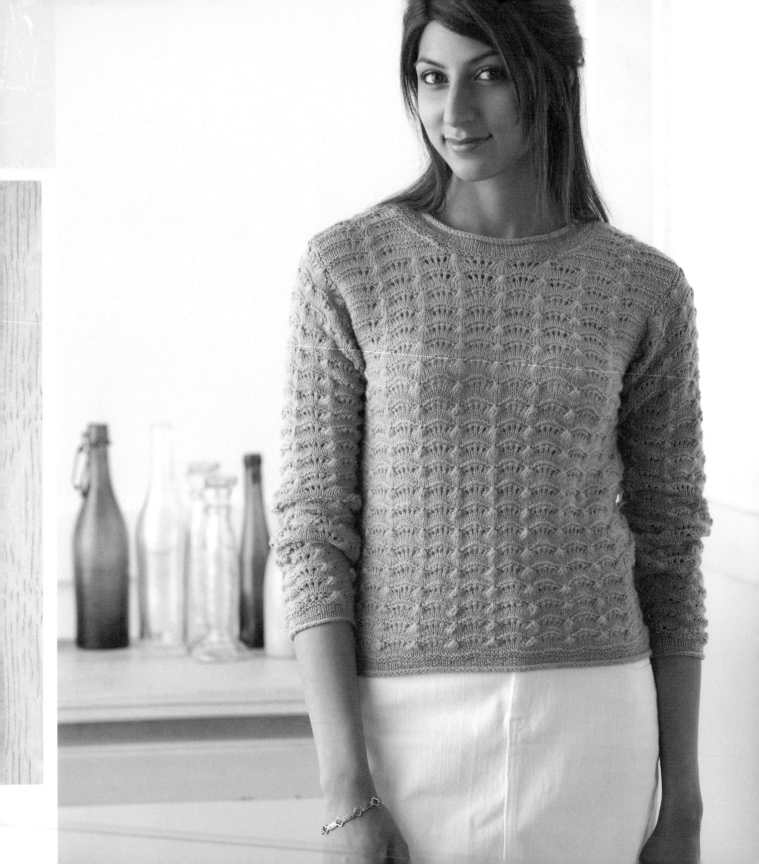

cunene river
PULLOVER

designed by:
JoLene Treace

The Cunene River runs through southern Africa along Angola and Namibia and borders areas that are a natural habitat for *Struthio camelus*, the common ostrich. For this feminine pullover, **JoLene Treace** chose a stitch pattern that has the look and feel of ostrich feathers. The sweater is worked in a fingering-weight wool yarn hand-dyed with hydrangea petals by Darlene Hayes (see page 122). The natural colors in the yarn shimmer much the same as sunlight reflected off a river.

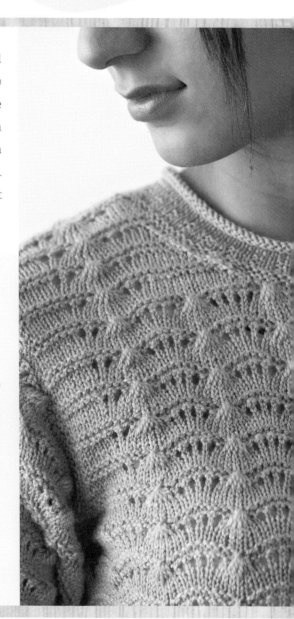

Finished Size

About 35½ (39, 43½, 48, 51)" (90 [99, 110.5, 122, 129.5] cm) bust circumference.

Sweater shown measures 35½" (90 cm).

Yarn

Fingering Weight (#1 Super Fine).

SHOWN HERE: Hand Jive Nature's Palette Fingering (100% plant-dyed merino; 185 yd [169 m]/50 g): #112 hydrangea, 9 (9, 10, 11, 12) skeins.

Needles

BODY AND SLEEVES: sizes U.S. 2 and 3 (3 and 3.25 mm): 24" (60 cm) circular (cir). NECKBAND: sizes U.S. 2 and 3 (3 and 3.25 mm): 16" (40 cm) cir. Adjust needle size if necessary to obtain the correct gauge.

Notions

Stitch holders; stitch marker (m); tapestry needle.

Gauge

30 stitches and 64 rows (3 patt reps wide and 8 patt reps high) measure 4¾" (12 cm) wide and 6" (15 cm) high in Cunene River pattern from chart on larger needles (see Notes).

NOTES

- Although circular needles are specified for this project, the back, front, and sleeves are worked separately, back and forth in rows, so straight needles or longer circular needles may be substituted for the 24" (60 cm) needles in both sizes.

- Work a 1-stitch stockinette selvedge at the edges of all pieces, reestablishing the selvedge stitches at the neck and armhole edges after completing the shaping. Work all increases and decreases inside the selvedge stitches. The selvedge stitches are not shown on the chart.

- The main pattern repeat for the Cunene River chart begins as a multiple of 10 stitches, then increases to a multiple of 14 stitches in Row 5 (counting each double-wrapped stitch as a single stitch), then decreases back to a multiple of 10 stitches in Row 8.

- Measure gauge and check stitch counts after completing Rows 1–4 or Row 8 of the chart when the stitch count has been restored to its original number, and not after completing Rows 5, 6, or 7 when it has temporarily increased.

- When working the Cunene River chart, if there are not enough stitches to work a complete pattern repeat all the way through Row 8, work the stitches of the partial repeat to match the underlying stitch instead, i.e., work stockinette stitch on Rows 1–4 and garter stitch on Rows 5–8. During armhole and neck shaping in particular, read ahead before starting Row 5 to make sure it will be possible to finish any repeats that you start.

Back

With longer cir needle in smaller size, CO 102 (111, 123, 138, 147) sts. Do not join. Work 8 rows in St st, ending with a WS row. Work rib as foll:

ROW 1: (RS) K1 (selvedge st; work in St st), *p1, k2; rep from * to last 2 sts st, p1, k1 (selvedge st; work in St st).

ROW 2: (WS) Purl.

Rep these 2 rows 2 more times—6 rib rows total.

INC ROW: (RS) K6 (6, 3, 9, 9), M1 (see Glossary), [k9 (9, 9, 10, 10), M1] 10 (11, 13, 12, 13) times, k6 (6, 3, 9, 8)—113 (123, 137, 151, 161) sts.

Change to longer cir needle in larger size. Knit 3 rows, beg and ending with a WS row—piece measures about ¾" (2 cm) with lower edge rolled.

NEXT ROW: (RS) K1 (selvedge st), beg and ending where indicated for your size work Row 1 of Cunene River chart (see page 80) over center 111 (121, 135, 149, 159) sts, k1 (selvedge st).

Cont in chart patt with selvedge sts, work Rows 2–8 once, then rep Rows 1–8 thirteen times, then work Rows 1 and 2 once more—piece measures about 11½" (29 cm) from CO with lower edge rolled for all sizes.

Shape Armholes

BO 6 (7, 9, 11, 13) sts at beg of next 2 rows—101 (109, 119, 129, 135) sts rem.

DEC ROW: (RS; see Notes) K1 (selvedge st), ssk, work in patt to last 3 sts, k2tog, k1 (selvedge st)—2 sts dec'd.

Maintaining selvedge sts, dec 1 st at each side in this manner on the next 7 (8, 9, 11, 11) RS rows (see Notes), then work 1 (3, 1, 1, 1) row(s) even after last dec row to end with Row 4 (8, 8, 4, 4) of chart—85 (91, 99, 105, 111) sts rem. Work 52 (50, 56, 60, 68) more rows even in patt to end with Row 8 (2, 8, 8, 8) of chart—armholes measure about 6½ (6¾, 7¼, 8, 8¾)" (16.5 [17, 18.5, 20.5, 22] cm).

Shape Back Neck

NEXT ROW: (RS) Keeping in patt, work 27 (30, 32, 33, 35) sts, place center 31 (31, 35, 39, 41) sts on holder for back neck, join a second ball of yarn, work in patt to end—27 (30, 32, 33, 35) sts rem each side.

Establishing selvedge sts at each neck edge, work 1 WS row even.

DEC ROW: (RS) For first group of sts, k1, work in patt to last 3 sts, k2tog, k1; for second group, k1, ssk, work in patt to last st, k1—1 st dec'd at each neck edge.

Maintaining selvedge sts, dec 1 st at each neck edge in this manner on the next 4 RS rows, then work 1 WS row even after last dec row to end with Row 4 (6, 4, 4, 4) of chart; for second size 39" (99 cm) only, work the last 2 rows in St st instead of as Rows 5 and 6—22 (25, 27, 28, 30) sts rem at each side; armholes measure about 7¾ (8, 8½, 9¼, 10)" (19.5 [20.5, 21.5, 23.5, 25.5] cm). With RS facing, BO all sts. Cut yarn, leaving at 10" (25.5 cm) tail at each shoulder for seaming.

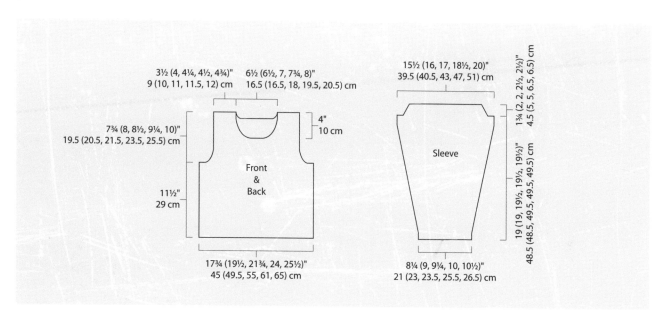

3½ (4, 4¼, 4½, 4¾)"
9 (10, 11, 11.5, 12) cm

6½ (6½, 7, 7¾, 8)"
16.5 (16.5, 18, 19.5, 20.5) cm

7¾ (8, 8½, 9¼, 10)"
19.5 (20.5, 21.5, 23.5, 25.5) cm

4"
10 cm

Front
&
Back

11½"
29 cm

17¾ (19½, 21¾, 24, 25½)"
45 (49.5, 55, 61, 65) cm

15½ (16, 17, 18½, 20)"
39.5 (40.5, 43, 47, 51) cm

1¾ (2, 2, 2½, 2½)"
4.5 (5, 5, 6.5, 6.5) cm

Sleeve

19 (19, 19½, 19½, 19½)"
48.5 (48.5, 49.5, 49.5, 49.5) cm

8¼ (9, 9¼, 10, 10½)"
21 (23, 23.5, 25.5, 26.5) cm

Front

Work as for back until armhole shaping has been completed, ending with Row 4 (8, 8, 4, 4) of chart—85 (91, 99, 105, 111) sts rem. Work 20 (18, 24, 28, 36) more rows even in patt to end with Row 8 (2, 8, 8, 8) of chart—armholes measure about 3½ (3¾, 4¼, 5, 5¾)" (9 [9.5, 11, 12.5, 14.5] cm).

Shape Front Neck

(RS) Keeping in patt, work 36 (39, 42, 45, 47) sts, place center 13 (13, 15, 15, 17) sts on holder for back neck, join a second ball of yarn, work in patt to end—36 (39, 42, 45, 47) sts rem each side. Work 1 WS row even. Cont in patt, at each neck edge BO 2 sts 2 (2, 3, 4, 4) times, ending with a WS row—32 (35, 36, 37, 39) sts rem at each side.

DEC ROW: (RS) For first group of sts, k1, work in patt to last 3 sts, k2tog, k1; for second group, k1, ssk, work in patt to last st, k1—1 st dec'd at each neck edge.

Maintaining selvedge sts, dec 1 st at each neck edge in this manner on the next 9 (9, 8, 8, 8) RS rows—22 (25, 27, 28, 30) sts rem at each side. Beg and ending with a WS row, work 19 (19, 19, 17, 17) rows even after last dec row to end with Row 4 (6, 4, 4, 4) of chart; for second size 39" (99 cm) only, work the last 2 rows in St st instead of as Rows 5 and 6—armholes measure about 7¾ (8, 8½, 9¼, 10)" (19.5 [20.5, 21.5, 23.5, 25.5] cm). BO all sts with RS facing.

Sleeves

With longer cir needle in smaller size, CO 49 (52, 58, 58, 61) sts. Do not join. Work 8 rows in St st, ending with a WS row. Work rib as foll:

ROW 1: (RS) K1 (selvedge st; work in St st), *k2, p1; rep from * to last 3 sts, k2, k1 (selvedge st; work in St st).

ROW 2: (WS) Purl.

Rep these 2 rows 2 more times—6 rib rows total.

INC ROW: (RS) K4 (2, 3, 3, 3), M1, [k14 (12, 26, 13, 11) M1] 3 (4, 2, 4, 5) times, k3 (2, 3, 3, 3)—53 (57, 61, 63, 67) sts.

Change to longer cir needle in larger size. Knit 3 rows, beg and ending with a WS row—piece measures about ¾" (2 cm) with lower edge rolled.

NEXT ROW: (RS) K1 (selvedge st), beg and ending where indicated for your size work Row 1 of Cunene River chart over center 51 (55, 59, 61, 65) sts, k1 (selvedge st).

Work 1 WS row even. Cont in chart patt and selvedge sts as established, beg on the next RS row, inc 1 st at each end of needle every 6 (0, 6, 6, 6) rows 4 (0, 4, 16, 28) times, then every 8 rows 19 (22, 19, 11, 2) times, working new sts into patt—99 (101, 107, 117, 127) sts. Cont in patt until Rows 1–8 of chart have been worked a total of 24 (24, 25, 25, 25) times, then work Rows 1 and 2 once

Cunene River

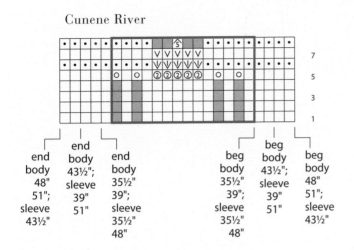

	k on RS; p on WS
·	k on WS
o	yo
②	k, wrapping yarn 2 times around needle
ꝟ	sl double-wrapped st pwise wyf, dropping 1 wrap
v	sl elongated st pwise wyb
⃝	p5tog on WS
	no stitch
	pattern repeat

more—194 (194, 202, 202, 202) chart rows total; piece measures about 19 (19, 19½, 19½, 19½)" (48.5 [48.5, 49.5, 49.5, 49.5] cm) from CO with lower edge rolled. NOTE: To adjust sleeve length, work more or fewer rows after completing the sleeve incs, making sure to end with Row 2 to match the body; every 8 rows added or removed will lengthen or shorten the sleeve by about ¾" (2 cm).

Shape Cap

BO 6 (7, 9, 11, 13) sts at beg of next 2 rows—87 (87, 89, 95, 101) sts.

DEC ROW: (RS) K1 (selvedge st), ssk, work in patt to last 3 sts, k2tog, k1 (selvedge st)—2 sts dec'd.

Maintaining selvedge sts, dec 1 st at each side in this manner on the next 7 (8, 9, 11, 11) RS rows, then work 1 (3, 1, 1, 1) row(s) even after last dec row to end with Row 4 (8, 8, 4, 4) of chart—71 (69, 69, 71, 77) sts rem; cap measures about 1¾ (2, 2, 2½, 2½)" (4.5 [5, 5, 6.5, 6.5] cm). BO all sts on next RS row.

Finishing

Block pieces to measurements. With yarn threaded on a tapestry needle, sew shoulder seams. Sew sleeve caps into armholes, matching center of cap to shoulder seam. Sew sleeve and side seams.

Neckband

With shorter cir needle in larger size, RS facing, and beg at left shoulder seam, pick up and knit 31 (31, 31, 31, 32) sts along left front neck, k13 (13, 15, 15, 17) held center front sts, pick up and knit 31 (31, 31, 31, 32) sts along right front neck to shoulder seam, then 8 sts along right back neck, k31 (31, 35, 39, 41) held center back sts, then pick up and knit 9 (9, 9, 8, 8) sts along left back neck—123 (123, 129, 132, 138) sts total. Place marker (pm), and join for working in rnds. Change to shorter cir needle in smaller size. Purl 1 rnd, knit 1 rnd, purl 1 rnd.

DEC RND: K31 (31, 31, 31, 32) left front sts and *at the same time* dec 2 (2, 0, 0, 2) sts evenly, k6 (6, 7, 7, 8), pm, k1 (center front st), pm, k6 (6, 7, 7, 8), k31 (31, 31, 31, 32) right front sts dec 2 (2, 0, 0, 2) sts evenly, k8 right back sts, k31 (31, 35, 39, 41) center back sts dec 2 (2, 3, 3, 2) sts evenly, k9 (9, 9, 8, 8) left back sts—6 (6, 3, 3, 6) sts dec'd; 117 (117, 126, 129, 132) sts rem.

RND 1: [K2, p1] 11 (11, 12, 12, 12) times, k2, slip marker (sl m), p1 (center st), sl m, *k2, p1; rep from * to end.

RND 2: Knit.

Rep Rnds 1 and 2 two more times—6 rib rnds total. Knit 8 rnds. BO all sts loosely—neckband measures about 1" (2.5 cm) from pick-up rnd with upper edge rolled.

Weave in loose ends.

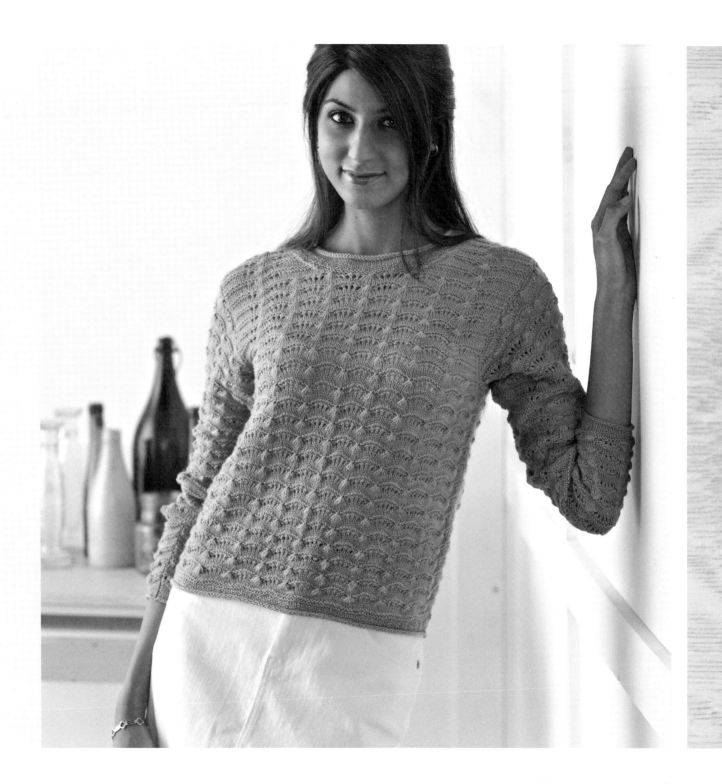

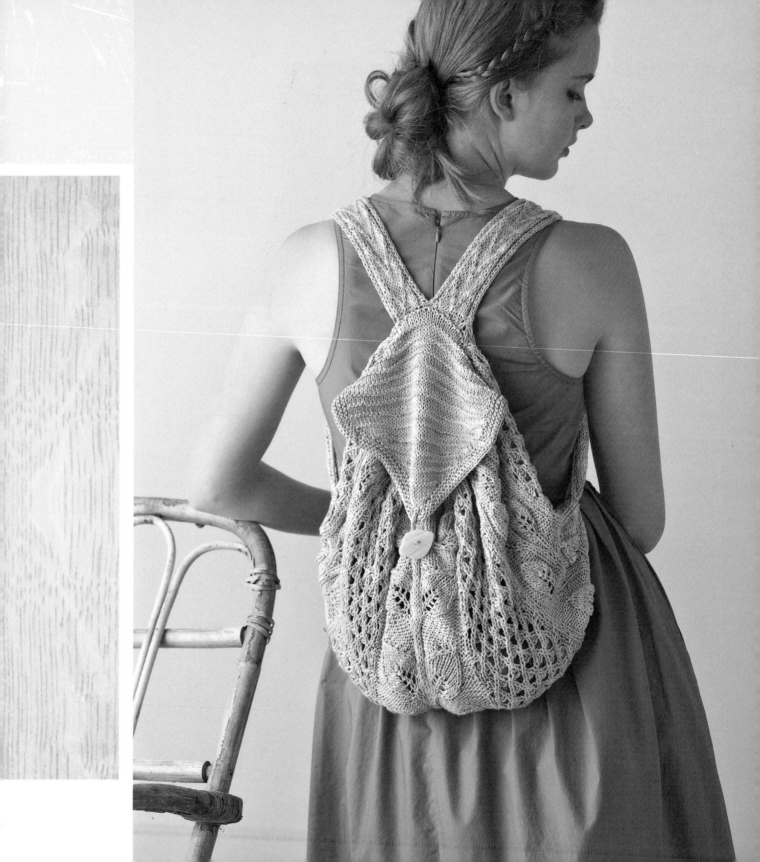

commuter
KNAPSACK

designed by:
Deborah Newton

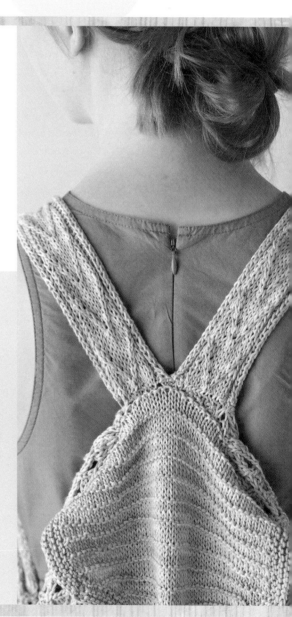

A knapsack is invaluable for carrying belongings when riding a bike or traveling on the bus or subway without straining your arms or shoulders. But just because a knapsack is practical, **Deborah Newton** proves that it doesn't have to be plain. For her version, Deborah chose lacy leaf patterns knitted in a naturally dyed cotton yarn from Nashua Handknits' Natural Focus line. The sack features knitted straps, a drawstring opening, and a flap with a button closure. To keep small items secure, consider adding a cotton lining.

Finished Size

About 13" (33 cm) wide, 12½" (31.5 cm) tall, and 4½" (11.5 cm) deep at base.

Yarn

DK weight (#3 Light).

SHOWN HERE: Nashua Handknits Natural Focus Ecologie Cotton (100% naturally dyed pima cotton; 110 yd [110 m]/50 g): #0080 chestnut brown, 7 balls.

Needles

Size U.S. 6 (4 mm): straight and 24" (60 cm) circular (cir). Adjust needle size if necessary to obtain the correct gauge.

Notions

Cable needle (cn); markers (m); removable markers; stitch holders; tapestry needle; one 1½" (3.8 cm) decorative button; one ⅞" (2.2 cm) backing button.

Gauge

21 stitches and 26 rows = 4" (10 cm) in waffle pattern; 26 to 30 stitches (see Notes) and 48 rows of Vine Leaf pattern from chart measure 4½" (11.5 cm) wide and 7" (18 cm) high; 29 to 45 stitches (see Notes) of double leaf pattern from chart measure about 5" (12.5 cm) wide.

STITCH GUIDE

Right Twist (RT)

K2tog and leave both sts on needle, then knit the first st again through the front loop and slip both sts off left needle together.

Left Twist (RT)

Skip the first st on left needle, then knit into the back loop of second st, then knit first st through front loop, then slip both sts off left needle together.

Waffle Pattern (multiple of 4 sts + 2)

ROW 1: (RS) P2, *RT, p2; rep from *.

ROW 2: (WS) K2, *p2, k2; rep from *.

ROW 3: P1, *k2tog, [yo] twice, ssk; rep from * to last st, p1.

ROW 4: P2, *work (k1, p1) into double yo of previous row, p2; rep from *.

ROW 5: K2, *p2, LT; rep from * to last 4 sts, p2, k2.

ROW 6: P2, *k2, p2; rep from *.

ROW 7: P1, yo, *ssk, k2tog, [yo] twice; rep from *, to last 5 sts, ssk, k2tog, yo, p1.

ROW 8: K2, *p2, work (k1, p1) in double yo of previous row; rep from * to last 4 sts, p2, k2.

Rep Rows 1–8 for pattern.

Strap Pattern (14 sts)

SET-UP ROW: (WS) K2, p10, k2.

ROW 1: (RS) P2, k3, RT, LT, k3, p2.

ROWS 2, 4, AND 6: K2, p10, k2.

ROW 3: P2, k2, RT, k2, LT, k2, p2.

ROW 5: P2, k1, RT, k4, LT, k1, p2.

ROW 7: P2, RT, k6, LT, p2.

ROW 8: Rep Row 2.

Rep Rows 1–8 for pattern; do not rep the set-up row.

NOTES

- The stitch count of the double leaf panel does not remain constant from row to row; it begins with 29 stitches, increases gradually to a maximum of 45 stitches after completing Row 7, then decreases back to 29 stitches again after completing Row 17.

- The stitch count of the vine leaf panel also does not remain constant; it begins and ends with 26 stitches but varies from 26 to 30 stitches depending on the row.

Bottom Cable Strip

With straight needles, CO 10 sts.

SET-UP ROW: (WS) K1, p8, k1.

ROW 1: (RS) P1, sl 2 sts onto cable needle (cn) and hold in back, k2, k2 from cn, sl 2 sts onto cn and hold in front, k2, k2 from cn, p1.

ROWS 2 AND 4: K1, p8, k1.

ROW 3: P1, k8, p1.

Rep Rows 1–4 until piece measures about 4½" (11.5 cm), ending with RS Row 1. With WS facing, BO all sts.

Bottom and Sides

With straight needles and RS facing, pick up and knit 30 sts evenly spaced along one long side of cable strip.

SET-UP ROW: (WS) P2 (edge sts), k5, p5, k4, p3, k9, p2 (edge sts).

NEXT ROW: (RS) K2 (edge sts), work Row 1 of Vine Leaf chart (see page 86) over center 26 sts and inc them to 28 sts as shown (see Notes), k2 (edge sts).

Keeping 2 edge sts at each side in St st, work Rows 2–24 of chart, then work Rows 1–18 once more—piece measures about 6" (15 cm) from pick-up row. Mark each end of last row with removable markers to indicate bottom corners. Cont in established patts, work Rows 19–24 of chart once, then rep Rows 1–24 once more—piece measures about 4½" (11.5 cm) from marked row.

DEC ROW: (RS) K1, ssk, work in patt to last 3 sts, k2tog, k1—2 sts dec'd; 1 rev St st dec'd from each side of vine leaf section.

Keeping 2 edge sts in St st, work in patt for 13 rows, then rep the dec row—2 sts dec'd. Rep the last 14 rows 2 more times, then work 1 WS row even to end Row 20 of chart—22 sts rem: 18 center sts of Vine Leaf chart and 2 edge sts at each side; piece measures about 11" (28 cm) from marked row. Place sts on holder. With straight needles and RS facing, pick up and knit 30 sts evenly spaced along rem long side of cable strip. Work a second bottom and side piece the same as the first, then place these sts on a holder.

Back

With straight needles, CO 77 sts.

SET-UP ROW: (WS) P2 (edge sts), place marker (pm), p22, pm, k10, p9, k10, pm, p22, pm, p2 (edge sts).

NEXT ROW: (RS) K2 (edge sts), slip marker (sl m), work Row 1 of waffle patt (see Stitch Guide) over 22 sts, work Row 1 of Double Leaf chart (see page 86) over center 29 sts and inc them to 33 sts as shown (see Notes), sl m, work Row 1 of waffle patt over 22 sts, sl m, k2 (edge sts).

Keeping 2 edge sts at each side in St st, cont in established patts until Double Leaf chart has been worked a total of 4 times, ending with Row 18 of Double Leaf chart and Row 8 of waffle patt—72 rows total; piece measures about 11" (28 cm) from CO. Place sts on holder.

Front

Work as for back.

Finishing

With yarn threaded on a tapestry needle, sew CO edge of back between marked rows along one edge of bottom and side piece, matching center stem of double leaf to center of bottom cable strip, using a 1-st seam allowance, and easing to fit. Sew selvedges of back to selvedges of bottom and side piece with a 1-st seam allowance. Sew front to the rem edge of bottom and side piece in the same manner.

Top Edging

Place all held sts onto cir needle so that first sts to be worked are a group of 22 side sts—198 sts total. Pm and join for working in rnds.

NEXT RND: *K7, k2tog; rep from *—176 sts rem.

NEXT RND: *K2, p2; rep from *.

Rep the last rnd until rib section measures 1" (2.5 cm) from joining rnd.

EYELET RND: *K2, p2tog, yo, k2, p2; rep from *.

Resume working in established k2, p2 rib until piece measures ½" (1.3 cm) from eyelet rnd and rib measures 1½" (1.3 cm) from joining rnd. BO all sts.

Double Leaf

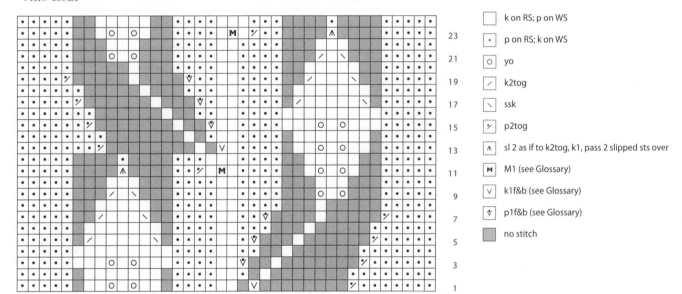

Vine Leaf

	k on RS; p on WS
·	p on RS; k on WS
o	yo
/	k2tog
\	ssk
⅃	p2tog
⋏	sl 2 as if to k2tog, k1, pass 2 slipped sts over
M	M1 (see Glossary)
V	k1f&b (see Glossary)
ⱱ	p1f&b (see Glossary)
▨	no stitch

Drawstring

With cir needle, CO 240 sts. BO all sts on next row. Beg and ending at center front, weave drawstring through the eyelet holes. Knot the ends of the drawstring, or double the ends of back on themselves and sew in place using yarn tails.

Straps

With straight needles, CO 18 sts.

SET-UP ROW: (WS) P2 (edge sts), pm, work Set-up row of strap patt (see Stitch Guide) over center 14 sts, pm, p2 (edge sts).

NEXT ROW: (RS) K2 (edge sts), work Row 1 of strap patt over center 14 sts, k2.

Keeping 2 edge sts at each side in St st, cont in established patts until strap measures 16" (40.5 cm) from CO. Cut yarn, leaving a 10" (25.5 cm) tail. Thread tail on tapestry needle, draw through all sts, pull tight, and fasten off—this end will be sewn to the lower back corner later. Make a second strap the same as the first.

Lay knapsack on a flat surface with RS of facing back up. With RS of straps facing, sew a gathered strap end securely to each lower back corner. With RS of back still facing, place a removable marker in the center of the last row of the double leaf patt, just below the start of the top ribbing. Place two more removable markers in the same row, each about 2½" (6.5 cm) away from the center marker. With RS of strap facing, sew the CO edge of one strap securely between the markers on one side of center back, then sew the CO edge of the other strap between the markers on the other side.

Flap

With straight needles, CO 98 sts. Knit 1 WS row.

ROW 1: (RS) Knit.

ROW 2: (WS) Purl.

ROWS 3 AND 4: Knit.

Rep Rows 1–4 until piece measures 3½" (9 cm), ending with a WS row. Cont in patt, BO 2 sts at the beg of the next 47 rows, ending with a RS row—4 sts rem.

NEXT ROW: (WS) K1, k2tog, k1—3 sts rem.

Work these 3 sts in I-cord (see Glossary) for 2" (5 cm).

BO all sts, leaving a long tail.

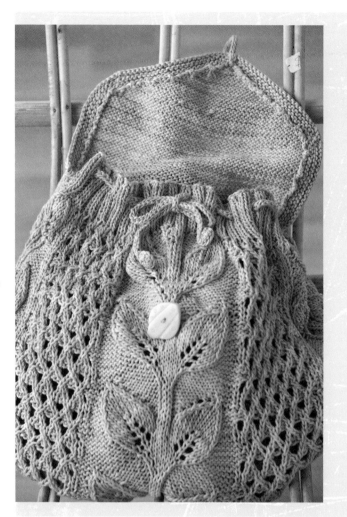

Flap Trim

With straight needles and RS facing, pick up and knit 21 sts along straight selvedge of flap, pm, 24 sts along shaped edge (about 1 st for every 2-st BO "step"), pm, 1 st from back side of the base of the I-cord (cord should hang loose in front of trim), pm, 24 sts along other shaped edge, pm, and 21 sts along rem straight selvedge—91 sts total. Knit 1 WS row.

NEXT ROW: (RS) Knit to m, sl m, k1f&b, knit to m, k1f&b, sl m, k1 (center st), sl m, k1f&b, knit to m, k1f&b, sl m, knit to end—4 sts inc'd.

Knit 1 WS row. Rep the last 2 rows once more—99 sts. BO all sts as if to knit. Fold the I-cord loop in half and use its tail threaded on a tapestry needle to sew the BO end of the loop to the WS of the flap, directly underneath the start of the I-cord.

With RS of back facing, place removable markers in the seams on each side of the back in the last row of the Waffle patt, just below the start of the top ribbing. Sew CO edge of flap between markers. Weave in ends.

Close top of knapsack with drawstring, fold flap over the top and down in front, and mark the position on the RS of the front that best corresponds to the I-cord button loop on the flap. Sew the decorative button to the RS of the front at the marked position, anchoring it on the WS with the smaller backing button.

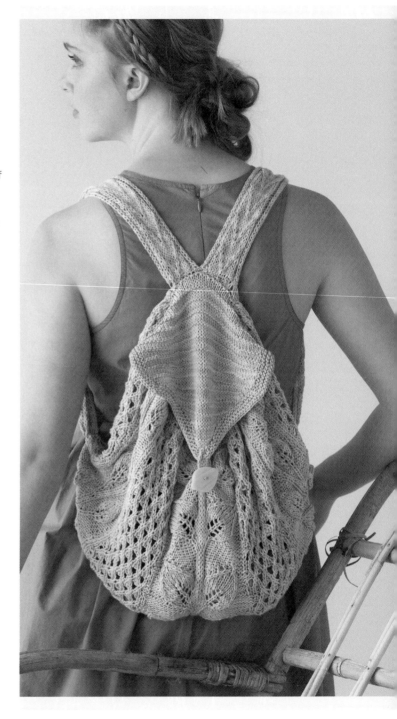

touching the sun through fiber

essay by:
Carmen S. Hall
Knitter

I've heard knitting described as a solitary activity best done in good company. For me, the company I keep is at its very best when the fiber is organically raised, minimally processed, and naturally dyed.

When I hold a beautiful skein of wool that has passed through an artisan's hands, that was shorn from an animal that was cared for in a sustainable manner, that was carded and spun by hand, and dipped into colors with care by hand, I structure the cast of characters in whose company I shall knit. I imagine what the horizon looked like as the animals grazed and the lives of the people who did the shearing, washing, carding, and dyeing. The same can't be said of synthetic fiber. There are no pastures to walk through, no frolicking animals, no caretakers, and precious little human touch involved. Simply put, there is no company to keep.

This circle of benevolent spirits extends far beyond the animals and artisans who produce the fiber itself. I can feel my dear grandmothers watching over me when I knit, and the presence of other ancestors I never knew. Like Jamling Norgay, who wrote a memoir called *Touching My Father's Soul* about scaling Mt. Everest to better understand his father, the famed Nepalese sherpa Tenzing Norgay, I touch the souls of others when I knit. I also learn to better touch my own soul. Heavy equipment is not necessary for my soul searching, but true natural fiber is essential.

Zen poet Thich Nhat Hanh tells a beautiful story about looking deeply into a piece of paper. He says that if you are still enough and look deeply enough, it is possible to touch the tree from which the paper was made, to feel the soil beneath its roots, the wind that blew through its branches, the shade of the cloud that passed overhead, the gentle rain that fell, and even to meet the worker at the paper mill. Ultimately, he says, if you look deeply enough, it is possible to touch the sun.

When I knit with natural fibers, I can touch a sheep, feel the breeze, and see the sun rise and set in the outdoors. I can feel the dirt and smell the grass. I can visit with the sheepherder, watch as the sheep is shorn and help pick out debris as the fiber is carded. I too can touch the sun.

Natural fibers enhance my knitting experience and give me garments to treasure. As I knit, I hope to pave the path for others as they tap into the mystery of craft and creation. I hope my children will remember me knitting through joys and through sorrows, securing my web to a much grander one filled with a host of souls. I hope they too will learn to touch the sun.

Alpacas

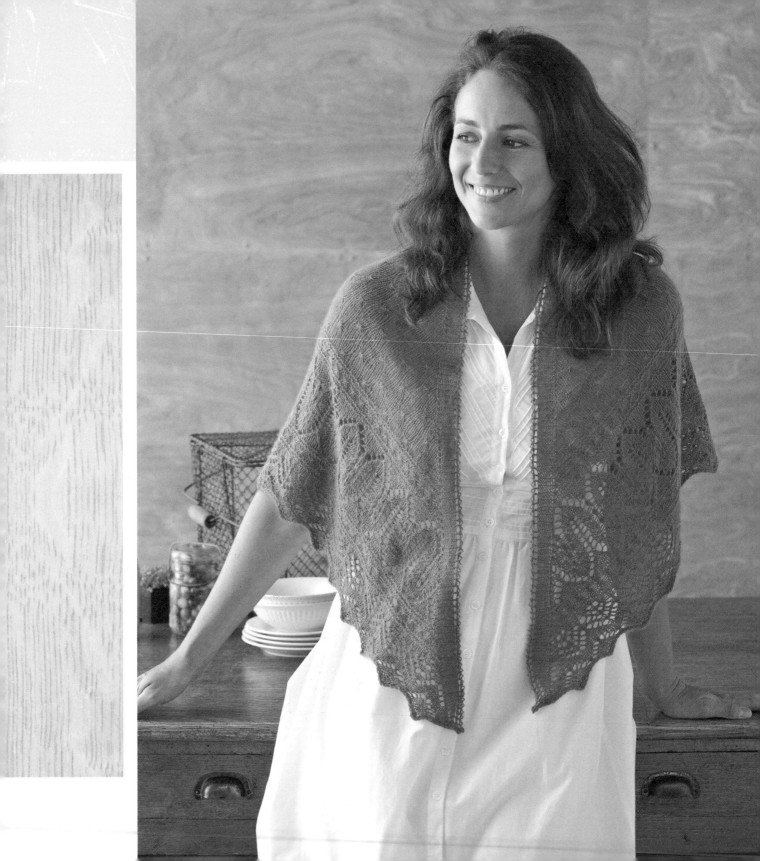

videvik
SHAWL

designed by:
Nancy Bush

Shawls are ideal all-season wear—from chasing the cool of a summer evening to providing a welcome extra layer in the depth of winter. For this shawl, **Nancy Bush** took inspiration from the triangular shawls made in Estonia today and combined a variety of patterns. She worked it in the softest cashmere, in green, of course. *Videvik* means dusk in Estonian, and this shawl provides a warm retreat on a winter's evening, when the last of the sun's rays give way to darkness, and it's time to light the lamp. Nancy worked this shawl from the bottom to the top, shaping it with decreases along the way.

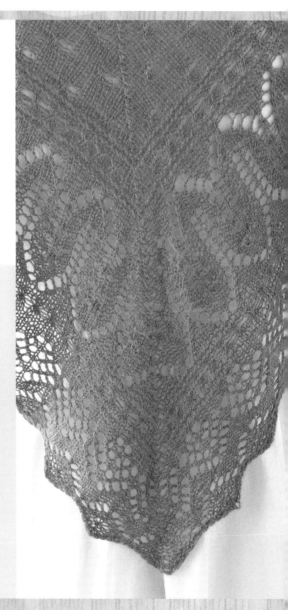

Finished Size
About 62" (157.5 cm) wide across top edge and 36" (91.5 cm) long from center of top edge to tip of lower point.

Yarn
Laceweight (#0 Lace).

SHOWN HERE: Jojoland 100% Cashmere 2 Ply (100% cashmere; 400 yd [366 m]/2 oz [57 g]): #C245 turtle green, 2 skeins.

Needles
Size U.S. 4 (3.5 mm): 32" (80 cm) or longer circular (cir) and 2 double-pointed (dpn). Adjust needle size if necessary to obtain the correct gauge

Notions
Markers (m); tapestry needle; removable marker; blocking wires.

Gauge
24 stitches and 32 rows = 4" (10 cm) in stockinette stitch, before blocking; 17½ stitches and 33 rows = 4" (10 cm) in pattern from center charts, after blocking.

STITCH GUIDE

Nupp

On a RS row, very loosely work (k1, yo, k1, yo, k1) all the same st—1 st inc'd to 5 sts. On the following WS row, purl these 5 sts tog—5 sts dec'd to 1 st.

Gathered Sts (worked over 3 sts)

K3tog but do not slip sts from needle, yo, then knit the same 3 sts tog again, then slip all 3 sts from needle.

NOTES

• The shawl begins with stitches cast on for the lace edge along the two lower sides using a double strand of yarn, then the rest of the shawl is worked using a single strand.

• Stitches are decreased inside each garter-stitch border and on each side of the center stitch (beginning in Row 7) to produce a triangle shape.

• The first time you work Rows 79–94 of the center charts, there will be enough stitches to work each red outlined repeat box 9 times. The stitch count decreases by 32 stitches each time you work Rows 79–94, so there will be 16 fewer stitches in each half (two fewer 8-stitch pattern repeats) every time these rows are repeated. Work each red outlined box 7 times the second time you work Rows 79–94, then work each red outlined box 5 times on the third repeat, 3 times on the fourth repeat, and only once on the fifth and final repeat.

• When only the stitches of the garter borders and a single stitch from each main section remain, the stitches are divided into two equal groups and grafted together at the center of the top edge to finish the shawl.

Shawl

Lace Edge

With two strands of yarn held together and using the knitted method (see Glossary), CO 371 sts. Break off one strand and cont with a single strand of yarn to end of shawl. Knit 1 row. Establish patts for lace edge charts as foll: Work Row 1 of Right Lace Edge chart across first 186 sts placing a marker (pm) after the first 4 sts, then work Row 1 of Left Lace Edge chart over 185 sts and pm before last 4 sts—369 sts rem. Place a removable marker in the center st itself (shaded in gold) and not on the needle; move this marker up every few rows so you can always easily identify the center st. Work Rows 2–22 of charts—341 sts rem; 1 center st; 162 sts on each side of center inside markers; 8 garter border sts at each side.

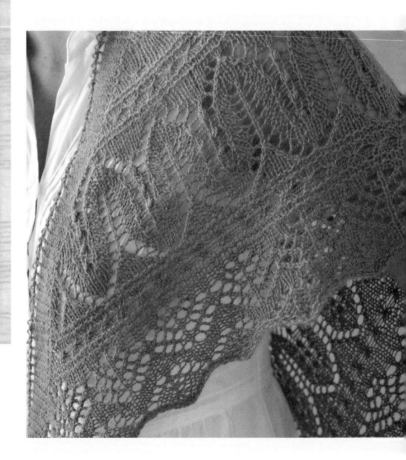

Right Lace Edge

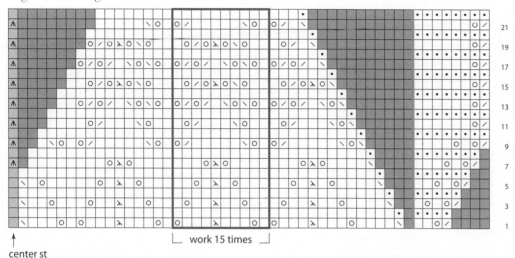

↑
center st

work 15 times

Left Lace Edge

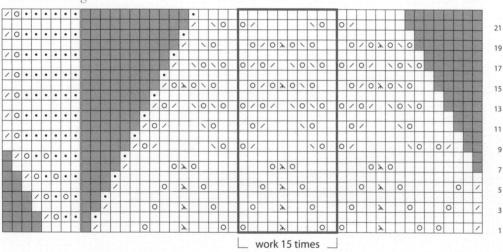

work 15 times

☐ k on RS; p on WS	入 sl 1, k2tog, psso	☐ pattern repeat
• p on RS; k on WS	🧺 nupp (see Stitch Guide)	│ marker position
O yo	仐 p5tog	⟋⟋ gathered sts (see Stitch Guide)
⟋ k2tog on RS and WS	▨ no stitch	
⟍ sl 1, k1, psso	▨ center stitch	

First Break, Border, and Second Break

Change to First Break chart and work Rows 23-34—317 sts rem. Establish patts for border charts as foll: Work Row 35 of Right Border chart across first 160 sts, ending with the center st, then work Row 35 of Left Border chart over 157 sts—313 sts rem. Work Rows 36-64 of charts—257 sts rem; 1 center st; 120 sts on each side of center inside markers; 8 garter border sts at each side. Change to Second Break chart and work Rows 65-78—229 sts rem.

☐ k on RS; p on WS	⬆ p5tog
· p on RS; k on WS	▨ no stitch
○ yo	▥ center stitch
╱ k2tog on RS and WS	☐ pattern repeat
╲ sl 1, k1, psso	▮ marker position
⋏ sl 1, k2tog, psso	▷ gathered sts (see Stitch Guide)
⌸ nupp (see Stitch Guide)	

First Break

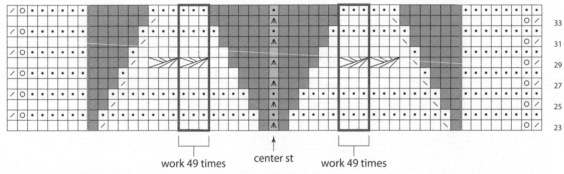

work 49 times · center st · work 49 times

Second Break

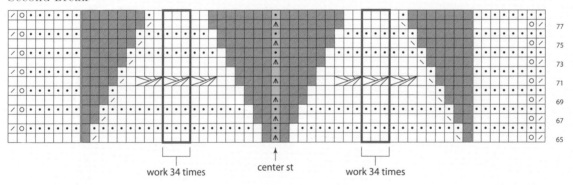

work 34 times · center st · work 34 times

Right Border

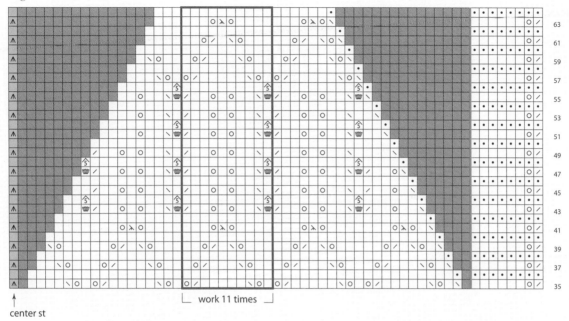

work 11 times

↑
center st

Left Border

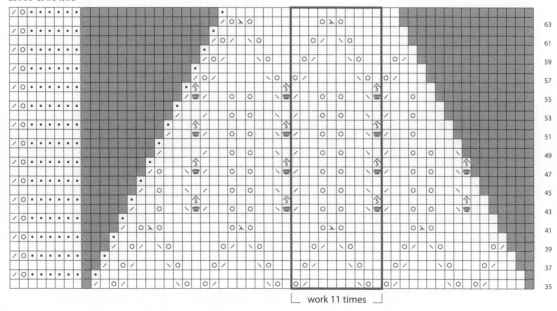

work 11 times

Center Section

Establish patts for center charts as foll (see Notes): Work Row 79 of Right Center chart across first 116 sts, ending with the center st (shaded gold on chart), then work Row 79 of Left Center chart over 113 sts—225 sts rem. Work Rows 80–94 of charts once—197 sts rem. Rep Rows 79–94 four more times—69 sts rem; 1 center st; 26 sts on each side of center inside markers; 8 garter border sts at each side; 158 chart rows completed from beg. Cont in patt from charts, work Rows 159–186 once; note that in Row 185 of the Right Center chart the (sl 1, k1, psso) dec eliminates the center st—18 sts rem. With RS facing, knit 1 row. Break yarn, leaving a 12" (30.5 cm) tail. Place 9 sts each on two dpn.

With WS facing and tail threaded on a tapestry needle, use the Kitchener st (see Glossary) to graft the two sets of 9 sts tog.

Finishing

Handwash gently in mild soap and warm water. Block shawl to 62" (157.5 cm) wide across top edge and 36" (91.5 cm) from top edge to tip of lower point, using blocking wires threaded through every edge stitch along straight top edge, and pinning out each (sl 1, k2tog, psso) point along the remaining two sides. Allow to air-dry thoroughly. Weave in loose ends.

Left Center

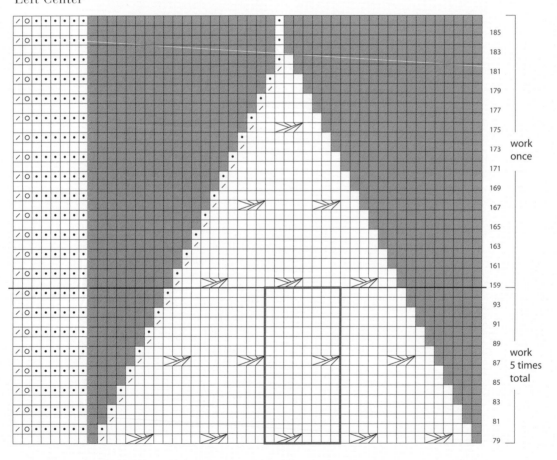

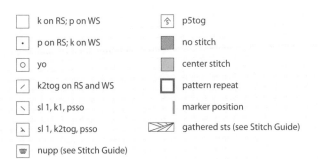

☐	k on RS; p on WS	
·	p on RS; k on WS	
○	yo	
╱	k2tog on RS and WS	
╲	sl 1, k1, psso	
⅄	sl 1, k2tog, psso	
▦	nupp (see Stitch Guide)	
⬆	p5tog	
▨	no stitch	
▨	center stitch	
☐	pattern repeat	
▎	marker position	
⧓	gathered sts (see Stitch Guide)	

Right Center

work once

work 5 times total

↑
center st

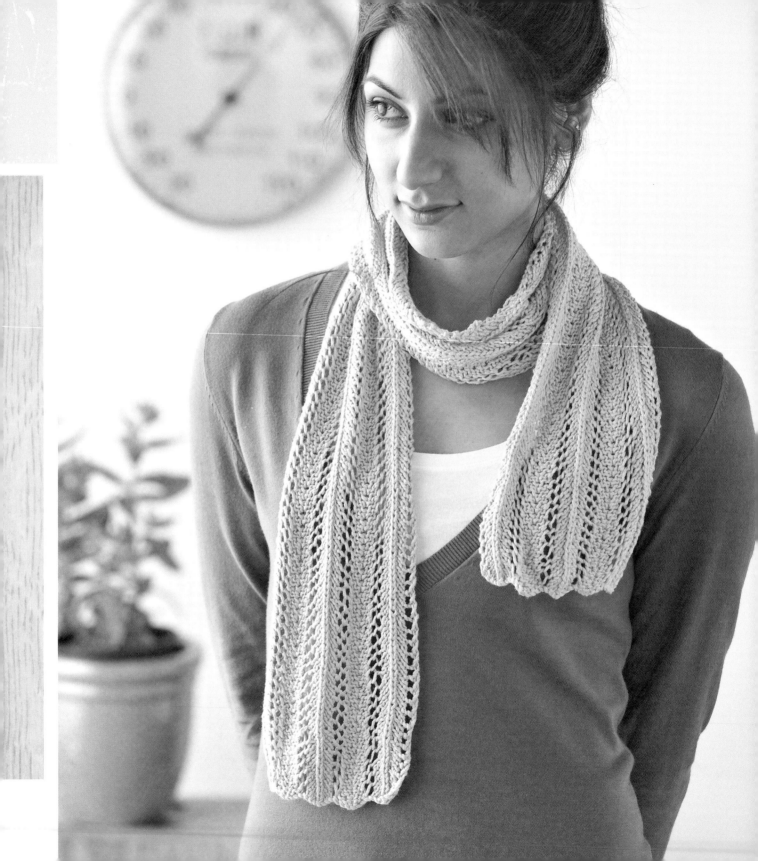

sustainable bamboo
SCARF

designed by:
Ann Budd

Bamboo and soya—a fiber derived from soybeans—rival silk in softness without the need to sacrifice silk moths. Both plants are highly renewable (bamboo grows to maturity in sixty days and soybeans are cultivated worldwide). **Ann Budd** used the silky drape of these fibers to advantage in a reversible lace scarf that is worked in two halves and grafted together at the center. Stitches that are purled on one side are worked in a stockinette lace pattern on the other and vice versa, and the two cast-on edges form pretty scallops at the ends.

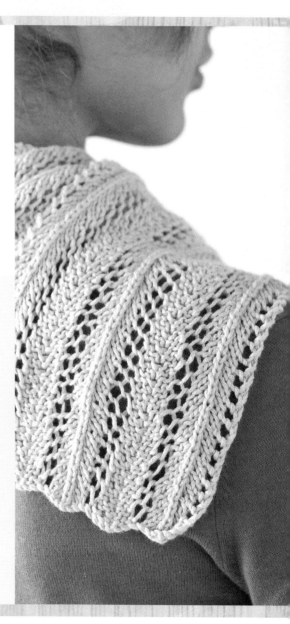

Finished Size

About 5¾" (14.5 cm) wide and 50" (127 cm) long.

Yarn

DK weight (#3 Light).

SHOWN HERE: Schulana Sojabama (55% bamboo, 45% soya; 120 yd [110 m]/50 g): #04 silver, 2 balls (see Notes).

Needles

Size U.S. 6 (4 mm). Adjust needle size if necessary to obtain the correct gauge.

Notions

Stitch holder; tapestry needle.

Gauge

13 stitches and 13 rows = 2" (5 cm) in pattern stitch.

NOTES

- The scarf is worked in two halves from the ends toward the middle, then the live sts are grafted together at the center.
- The scarf shown used almost all of two balls of yarn, with very little left over. If making a longer scarf, plan on purchasing extra yarn.

First Half

Using the cable method (see Glossary), CO 37 sts.

ROW 1: (RS) K1, [yo, k2, sl 2 tog kwise, k1, p2sso, k2, yo, p7] 2 times, yo, k2, sl 2 tog kwise, k1, p2sso, k2, yo, k1.

ROW 2: (WS) K1, p7, [yo, k2, sl 2 tog kwise, k1, p2sso, k2, yo, p7] 2 times, k1.

Rep Rows 1 and 2 until piece measures about 25" (63.5 cm) from CO, ending with Row 2. Cut yarn and place sts on holder.

Second Half

Work as first half, but leave sts on needles. Cut yarn, leaving a 20" (51 cm) tail for grafting.

Finishing

Return held sts of first half to empty needle with RS facing and needle tip at the left side (end of RS rows). Hold needles tog with WS of halves touching, and use tail threaded on a tapestry needle to graft live sts tog using Kitchener st (see Glossary). For a non-grafted join, hold the needles with RS touching and WS facing outward, then use the three-needle method (see Glossary) to BO the sts tog; the three-needle BO will leave a welt on the WS. Weave in loose ends. Block lightly, pulling out scallops on CO edges.

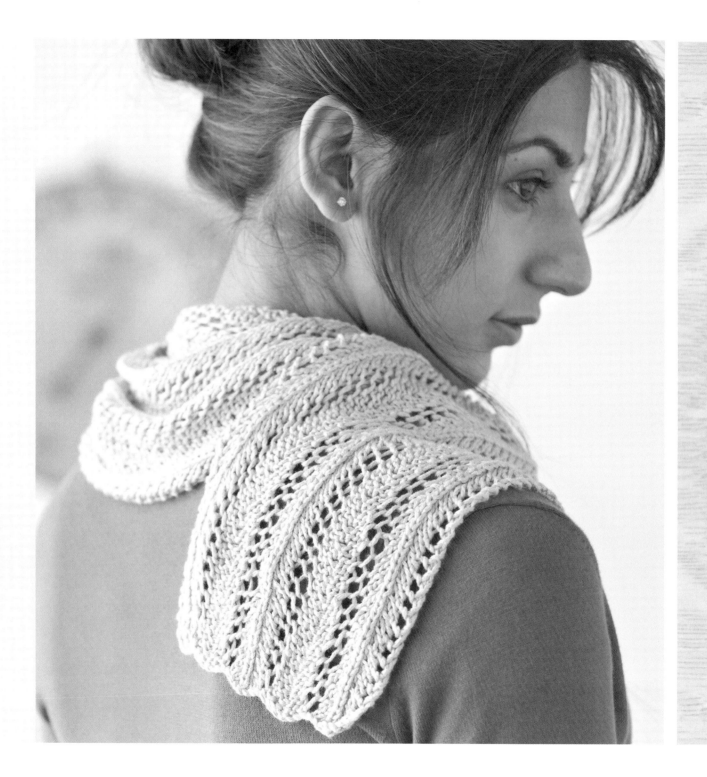

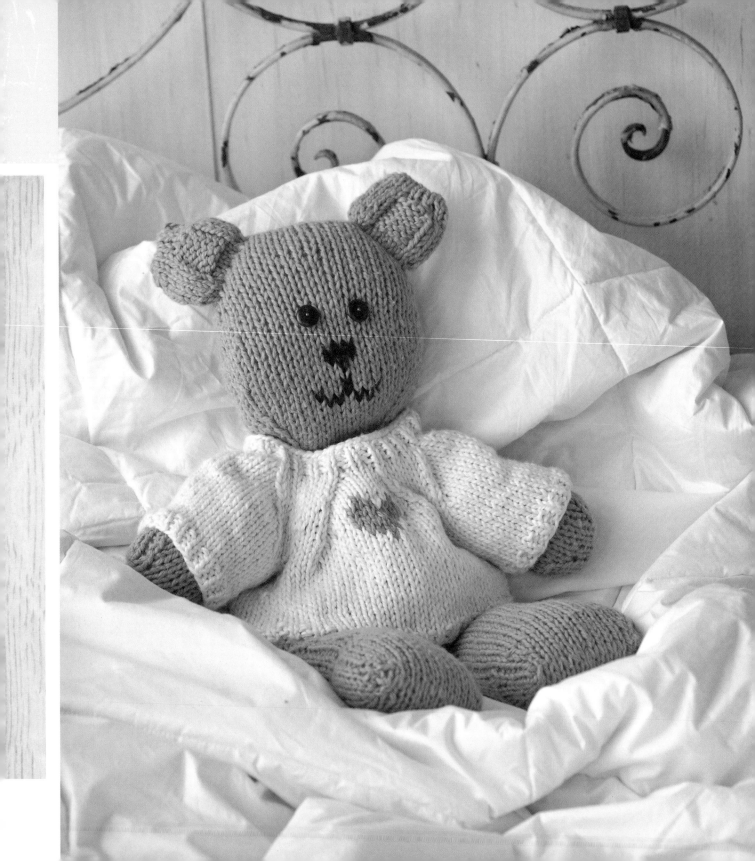

cotton comfort
BEAR

designed by:
Michele
Rose Orne

Few things comfort like a huggable teddy bear, especially one with a heatable pouch in the belly to soothe tummy aches. **Michele Rose Orne** knitted this bear and its removable sweater out of organic cotton, grown and processed without the use of agri-chemicals, bleach, or dyes, and filled it with a microwaveable pouch of natural rice. Michele knitted the bear from top of head down to the feet; she picked up stitches and knitted the arms downward to the paws. The head is stuffed and the face is added with buttons and embroidery.

Finished Size

About 19¾" (50 cm) tall, excluding ears, and 15" (38 cm) from paw tip to paw tip with arms outstretched. Sweater measures about 18¾" (47.5 cm) around chest circumference.

Yarn

Chunky weight (#5 Bulky).

SHOWN HERE: Blue Sky Alpacas Organic Cotton (100% organic cotton; 150 yd [137 m]/100 g): #82 nut (MC), 2 skeins for bear; #80 bone (CC), 1 skein for sweater.

Needles

Size U.S. 9 (5.5 mm): 12" (30 cm) circular (cir) and set of 5 double-pointed (dpn). Adjust needle size if necessary to obtain the correct gauge.

Notions

Markers (m); stitch holders; tapestry needle; two ⅝" (1.5 cm) buttons for eyes (optional); small amount of dark brown wool embroidery floss; polyester fiberfill or cotton or wool batting for stuffing; 3 sets of ⅝" (1.5 cm) Velcro dots; sharp-point sewing needle and matching thread; ¼ yd (0.25 m) cotton muslin; 22 to 24 ounces (625 to 680 grams) of flaxseed, buckwheat hulls, rice, or similar warmable material.

Gauge

15 stitches and 20 rows/rounds = 4" (10 cm) in stockinette stitch.

Bear

Head

With MC and dpn, CO 24 sts. Arrange sts evenly on 4 dpn, place marker (pm) and join for working rnds, being careful not to twist sts—6 sts on each needle; rnd beg at side of head.

RNDS 1, 3, 5, AND 7: Knit.

RND 2: *K1, M1 (see Glossary), k10, M1, k1, pm for other side of head; rep from *—28 sts.

RNDS 4, 6, AND 8: *K1, M1, knit to 1 st before m, M1, k1, slip marker (sl m); rep from *—4 sts inc'd each rnd.

RNDS 9–11: Knit.

RND 12: Rep Rnd 4—44 sts.

RNDS 13–16: Knit.

RNDS 17–21: Rep Rnds 12–16—48 sts.

RND 22: *K1, ssk, knit to 3 sts before next m, k2tog, k1, sl m; rep from *—4 sts dec'd.

RNDS 23–25: Knit.

RND 26: Rep Rnd 22—40 sts rem.

RNDS 27, 29, AND 31: Knit.

RND 28, 30, 32: Rep Rnd 22—28 sts rem after Rnd 32; 14 sts each for front and back of head.

RND 33: Knit—piece measures about 6½" (16.5 cm) from CO.

Neck

Place 14 front-of-head sts on one needle and 14 back-of-head sts on a second needle. Hold needles parallel and, with a third needle, knit the stitches of the front and back needles tog—14 sts rem on one needle. Turn work. With WS of live sts on needle facing, use another dpn to pick up and knit 1 st from each pair of sts worked tog on previous row—28 sts; 14 sts each on 2 dpn.

Body

Resume working in rnds with sts on 2 dpn.

RNDS 1, 3, AND 5: Knit.

RND 2: *K1, M1, k12, M1, k1, sl m; rep from *—32 sts.

RNDS 4 AND 6: *[K1, M1] 2 times, knit to 2 sts before m, [M1, k1] 2 times, sl m; rep from *—8 sts inc'd each rnd; 48 sts after completing Rnd 6.

RND 7: Knit—piece measures about 1½" (3.8 cm) from sts picked up at base of neck.

Center Back Opening

Work back and forth in rows to create a slit for inserting the seed pouch as foll:

SET-UP ROW: (RS) K14 to 2 sts beyond center back, turn; rows now beg and end on each side of back opening.

ROW 8: (WS) K4, pm, p10, sl side m, p24 for front, sl side m, p10, pm, pick up and knit 4 sts from base of first 4 sts of row, turn—52 sts total; 24 front sts; 14 sts each side of back opening; 4 sts at each end of row overlap for edgings on each side of opening.

ROWS 9 AND 11: (RS) K4, sl m, k10, sl m, k24, sl m, k10, sl m, k4.

ROWS 10 AND 12: K4, sl m, p10, sl m, p24, sl m, p10, sl m, k4.

ROW 13: (inc row) K4, sl m, *knit to 1 st before side m, M1, k1, sl m, k1, M1; rep from * once more, knit to last 4 sts, sl m, k4—4 sts inc'd: 2 sts on front, 1 st on each side of back.

ROWS 14–16: Rep Rows 10–12.

ROW 17: Rep Row 13—4 sts inc'd.

ROWS 18–25: Rep Rows 14–17 two times—68 sts total; 32 front sts; 18 sts each side of back opening.

ROWS 26–28: Rep Rows 10–12—back opening measures about 5¾" (14.5 cm) including set-up row; body measures about 7¼" (18.5 cm) from base of neck.

Close Lower Body

With RS of back facing, k4, remove m, k14, remove side m. Turn work so RS of front is facing. Hold front needle parallel to and in front of needle holding sts just worked for back. Using a third needle, knit the first 14 front and back sts tog—18 front sts and 4 sts from first half of back rem. Overlap the 4-st garter edgings of the center back opening, hold all 3 needles parallel, and work [k3tog] 4 times to join front and overlapped edgings. Redistribute sts with 14 rem front sts and 14 rem back sts on 2 needles, and work [k2tog] 14 times—32 sts rem. Leave last 13 sts worked on needle for left leg, and place rem 19 sts on holder.

Left Leg

Turn work so back is facing again. Use an empty dpn to pick up and knit 1 st from the first 13 pairs of sts worked tog on previous row, then knit across first 13 front sts again, pm and join for working in rnds—26 left leg sts; rnd beg at outside edge of leg with back of bear facing you. Knit 15 rnds.

Shape Foot

RND 1: K2, M1, k11, pm for inside of leg, k11, M1, k2, pm—28 sts.

RNDS 2, 4, AND 6: Knit.

RNDS 3, 5, AND 7: K2, M1, knit to m, sl m, knit to last 2 sts, M1, k2—2 sts inc'd each rnd; 34 sts after completing Rnd 7.

RNDS 8–10: Knit.

RND 11: Knit to 4 sts before m, k2tog, k2, sl m, k2, ssk, knit to end—32 sts rem.

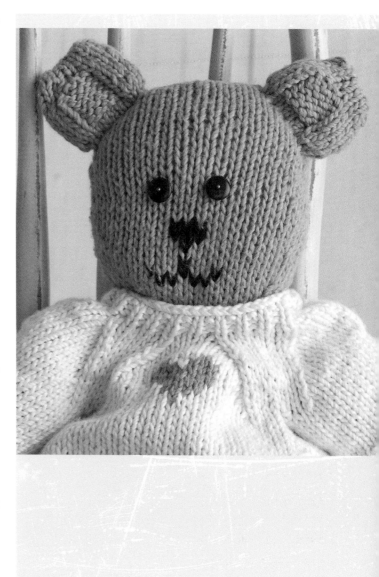

RND 12: Knit.

RND 13: K1, ssk, knit to 4 sts before m, k2tog, k2, sl m, k2, ssk, knit to last 3 sts, k2tog, k1—28 sts rem.

RND 14: K1, ssk, knit to m, sl m, knit to last 3 sts, k2tog, k1—26 sts rem; leg measures about 6″ (15 cm) from end of body.

Place sts on holder. Break yarn, leaving a 10″ (25.5 cm) tail for grafting later.

Right Leg

Return 19 held lower body sts to needle with back of bear facing and rejoin MC to inner edge of leg. BO 6 sts between legs, then return st on right-hand needle after last BO to left-hand needle—13 sts rem. With back still facing, use an empty dpn to pick up and knit 1 st from the first 13 pairs of sts knit tog at end of lower body, pm, and join for working in rnds—26 right leg sts; rnd beg at outside edge of leg with front of bear facing you. Knit 15 rnds. Shape foot as for left leg.

Right Arm

With front of bear facing and head to the right, measure about 1″ (2.5 cm) down from the neck along the right side "seam" and rejoin yarn. Pick up and knit 11 sts along front side of seam, pm, turn bear so back is facing, then pick up and knit 11 sts along back side of seam, pm, and join for working in rnds—22 sts; rnd begs at "shoulder" side of arm. Knit 17 rnds. Shape end of paw as foll:

RND 1: *K1, ssk, knit to 3 sts before m, k2tog, k1, sl m; rep from *—4 sts dec'd.

RND 2: Knit.

RND 3: Rep Rnd 1—14 sts rem.

RND 4: Knit—arm measures about 4½″ (11.5 cm) from pick-up row.

Place sts on holder. Break yarn, leaving a 10″ (25.5 cm) tail for grafting later.

Left Arm

With back of bear facing and head to the right, measure about 1″ (2.5 cm) down from the neck along the left side "seam" and rejoin yarn. Pick up and knit 11 sts along back side of seam, pm, turn bear so front is facing, then pick up and knit 11 sts along front side of seam, pm and join for working in rnds—22 sts; rnd beg at shoulder side of arm. Work as for right arm.

Right Ear

With front of bear facing, join yarn to CO edge at right side of head. Pick up and knit 9 sts along front side of head shaping slope, pm, turn bear so back is facing, pick up and knit 9 sts along back side of slope, pm, and join for working in rnds—18 sts; rnd beg at top of head at start of front-of-ear sts.

RND 1: *K1, M1, knit to 1 st before m, M1, k1, sl m; rep from *—22 sts.

RND 2: Knit.

RNDS 3–6: K3, p5, k3, sl m, k11.

RNDS 7 and 8: K2, ssk, purl to 4 sts before m, k2tog, k2, sl m, k2, ssk, knit to last 4 sts, k2tog, k2—4 sts dec'd each rnd; 14 sts after completing Rnd 8.

RNDS 9 and 10: Knit—piece measures about 2″ (5 cm) from pick-up rnd.

Cut yarn, leaving a 10″ (25.5 cm) tail. Thread tail on tapestry needle and use the Kitchener st (see Glossary) to graft top of ear closed.

Left Ear

With front of bear facing, join yarn to left side "seam" of head about the same distance from the CO edge as for right ear, so both ears will be the same width at their bases. Pick up and knit 9 sts along front side of head shaping slope to CO edge, pm, turn bear so back is facing, then pick up and knit 9 sts along back side of slope, pm and join for working in rnds—18 sts; rnd beg at lower edge of ear at start of front-of-ear sts. Work as for right ear.

Finishing

Face

Sew buttons for eyes firmly in place on front of head, about 3″ (7.5 cm) down from the top of the head and 2″ (5 cm) in from each side. With embroidery floss threaded on a tapestry needle, use duplicate sts (see Glossary) to embroider triangular nose and mouth as shown.

Stuffing

Stuff arms, legs, and head with fiberfill or batting. With yarn threaded on a tapestry needle, use the Kitchener stitch to join the ends of the arms and bottoms of the feet, and sew top of the head closed.

Back Closure

Mark positions for Velcro dots on garter-st edgings of back opening, with the top and bottom dots each about 1″ (2.5 cm) from the ends of the opening, and the rem dot centered in between. With sharp-point sewing needle and thread, sew the hook half of each dot set to the WS of the garter edging in the upper layer of the overlap and the loop half of each dot set to the RS of the garter edging on the lower layer of the overlap.

Beanbag Insert

Cut two pieces of muslin in trapezoid shapes 8½″ (21.5 cm) wide across the base, tapering to 6″ (15 cm) wide across the top, and 7″ (18 cm) high. With sewing needle and thread, sew pieces tog with a ½″ (1.3 cm) seam allowance, leaving a 1½″ (3.8 cm) opening. Clip corners, turn RS out, and press. Fill bag with seeds or rice and sew opening closed. Insert beanbag into back opening of bear and close back with Velcro dots.

Sweater

Lower Body

With CC and cir needle, CO 70 sts. Pm and join for working in rnds, being careful not to twist sts. Work in k1, p1 ribbing for 3 rnds, pm after 35 sts in last rnd to mark side "seam." Change to St st (knit every rnd) and work even until piece measures 2″ (5 cm) from CO.

NEXT RND: *K2, ssk, knit to 4 sts before m, k2tog, k2; rep from *—4 sts dec'd.

Knit 3 rnds. Rep the last 4 rnds once more—62 sts rem; 31 sts each for front and back; piece measures about 3½″ (9 cm) from CO.

DIVIDING RND: Removing m as you come to them, *BO 6 sts (1 st on right needle tip), k24; rep from *—25 sts each for front and back. Place sts on separate holders.

Sleeves

With CC and dpn, CO 30 sts. Pm and join for working in rnds, being careful not to twist sts. Work in k1, p1 rib for 3 rnds. Knit 1 rnd.

NEXT RND: K1, M1, k28, M1, k1—32 sts.

Work even in St st for 8 rnds—piece measures about 2½″ (6.5 cm) from CO.

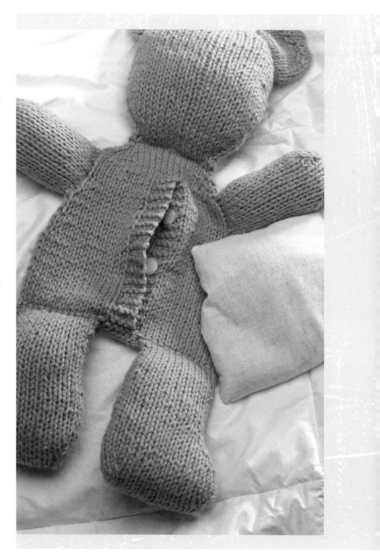

NEXT RND: BO 6 sts, knit to end—26 sts rem.

Place sts on holder. Make a second sleeve the same as the first.

Yoke

Return held body sts to cir needle and rejoin CC with RS facing to beg of front sts.

JOINING RND: K25 front sts, pm, knit across 26 held right sleeve sts, pm, k25 back sts, pm, knit across 26 held left sleeve sts, pm, and join for working in rnds—102 sts total; rnd beg at start of front sts.

DEC RND: *K2, ssk, knit to 4 sts before m, k2tog, k2, sl m; rep from * 3 more times—8 sts dec'd; 2 sts each from front, back, and each sleeve.

Knit 1 rnd. Rep the last 2 rnds 6 more times—46 sts rem; 11 sts each for front and back; 12 sts each sleeve. Work in k1, p1 ribbing for 4 rnds—piece measures about 3½" (9 cm) from joining rnd. BO all sts loosely in rib patt.

Finishing

With CC threaded on a tapestry needle, sew underarm seams. With MC threaded on a tapestry needle, use duplicate stitches to embroider heart motif (see below) on center front of sweater, about 6 rnds below start of neckband ribbing. Weave in loose ends.

Heart embroidery diagram

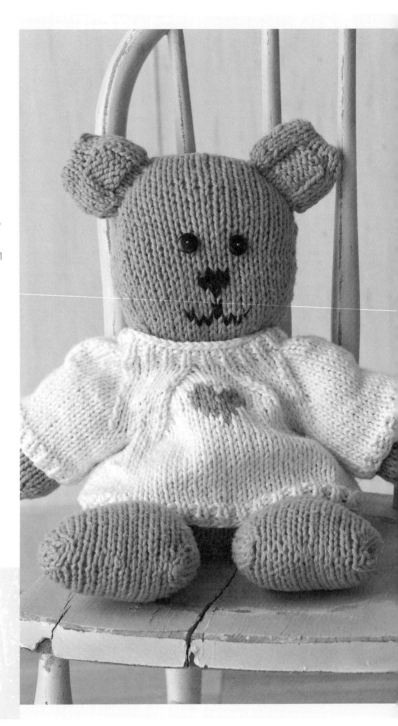

knitting
stone-age style

essay by:
Kristeen Griffin-Grimes
Knitwear Designer

Two winters ago, after a massive windstorm left much of Seattle in Stone Age darkness, we hunkered down by our diminutive fireplace with candles and steaming pots of tea. Everyone in our once-bustling metropolis had been democratically shoveled into the same boat. The city slept under blankets of frost and tundra and we were left to dig into that primeval reserve of survival instinct.

At first, I loved it when the power went out, remembering my early years in a bay-side cabin where the path to the outhouse was marked by Coleman lanterns during incessant storms that rolled eastward from the Pacific. In my romantic childhood vision of that time, I see my mother leaning against our makeshift sink, washing dishes by lamplight and singing her favorite ballads. Everything was rosy in my innocent eyes. As the pitch-black evenings in Seattle stretched to almost a week, I reconsidered my fairy-tale vision and longed for hot water to flow from the tap and the unfettered freedom to walk barefoot through a snug, cozy home.

Sitting in the morning dark with only a candle's flicker slows life to a gentle rhythm. Every nascent sound is noticeable, food tastes better, and reading and needlework become a gentle tether to generations of history. I reflected on my French and Italian great-grandparents, who woke in the dark to a cold stone house. They, too, sat by their fire, tended their animals, fed their children, and labored at tasks we now complete so easily. It's a wonder that the women of the house could grab a moment for the exquisite needlework that still survives—fine Italian bobbin lace, delicate French embroidered christening gowns—something we can now choose to do expressly for leisure.

Flax

Many of us have an unresolved desire for what we perceive as a simpler life. My years as an earth-mother on rural farms offered lessons in self-sufficiency. The memory of the hours spent spinning, dyeing, knitting, and sewing every stitch of clothing faded, leaving only the dreamy notion of our sojourn on the land and a deep longing to return to that life where time stretched out expansively, in contrast to my harried city life. A few days in the bitter, stinging cold of our frozen town permanently cured me of this desire to return to the "simple life."

If you hanker to turn back the clock, I encourage you to unplug every modern appliance, read by lantern light, haul water from the nearby creek, and then not be too bone-tired at day's end to knit a few rows in the fading lantern's glow. The gift of knitting, spinning, or crocheting as a pastime, rather than a necessity, is a welcome antidote to our tech-heavy age. I am thankful that these pursuits still remain an unbreakable connection to earlier times, and I make a small vow to rise early in the morning dark, light candles, sit by my warming fire, knit, and remember.

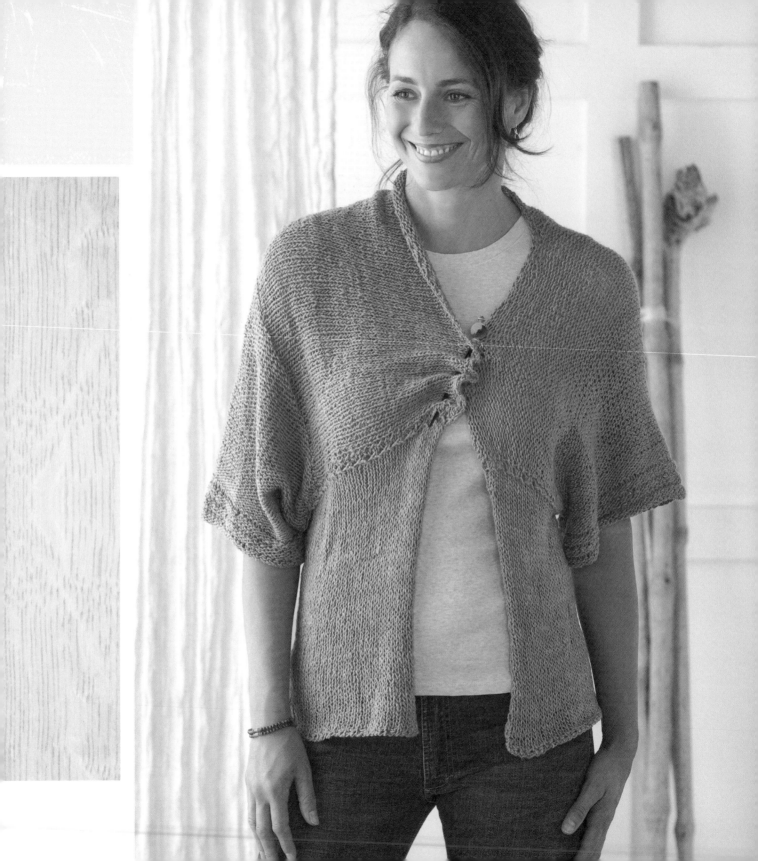

caterina
WRAP

designed by:
Kristeen
Griffin-Grimes

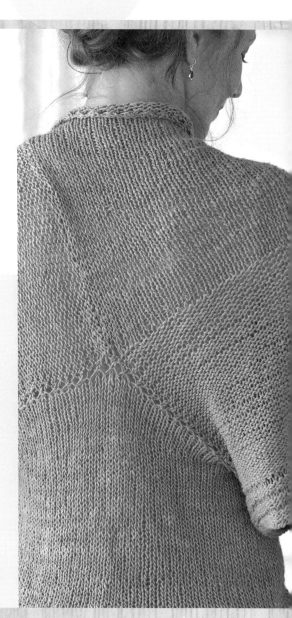

Kristeen Griffin-Grimes designed this asymmetrical minimalist wrap to echo the shawls worn by her northern Italian great-grandmother, Caterina. To mimic the rustic yarns of this mountainous region, Kristeen knitted her version from handspun yarn that was hand-dyed with walnut hulls. She constructed the wrap in one piece, beginning with the right upper section/sleeve, then picked up stitches in sections to work the remaining portions using short-rows to fill in the asymmetrical triangle at the upper back. A decorative shawl pin allows the wearer to adjust the closure for perfect fit.

Finished Size

About 33½ (38½, 44)" (85 [98, 112] cm) bust circumference, fastened.
Wrap shown measures 33½" (85 cm).

Yarn

Sportweight (#2 Fine).
SHOWN HERE: La Lana Wools Phat Silk Fine (50% silk, 50% wool; 142 yd [130 m]/ about 2 oz [56.7 g]/skein): walnut, 6 (7, 8) skeins.

Needles

BODY AND SLEEVES—size U.S. 10½ (6.5 mm): 20" and 36" (50 and 90 cm) circular (cir). NECK EDGING—size U.S. 10 (6 mm): 36" (90 cm) cir. NECK BIND OFF—U.S. size 11 (8 mm). Adjust needle size if necessary to obtain the correct gauge.

Notions

Waste yarn for provisional CO; marker (m); tapestry needle.

Gauge

12 stitches and 20 rows/rounds = 4" (10 cm) in stockinette stitch using middle-size needles, after blocking (see Notes).

Drop-Stitch Pattern

(worked in rnds with WS facing)

RND 1: *K1, yo; rep from *—st count has doubled.

RND 2: Knit, dropping each yo from needle as you come to it—st count has decreased to original number again.

RND 3: Knit.

Repeat Rnds 1–3 for pattern.

NOTES

- Because this project is worked much more loosely than usual for sportweight yarn, knit a swatch at least 8" (20.5 cm) square, then wet-block the swatch. When dry, allow the swatch to hang for a day or so before measuring the gauge in order to get a more accurate idea of how the fabric will drape when worn.

- The right upper body begins with a provisional cast-on along the back neck and right front collar edges and is worked outward in rows to the underarm, then the stitches are joined for working the right sleeve in the round. The left upper body begins with a provisional cast-on for the left neck edge and stitches picked up along one selvedge of the right body. The left body is also worked outward in rows to the underarm and then joined for working the left sleeve in the round. Stitches for the lower body are picked up along the bottom edges of the assembled upper body and worked down, with a short-rowed "peak" in the back that forces the sleeves to angle downward.

- To wear, insert arms into sleeves and pull the right sleeve up until the transition line between its reverse-stockinette and stockinette sections are aligned with the shoulder and the sleeve openings reach to about the same place on each arm. Fold back the right-hand side of the collar and secure with a decorative pin as shown in photograph. The right collar is not shown turned back on the schematic.

- The left-hand side of the neck has little or no collar fold-back, and the right front hangs longer than the left front. The line where the left upper body stitches were picked up along the right body selvedge runs diagonally across the wearer's upper back from the top the short-rowed "peak" in the lower body up to the left neck edge.

Wrap

Right Upper Body

With shorter cir needle in middle size and using a provisional method (see Glossary), CO 68 sts for all sizes. Do not join. Beg and ending with a RS row, work even in St st (knit RS rows; purl WS rows) for 59 rows—piece will measure about 11¾" (30 cm) from CO after blocking. Beg and ending with a WS row, work even in rev St st (purl RS rows; knit WS rows) for 39 (47, 57) rows—piece will measure about 19½ (21¼, 23¼)" (49.5 [54, 59] cm) from CO after blocking.

Right Sleeve

JOINING RND: With WS facing still facing, place marker (pm) and join for working in rnds; WS of piece is facing outward as you work the sleeve in the rnd.

Knit 5 rnds. Rep Rnds 1–3 of drop-stitch patt (see Stitch Guide) 3 times—9 patt rnds. Knit 2 more rnds—16 rnds total completed; piece will measure about 3¾" (9.5 cm) from joining rnd after blocking. Using the decrease method (see Glossary), loosely BO all sts.

Left Upper Body

With shorter cir needle in middle size and using a provisional method, CO 30 sts. Lay right upper body and sleeve flat with RS facing so that the provisional CO is at the bottom and the sleeve at the top. In this position, identify the selvedge on the right-hand side of the right upper body that runs from the CO edge to the underarm. With RS of right upper body still facing, use the needle holding the new CO sts to pick up and knit 38 sts along the St st portion of this selvedge from CO edge to where the St st section ends (about 3 sts for every 5 rows); do not pick up any sts from the rev St st section of the right body—68 sts on needle; 30 CO sts, and 38 picked-up sts. Do not join. Beg and ending with a WS row, work even in rev St st for 65 (73, 83) rows—piece will measure about 13 (14½, 16½)" (33 [37, 42] cm) from CO/pick-up row after blocking.

Left Sleeve

Work as for right sleeve.

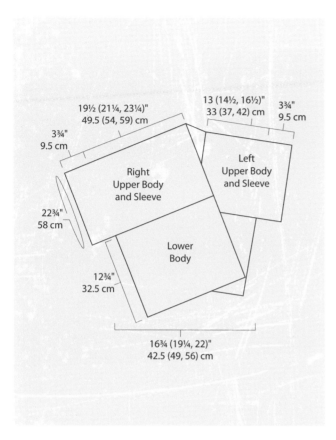

19½ (21¼, 23¼)"
49.5 (54, 59) cm

13 (14½, 16½)"
33 (37, 42) cm

3¾"
9.5 cm

3¾"
9.5 cm

Right
Upper Body
and Sleeve

Left
Upper Body
and Sleeve

22¾"
58 cm

Lower
Body

12¾"
32.5 cm

16¾ (19¼, 22)"
42.5 (49, 56) cm

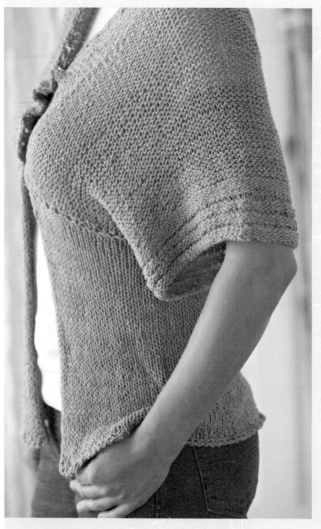

Lower Body

Lay assembled upper bodies flat with RS facing so that the provisional CO edges are at the bottom, the left sleeve is to your right, and the right sleeve is to your left. The selvedge that is uppermost in this position is the edge along which you will pick up sts for the lower body. With longer cir needle in middle size, RS facing, and beg at left front CO edge, pick up and knit 29 (33, 37) sts along selvedge of left front to left underarm, pm, 29 (33, 37) sts across left back from left underarm to where sts were picked-up from right upper body, 21 (25, 29) sts along right back to right underarm, pm, and 42 (46, 50) sts from right underarm to right front CO edge—121 (137, 153) sts total; 50 (58, 66) back sts between markers; right and left halves are deliberately asymmetrical and do not contain the same number of sts.

NEXT ROW: (WS) *K2tog, yo; rep from * to last st, k1.

NEXT ROW: *K1, knit into the back loop of the yo; rep from *.

NEXT ROW: Purl.

Work short-rows to create a "peak" at the small of the back as foll:

SHORT-ROW 1: (RS) K77 (89, 101) to 2 sts before right underarm m, turn.

SHORT-ROW 2: (WS) Backward yo (bring yarn to back between needles and then wrap it over top of right needle), purl to 2 sts before left underarm m, turn.

SHORT-ROW 3: Yo, knit to 2 sts before previous yo, turn.

SHORT-ROW 4: Backward yo, purl to 2 sts before previous yo, turn.

SHORT-ROWS 5-14: Rep Short-Rows 3 and 4 five more times.

SHORT-ROW 15: (RS) Yo, *knit to next yo, correct the mount of the yo so the leading leg is on the front of the needle as usual, then knit the yo tog with the st after it; rep from * until all yo's on this side have been worked, knit to end.

SHORT-ROW 16: *Purl to next yo, p2togtbl (the yo and the st after it; see Glossary); rep from * until all rem yo's have been worked, purl to end of row.

Cont even in St st for 59 more rows, beg and ending with a RS row—piece will measure about 12¾" (32.5 cm) from pick-up row at each side and about 15½" (39.5 cm) in center of back sts after blocking. **note:** To adjust length, work more or fewer rows here, ending with a RS row; every 5 rows added or removed will lengthen or shorten the garment by about 1" (2.5 cm). Using the decrease method, BO all sts.

Finishing

Neck Edging

Carefully remove waste yarn from provisional CO of right upper body (right front and back neck edges) and place 68 exposed live sts on cir needle in smallest size. Carefully remove waste yarn from provisional CO of left upper body (left front edge) and place 30 exposed live sts on the same needle—98 sts total. Rejoin yarn with WS facing to left front sts.

NEXT ROW: (WS) K29, k2tog tbl (last st of left front tog with first st of right front), k67, then pick up and knit 5 sts along next 1" (2.5) of lower body selvedge—102 sts.

NEXT ROW: (RS) Use the decrease method to BO 3 sts (1 st on right needle after last BO), *k2tog, yo; rep from * to last 2 sts, k2, then pick up and knit 4 sts along next 1" (2.5 cm) of lower body selvedge—103 sts.

With largest-size needle and using the decrease method, BO all sts loosely with WS facing.

Weave in loose ends. Block lightly, pinning out neckline, sleeve, and hem to open up drop-stitch patts on sleeves and eyelet holes of decrease BO along neck edges.

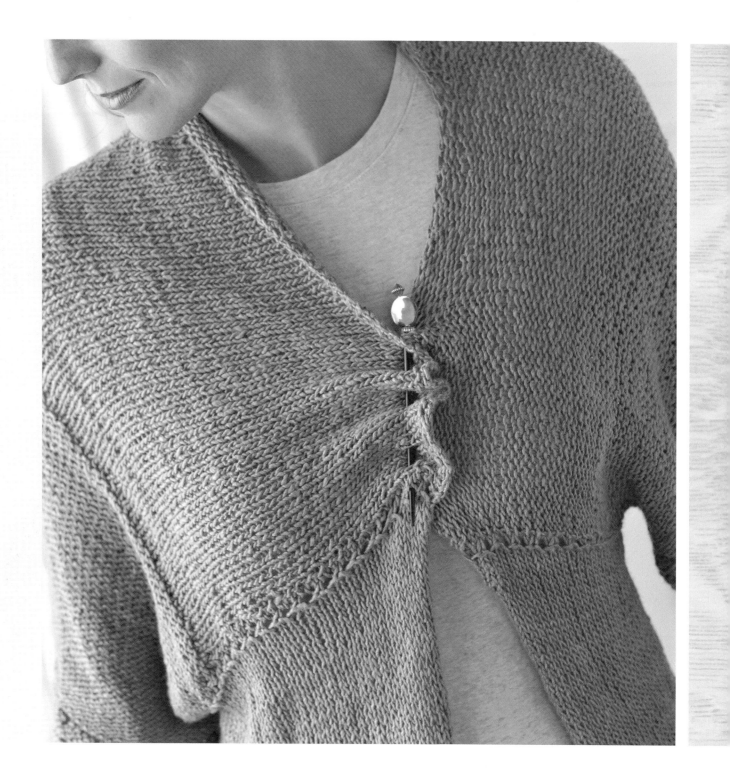

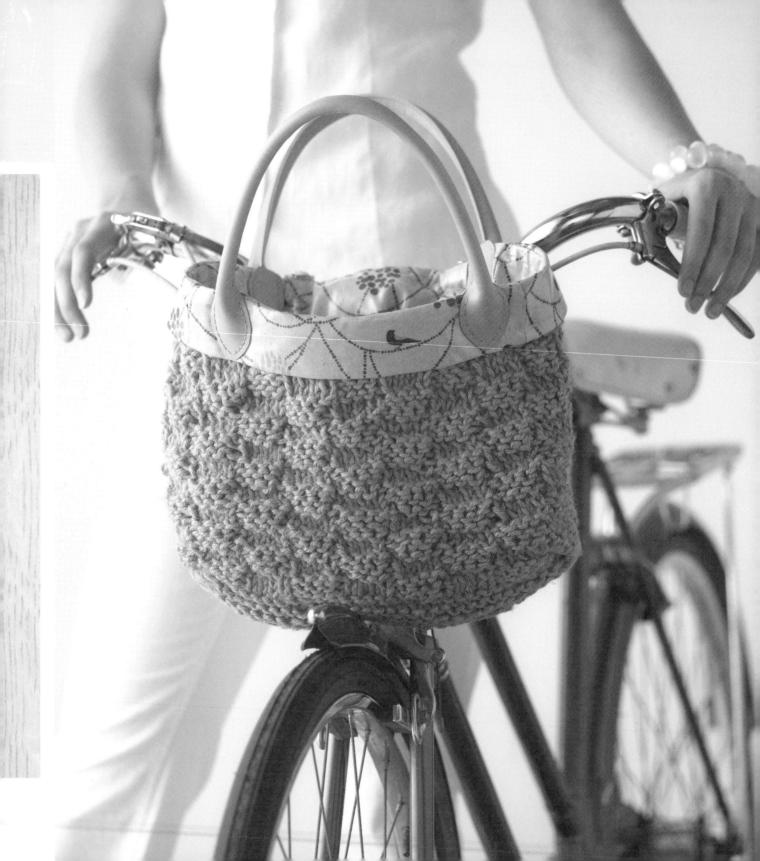

on-the-go
BIKE BASKET-PURSE

designed by:
Kim Hamlin

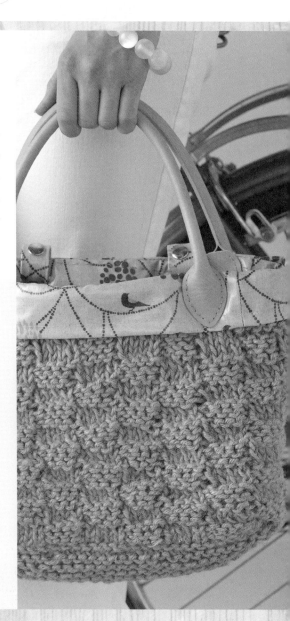

Gone are the days when bicycles were used just for idle (albeit athletic) entertainment—they are now a reliable mode of transportation for those of us concerned about high gas prices and carbon emissions. **Kim Hamlin** turns to her bike when running errands and designed this basket to double as a handbag to carry purchases and necessities. She knitted this bag out of rugged jute and lined it with decorative oilcloth to withstand the elements. Heavy-duty snaps hook the bag onto bicycle handlebars in transit, and stylish leather handles let you carry it away.

Finished Size

About 10½" (26.5 cm) wide, 8½" (21.5 cm) high, and 4½" (11.5 cm) deep, not including optional purse handles.

Yarn

Bulky weight (#6 Super Bulky).

SHOWN HERE: Jute twine (100% jute; 63 yd/roll): 3 rolls (available at craft and hardware stores).

Needles

Size U.S. 10½ (6.5 mm): 24" (60 cm) circular (cir). Adjust needle size if necessary to obtain the correct gauge.

Notions

Markers (m); Size H/8 (4.75 mm) crochet hook; ½ yard (.45 m) of 45" (114.5 cm) oilcloth; long sharp-point sewing needle and matching thread; waxed quilting thread; rotary cutter and self-healing mat; pinking shears; 4 sets of ⅝" (1.5 cm) heavy-duty snaps; one pair of 18" (45.5 cm) purchased leather purse handles (optional; available at craft stores).

Gauge

10" stitches and 19½ rows = 4" (10 cm) in garter stitch; 10½ stitches and 16½ rows = 4" (10 cm) in basketweave pattern.

Basket

Base

CO 28 sts. Knit every row until piece measures 4½"
(11.5 cm) from CO. BO all sts.

Sides

Beg at the center of one long edge, pick up and knit 14
sts to end of edge for half of back, 12 sts along first short
side, 28 front sts across next long side, 12 sts across
second short side, and 14 sts along rem edge of first long
side for other half of back—80 sts total. Place marker
(pm) and join for working in rnds.

RNDS 1–3: K2, *p4, k4; rep from * to last 2 sts, k2.

RND 4–6: P2, *k4, p4; rep from * to last 2 sts, p2.

Rep Rnds 1–6 four more times—piece measures about 7¼"
(18.5 cm) from pick-up rnd.

Top Edging

Knit 1 rnd, then purl 1 rnd.

NEXT RND: K7, BO 2 sts for carrier tab hole, knit to last 9
sts, BO 2 sts, knit to end.

NEXT RND: P7, use the backward-loop method (see Glos-
sary) to CO 2 sts over gap in previous row to complete
tab hole, purl to next gap, use the backward-loop method
to CO 2 sts, p7.

Knit 1 rnd, purl 1 rnd—piece measures about 8½" (21.5 cm)
from pick-up rnd. BO all sts.

Finishing

Weave in loose ends. Block well.

Oilcloth Lining

Using a rotary cutter against a self-healing mat, cut
the following pieces from the RS of the lining fabric as
shown in the illustration on page 119: 1 rectangle 11½" by
5" (29 by 12.5 cm) for base, 2 rectangles 11½" by 8½" (29
by 21.5 cm) for back and front, 2 rectangles 8½" by 5"
(21.5 by 12.5 cm) for sides, 2 rectangles 11½" by 3½" (29
by 9 cm) for back and front top facing, and 2 rectangles
5" by 3½" (12.5 by 9 cm) for side top facings. Cut 2 more
rectangles measuring 7" by 3" (18 by 7.5 cm) using pink-
ing shears for hanging tabs (shown by dotted lines on
diagram).

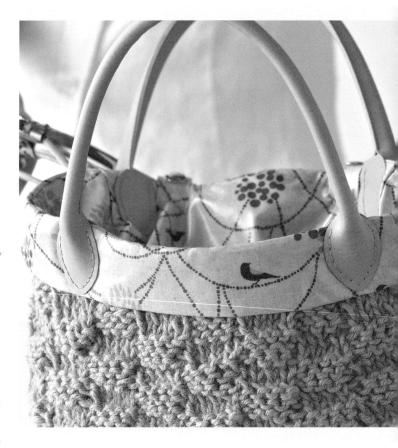

With sharp-point sewing needle and matching thread,
sew back, front, and sides to base using ½" (1.3 cm) seam
allowances according to assembly diagram on page 119.
Sew all four side seams from the base to the upper edge
to form a box shape as shown by arrows. Fold the top
edge of the box 1" (2.5 cm) to the WS and sew in place.

Mark four 1" (2.5 cm) hanging tab holes on WS of back
and back top facing positioned about 2" (5 cm) in from
the side seam and 1" (2.5 cm) away from the seam be-
tween the back and facing as shown in illustration. With
sharp scissors, cut slits measuring 1" by ⅛" (2.5 cm by
3 mm) at the marked hole positions. With sharp-point
sewing needle and waxed quilting thread, work button-
hole stitch (see Glossary) around each slit to reinforce
the hole.

Cutting Diagram

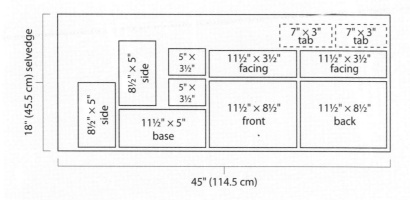

18" (45.5 cm) selvedge

8½" × 5" side

8½" × 5" side

5" × 3½"

5" × 3½"

11½" × 5" base

11½" × 3½" facing

11½" × 3½" facing

7" × 3" tab

7" × 3" tab

11½" × 8½" front

11½" × 8½" back

45" (114.5 cm)

Assembly Diagram

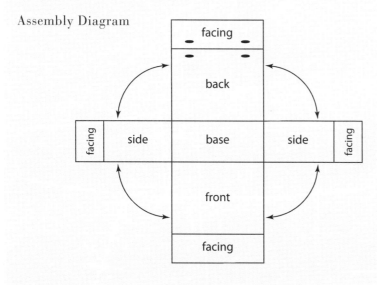

facing

back

facing

side

base

side

facing

front

facing

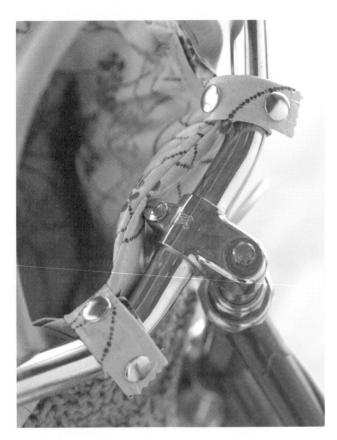

Insert lining into knitted basket with WS touching, RS facing out, and tab holes aligned. Leave top facings extending out the top of the basket for now. With sharp-point sewing needle, waxed thread, and long backstitches (see Glossary), sew lining and basket tog about ½" (1.3 cm) down from the BO edge. Fold top facings down to outside of basket on RS along seam lines as shown.

If adding purse handles, sew one handle in place on back of basket with ends of handle on outsides of the tab holes, using sharp-point sewing needle, waxed thread, and stitching through all three layers of basket, inner lining, and facing. Sew the other handle to the front with the same spacing between the handle ends as on the back.

Hanging Tabs

Fold one long side of a pinked tab rectangle 1" (2.5 cm) to WS and sew in place with sharp-point sewing needle and matching thread. Fold the other long side 1" (2.5 cm) to WS and sew in place in the same manner—tab measures 1" (2.5 cm) wide and 7" (18 cm) long. Sew across short ends of tab for reinforcement. Following manufacturer's instructions, attach one socket cap to RS of fabric tab about ½" (1.3 cm) from edge and another socket cap about 1" (2.5 cm) from the first. Wrap tab around handlebars and mark placement for post halves of snaps on RS of tab, aiming for a snug fit, and attach as instructed. Rep for other tab. Thread tabs through holes in back of completed basket and snap securely around handlebars.

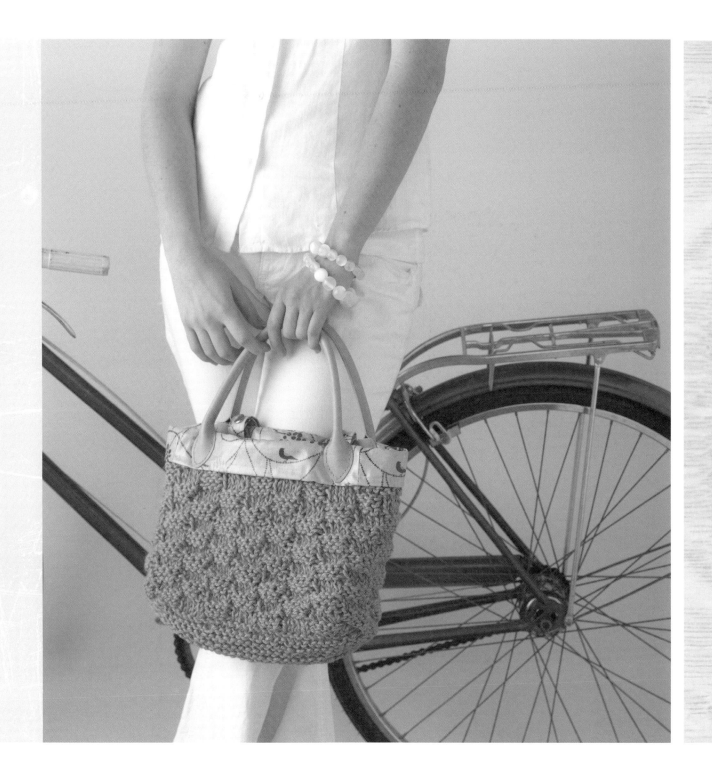

it's all about
the color

essay by:
Darlene Hayes
Natural Dyer

I came to dyeing late in life. After leaving careers in science and law, I found myself designing knitwear for a living. My design ideas seemed endless but finding the right yarn in the right colors was problematic. Enter my new career as a dyer and not just a dyer but a natural dyer: one that sources colors from the plant and insect world.

I never really considered using synthetically produced chemical dyes. They're inexpensive, easy to get, and seem easy to use, but they held no appeal for me. Instead, I went straight to boiling pots of leaves and twigs. Here's why.

- It is color that first captured me and continues to hold me in its sway, and natural dyes produce the most glorious colors imaginable. As a species we are drawn inexplicably to color, and the colors derived from natural sources have a depth that is not easily imitated using synthetic chemicals. Extracting colors from a natural source yields a complementary range of dye molecules rather than a single colorant. The resulting textile isn't just blue, for example, but blue with undertones of red and green that give the color movement and life and creates an emotional response to the dyed textile that is unique and a little mysterious. Yarn shop owners tell me that even non-knitters are drawn to displays of naturally dyed yarns.

- Natural dyes connect me with history. Humans have been taking colors from the natural world and applying them to walls and textiles since before the dawn of history.

Seeds of the weld plant, which yields a brilliant and long lasting yellow, have been found in the excavations of Stone Age settlements, while the oldest surviving dyed textile dates to 6000 B.C.E. The blues of indigo and the reds and oranges of madder can still be seen in textiles unearthed from the tombs of ancient Egypt, along with safflower seeds, a source for yellows and pinks. Textile dyeing has been a major industry in every civilization, as has been the growing and gathering of the necessary dye plants. It's said that the Spanish earned more money importing the cochineal insect into Europe from the New World than they took out in gold and silver (even today, many foods and cosmetics are colored with an extract of cochineal). Dye manuals many hundreds of years old are still available as resources, and I like the sense of continuity inherent in practicing such an ancient art.

- Natural dyes are easy on the earth. Not everyone agrees, and opponents often refer to something like "toxic heavy metal mordants necessary for the process." Nothing could be further from the truth. Many, although not all, natural dyes don't bind well to fibers and can be helped along by using a mordant—a metal salt that acts as a bridge between the dye molecule and the fiber. Mordants can also be used to shift colors from, say, bright yellow to olive green, which broadens the range of possible color obtainable from a single plant. People who speak of toxic mordants used in natural dyeing are usually referring to chromium, whose industrial use is regulated by most countries. While required for the manufacture and use of a variety of synthetic chemi-

cal dyes, chromium is not at all necessary when using natural dyes. I don't need it, I don't use it, and there seems to be no limit to the range of colors I can produce without it. Instead, I use mostly alum, a salt used in making pickles, styptic pencils, and deodorants, and tartaric acid, a byproduct of wine making. And once I'm done extracting color from a bunch of onion skins (golden yellow) or dill weed (light greenish-yellow), they go into my compost pile. This summer's dyestuffs help me grow next spring's peas. What could be better?

Although more dyers are using natural dyes, they do have drawbacks; for one thing, they're a lot more work. A dyer must gather and store bulky dyestuffs or obtain them from specialty importers and bulk herb companies. It takes time and additional equipment to extract the dyes, not to mention disposing of the spent dyestuff, and often multiple steps are needed to achieve a particular color. Different dyestuffs can require widely varying extraction times and/or methods, requiring experimentation and knowledge to get the process to work. And if that isn't enough, cellulose fibers, such as cotton and linen, require pretreatment to allow the fibers to accept and retain natural dyes.

The potential variability of the colors, even when you have developed and scrupulously follow a particular recipe, is another complication. Natural dyes are sensitive to pH and whatever minerals might be in the water supply, and the plants themselves can produce different amounts and types of dye molecules. Consistency between dyelots is elusive at best. That's not a problem if you are dyeing one batch of yarn for yourself, but it can be a significant challenge for the commercial dyer.

Still, there's nothing quite like the satisfaction I get from starting with a bunch of almost dull-looking leaves or roots and ending up with an armload of yarn with vibrant colors that dance. In the end, the colors are magic, and after all, it really is all about the color.

Indigo dyepot

Safflower

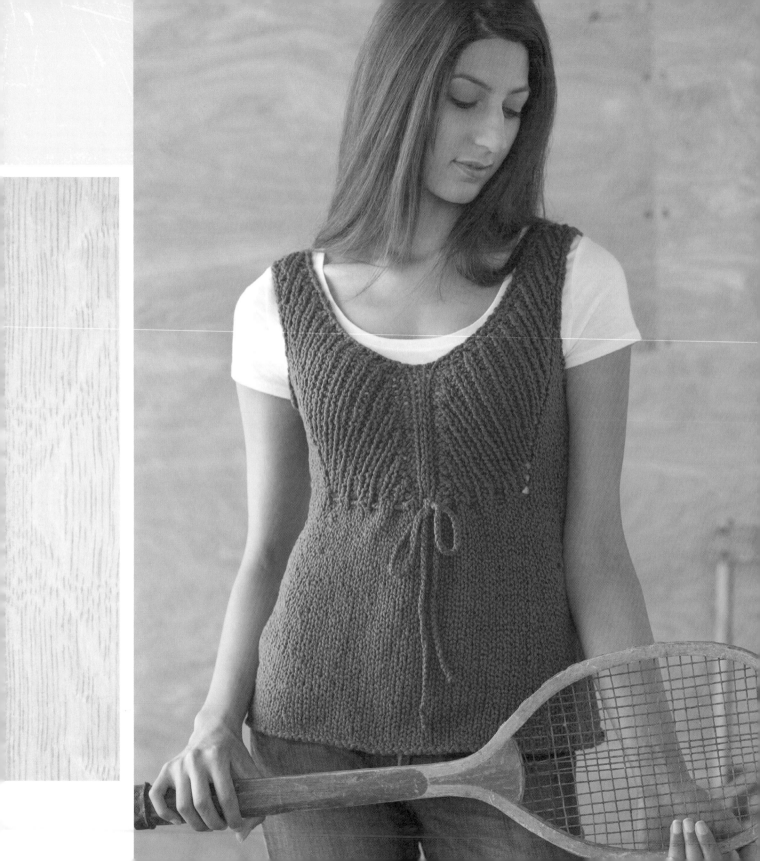

organic sprout
TANK

designed by:
Pam Allen

Sprout, a 100 percent organic cotton yarn with a pleasing pebbly texture, is on the bulky end of Classic Elite Yarn's Verde (that's "green" in Italian) line. **Pam Allen** used this yarn to advantage in her swingy summer top that features a diagonal stitch pattern, deep V-neck, and drawstring detail. Pam worked the body in the round to the armholes, then worked the back and front separately to the shoulders, incorporating the neck and armhole edging along the way. Sew the shoulder seams and you're done!

Finished Size

31¼ (34¾, 39, 43¼)" (79.5 [88.5, 99, 110] cm) bust circumference.
Tank shown measures 31¼" (79.5 cm).

Yarn

Chunky weight (#5 Bulky).
SHOWN HERE: Classic Elite Sprout (100% organic cotton; 109 yd [100 m]/100 g): #4355 sassafras tea, 3 (4, 4, 5) balls.

Needles

Size U.S. 9 (5.5 cm): 24" (60 cm) circular (cir). Adjust needle size if necessary to obtain the correct gauge.

Notions

Markers (m); stitch holders or waste yarn; size H/8 (5 mm) crochet hook; tapestry needle.

Gauge

12 stitches and 18 rows/rounds = 4" (10 cm) in stockinette stitch; 15 (17, 19, 21) stitches of each diagonal rib section in bodice measure about 4½ (5, 5¾, 6½)" (11.5 [12.5, 14.5, 16.5] cm) wide (see Notes).

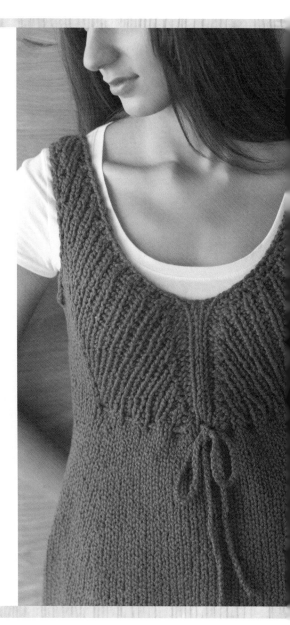

M1yo:

Insert the tip of the left needle underneath the strand between the two needles from front to back and lift the strand onto the left needle. Knit the lifted strand through the front loop—1 st increased. **note:** The M1yo increase does not twist the lifted strand at its base like an ordinary M1 increase; the new stitch should appear to have a yarnover hole at its base.

Left Diagonal Rib (odd number of sts)

RND 1: M1yo, *p1, k1; rep from * to last 3 sts, p1, ssk.

RND 2: K1, *p1, k1; rep from *.

RND 3: M1yo, *k1, p1; rep from * to last 3 sts, k1, ssp (see Glossary).

RND 4: P1, *k1, p1; rep from *.

Repeat Rnds 1–4 for patt.

Right Diagonal Rib (odd number of sts)

RND 1: K2tog, *p1, k1; rep from * to last st, p1, M1yo.

RND 2: K1, *p1, k1; rep from *.

RND 3: P2tog, *k1, p1; rep from * to last st, k1, M1yo.

RND 4: P1, *k1, p1; rep from *.

Repeat Rnds 1–4 for patt.

NOTES

- The peplum and bodice sections are worked in the round to the underarms, then divided for working the front and back separately in rows.
- When working the diagonal rib patterns back and forth in rows, work the stitches as they appear on WS rows, maintaining the alternation of knits and purls.
- To check the gauge of the diagonal rib patterns, do not measure along the bias lines of the ribs. Instead, lay a ruler horizontally across the rib section, parallel to the plain stockinette rounds, and measure the distance between the stitches on each side of the rib pattern.

Peplum

CO 120 (132, 144, 156) sts. Place marker (pm) and join for working in rnds, being careful not to twist sts; rnd beg at start of back sts. Knit 4 (6, 2, 4) rnds.

NEXT RND: *K13 (15, 16, 18), k2tog, pm for dart, k30 (32, 36, 38), pm for dart, ssk, k13 (15, 16, 18), pm for side "seam"; rep from * once more, omitting last pm because end-of rnd m is already in place—116 (128, 140, 152) sts; 58 (64, 70, 76) sts each for front and back.

Knit 5 rnds.

NEXT RND: *Knit to 2 sts before dart m, k2tog, sl m, k30 (32, 36, 38), sl m, ssk, knit to side m, sl m; rep from * once more—4 sts dec'd; 2 sts each from front and back.

Rep the last 6 rnds 5 (5, 6, 6) more times, removing dart markers as you come to them in the final dec rnd, but leaving side and end-of-rnd-m in place—92 (104, 112, 124) sts rem; 46 (52, 56, 62) sts each for front and back; piece measures about 9 (9½, 10, 10½)" (23 [24, 25.5, 26.5] cm) from CO.

Bodice

*K6 (7, 7, 8), pm, work Rnd 1 of Left Diagonal Rib patt (see Stitch Guide) over 15 (17, 19, 21) sts, pm, p1, k2, p1, pm, work Rnd 1 of Right Diagonal Rib patt (see Stitch Guide) over 15 (17, 19, 21) sts, pm, k6 (7, 7, 8), sl side m; rep from * once more.

Working sts outside diagonal rib sections in St st, work 3 rnds, ending with Rnd 4 of rib patts.

INC RND: K2, M1 (see Glossary), work in patt as established to 2 sts before side-seam m, M1, k2; rep from * once more—4 sts inc'd; 2 sts each in front and back.

[Work 7 rnds even in established patts, then rep the inc rnd] 1 (1, 2, 2) time(s), working new sts in St st—100 (112, 124, 136) sts; 50 (56, 62, 68) sts each for front and back arranged as 8 (9, 10, 11) St sts at each side, 2 diagonal rib sections of 15 (17, 19, 21) sts each, and 4 center sts as [p1, k2, p1]. Cont in patts until bodice measures 4½ (4¾, 5, 5)" (11.5 [12, 12.5, 12.5] cm), measured straight up along a k2 column at center front or back—piece measures about 13½ (14¼, 15, 15½)" (34.5 [36, 38, 39.5] cm) from CO.

Back

ROW 1: (RS) BO 3 (4, 4, 5) sts, knit to m, sl m, M1yo, work rib sts as they appear (knit the knits and purl the purls) to last 2 rib sts, sl 2 sts to right-hand needle, remove m, return slipped sts to left-hand needle and p3tog (last 2 sts of rib section tog with purl st after them), k1, join second ball of yarn at center, k1, sl 1, remove m, return slipped st to left-hand needle, sssp (purl st tog with first 2 sts of rib section; see Glossary), work sts as they appear to end of rib section, M1yo (see Stitch Guide), sl m, knit to side m, place next 50 (56, 62, 68) sts on holder for front.

Cont back and forth in rows on back sts as foll:

ROW 2: (WS) For first group of sts, BO 3 (4, 4, 5) sts, work sts as they appear to last 2 sts, k1, p1; for second group, p1, k1, work sts as they appear to end—21 (23, 26, 28) sts rem at each side.

ROW 3: For first group, BO 2 (2, 3, 3) sts, knit to rib section, M1yo, work sts as they appear to last 4 sts, p3tog, k1; for second group, k1, sssp, work sts as they appear to end of rib section, M1yo, knit to end.

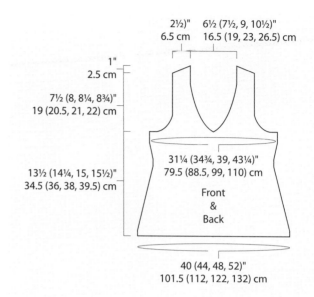

2½)"
6.5 cm

6½ (7½, 9, 10½)"
16.5 (19, 23, 26.5) cm

1"
2.5 cm

7½ (8, 8¼, 8¾)"
19 (20.5, 21, 22) cm

31¼ (34¾, 39, 43¼)"
79.5 (88.5, 99, 110) cm

Front
&
Back

13½ (14¼, 15, 15½)"
34.5 (36, 38, 39.5) cm

40 (44, 48, 52)"
101.5 (112, 122, 132) cm

ROW 4: For first group, BO 2 (2, 3, 3) sts, work sts as they appear to last 2 sts, k1, p1; for second group, p1, k1, work sts as they appear to end—18 (20, 22, 24) sts at each side.

ROW 5: For first group, sl 1 kwise wyb, k1, pass slipped st over (psso), knit to rib section, M1yo, work sts as they appear to last 4 sts p3tog, k1; for second group, k1, sssp, work sts as they appear to end of rib section, M1yo, knit to end.

ROW 6: For first group, sl 1, kwise wyf, p1, psso, work sts as they appear to last 2 sts, k1, p1; for second group, p1, k1, work sts as they appear to end—16 (18, 20, 22) sts at each side; 2 St sts rem outside rib patts at each armhole edge.

ROW 7: For first group, k1, p1, M1yo, work sts as they appear to last 4 sts, p3tog, k1; for second group, k1, sssp, work sts as they appear to last 2 sts, M1yo, p1, k1—1 st dec'd at each neck edge.

ROW 8: For first group, p1, k1, work sts as they appear to last 2 sts, k1, p1; for second group, p1, k1, work sts as they appear to last 2 sts, k1, p1.

Rep Rows 7 and 8 three (five, nine, eleven) more times—12 (12, 10, 10) sts rem at each side.

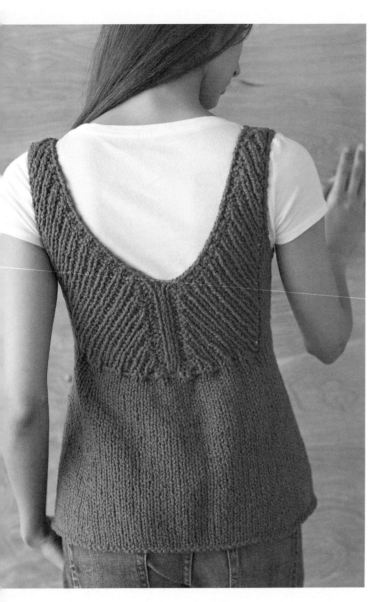

NEXT ROW: For first group, k1, p1, M1yo, work sts as they appear to last 4 sts, work p2tog or k2tog as necessary to maintain patt, p1, k1; for second group, k1, p1, work ssp or ssk as necessary to maintain patt, work sts as they appear to last 2 sts, M1yo, p1, k1—no change to st count.

NEXT ROW: Rep Row 8.

NEXT ROW: Rep Row 7—1 st dec'd at each neck edge.

NEXT ROW: Rep Row 8.

Cont in patt, rep the last 4 rows 3 (3, 1, 1) more time(s)—8 sts rem at each side for all sizes. Work even with no change to st count until armholes when slightly stretched measure 7½ (8, 8¼, 8¾)" (19 [20.5, 21, 22] cm) from dividing row, ending with a WS row. At each armhole edge, BO 4 sts 2 times—no sts rem.

Front

Return 50 (56, 62, 68) sts held front sts to needle and rejoin yarn with RS facing. Work as for back, except that Row 1 will finish by knitting to the end of the sts on the needle (not to the side m), and there will be no sts to place on a holder.

Finishing

With yarn threaded on a tapestry needle, sew shoulder seams. Block to measurements. Weave in loose ends.

Tie

With crochet hook, work a crochet chain (see Glossary) about 60" (152.5 cm) long for all sizes. Place last loop of chain on holder; do not cut yarn. Beg at center front, thread the starting end of the crochet chain in and out of first row of the diagonal rib section on right front, bring tie to WS and pass it across the WS of the St sts at right side of body, bring tie to RS again at beg of diagonal rib on right back, thread chain in and out of first row of both diagonal rib and center sections of back, bring tie to WS at end of diagonal rib at left back and pass it across the WS of the St sts at left side of body, bring tie to RS again at start of diagonal rib on left front, and thread chain in and out of first row of rib section to end at center front. Try on tank and adjust tie to where the best fit is achieved. Lengthen or shorten tie for the desired effect, then fasten off last st. Weave ends of tie back into chain.

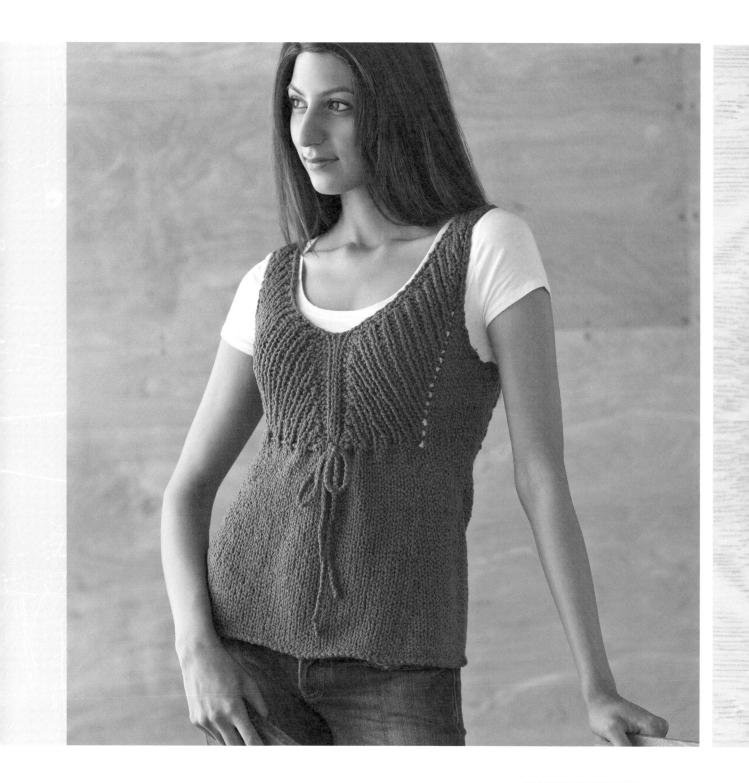

ode to sheep

essay by:
Kristin Nicholas
Sheep Farmer and Knitwear Designer

Like many knitters, I fell in love with the romance of sheep—with their curly locks, their soft white color that's the perfect shade of cream, the rich feel of the lanolin that remains in some favorite yarns, and the smell of wet wool on a rainy day. I was enamored with the fluffy, cloud-like sweet creatures dotting the hilly landscapes I saw in travel magazines about Great Britain. About thirty years ago, my husband and I bought some sheep and began living our dream. We now have more than 200 sheep on our farm in western Massachusetts. But the dream is much different than I envisioned. Living with sheep is real life at its rawest. It is full of ups and downs, sadness and joy, hard work, and plenty of challenges.

Our farm is not certified organic, but our practices are mostly green. We do not vaccinate our sheep (it's far too expensive for the random benefit), and we only treat for worms and administer penicillin when necessary. We've chosen Romney and Romney crossbreeds that thrive in the moist, cold New England climate, so we don't need to treat for foot rot (dipping hooves in a copper solution). What we *do* do: we provide our sheep with plenty of fresh grass and water and plenty of grazing land. In the winter months, we feed them hay that we've grown ourselves, and we only give grain as a protein supplement to milking ewes.

While we do lose some animals to disease, not to mention persistent coyotes, our farm is not much different than the sheep farms that used to dot the landscape during Colonial times. We use the sheep to reclaim acres of overgrown pastures where they eat the undergrowth, neatly trimming unwanted growth. In so doing, they deposit their manure, providing organic fertilizer right where it's needed. After the sheep have done their work, my husband, Mark, moves in with his chain saw to remove overgrown trees. In no time, the grass begins to grow. When it's the proper length, the sheep are brought in to graze again. The cycle of intensive grazing and depositing manure returns an overgrown pasture to agricultural use. What could be better for the earth?

Although many knitters may not want to think about it, most sheep are raised for food, and wool is a secondary product. The meat is the primary crop. Lamb and mutton provide a major source of protein for many parts of the world; the United States is one of the few locations where lamb and mutton are not primary food sources. My family and I are trying to change that, selling frozen lamb meat to restaurants and to "foodies" who visit the local farmer's markets and our self-serve farm store, where we also sell fleeces.

Sheep also produce milk that in many parts of the world is turned into fabulous cheeses, including true French Roquefort, Italian Pecorino Romano, Greek feta, and Spanish Manchego cheese, and yogurt. In Vermont, not far from us, several sheep farmers are making world-class sheep's milk cheese, including Vermont Shepherd.

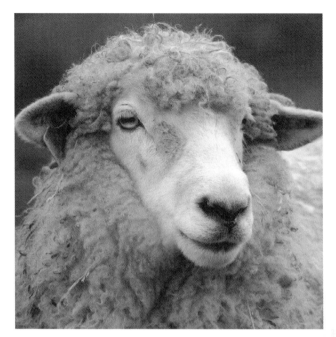

Wooly sheepskins are used for rugs, coats, shoes, bed pads for the infirm, and insulating weather-proof walls of yurts. The intestines or "guts" are cleaned and made into casings for sausages, strings for musical instruments and tennis racquets, and sutures. Lanolin (the greasy substance found in the wool) is used for cosmetics, skin creams, and pharmaceuticals. The fat (or tallow) is used for soap and candles. The hooves and bones are used to manufacture gelatin, piano keys, pet food, glue, bone meal for fertilizer, cellophane wrap and tape, buttons, laminated wood products, bone china, wallpaper paste, combs, toothbrushes, and more. In short, nothing is wasted. And all of this on a diet of pure green grass and water.

Next time you marvel at the soft and fluffy sheep in the show ring at a fiber festival, thank that little animal for all that it gives mankind and thank the shepherds who devote their lives to keeping the sheep population healthy and vital so that we can all benefit from their goodness.

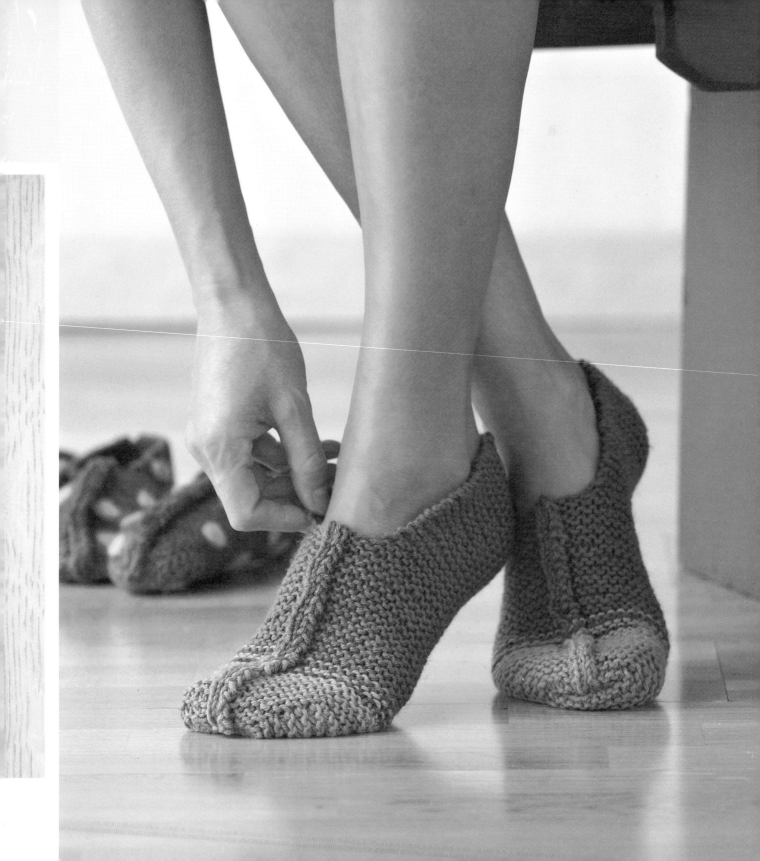

save-the-streams
SLIPPERS

designed by:
Kim Hamlin

Kim Hamlin knows that a no-shoes-in-the-house policy keeps floors clean and ultimately reduces the amount of cleaning products that get dumped down household drains. But, confesses Kim, it's one thing to ask family to partake in no-shoe zones; it's quite another to ask the same of guests. She therefore suggests keeping an inviting basket of slippers in all sizes at the door. Kim knitted these simple garter-stitch slippers with Sweet Earth from Himalaya Yarns, a pure wool yarn that is dyed naturally (with just alum as a mordant) to protect the waterways.

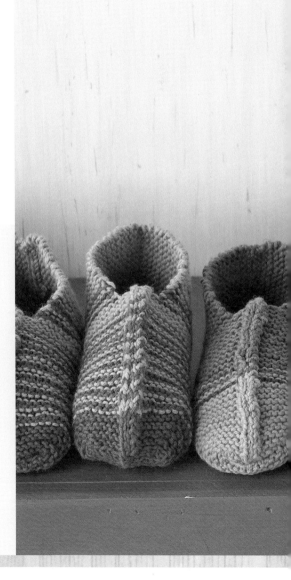

Finished Size
About 5 (7, 8, 9½, 10½, 11½)" (12.5 [18, 20.5, 24, 26.5, 29] cm) long; to fit child small (child medium, child large/adult small, adult medium, adult large, adult extra large).

Yarn
Worsted weight (#4 Medium).

SHOWN HERE: Himalaya Yarn Sweet Earth (100% wool; 190 yd [173 m]/100 g): 1 (1, 1, 1, 1, 2) skein(s). Shown in leaf (green), bark (brown), henna (orange), sky (light blue), pomegranate (red), tameric (gold), and mulberry (purple).

Needles
Size U.S. 5 (3.75 mm). Adjust needle size if necessary to obtain the correct gauge.

Notions
Tapestry needle; puff paint (optional; available at craft stores); needle-felting tools and cardboard for template (optional).

Gauge
20 stitches and 40 rows = 4" (10 cm) in garter stitch.

SIZE CHART

	CHILD SMALL	CHILD MEDIUM	CHILD LARGE/ ADULT SMALL	ADULT MEDIUM	ADULT LARGE	ADULT X-LARGE
U.S. SHOE SIZE:						
Children's	2–5½	7½–11½	12–1½			
Women's			3–5	6–8	9–11	
Men's			1–2	3½–6½	8–9½	11–12½
Foot Length	4–5" (10–12.5 cm)	6"–7" (15–18 cm)	7½"–8" (19–20.5 cm)	8½"–9½" (21.5–24 cm)	10"–10½" (25.5–26.5 cm)	11"–11½" (28–29 cm)
Finished Length	5" (12.5 cm)	7" (18 cm)	8" (20.5 cm)	9½" (24 cm)	10½" (26.5 cm)	11½" (29 cm)
Yards Required	55	80	105	145	160	200
Meters Required	50	73	96	133	146	183

NOTES

• Each slipper begins at the center back heel. After working the length of the foot opening, stitches are cast on at each side for the top of the foot. After completing the instep, stitches are decreased for the toe. The finished slipper is folded in half down the center (dotted line on schematic), and seams are sewn for the instep, heel, and toe.

• Change colors randomly to make the best use of small amounts of yarn. For sharp boundaries between colors, change colors on right-side rows; for blended colors, change colors on wrong-side rows.

• Because both sides of the garter-stitch fabric look identical, you may find it helpful to mark one side as the RS with waste yarn as an aid to changing colors and working the shaping.

• Add puff-paint lines or designs to soles of slippers for nonskid bottoms on slippery floors.

Slipper

Heel

CO 22 (24, 28, 34, 38, 42) sts. Work in garter st (knit every row) until piece measures 2 (2¾, 3½, 4, 4½, 5)" (5 [7, 9, 10, 11.5, 12.5] cm) from CO, ending with a RS row.

Foot

With WS facing, use the knitted method (see Glossary) to CO 4 sts, knit across these 4 new sts, then knit to end—26 (28, 32, 38, 42, 46) sts.

NEXT ROW: (RS) Use the knitted method to CO 4 sts, purl the first 2 new sts, knit the next 2 new stitches, knit to last 2 sts, p2—30 (32, 36, 42, 46, 50) sts; 2 rev St sts (purl on RS; knit on WS) at each side.

NEXT ROW: (WS) Knit.

NEXT ROW: P2, knit to last 2 sts, p2.

Rep the last 2 rows until piece measures 4¼ (6¼, 7¼, 8½, 9½, 10½)" (11 [16, 18.5, 21.5, 24, 26.5] cm) from CO, ending with a WS row.

Toe

ROW 1: (RS) P2, k3 (4, 5, 6, 7, 8), k2tog, ssk, k12 (12, 14, 18, 20, 22), k2tog, ssk, k3 (4, 5, 6, 7, 8), p2—26 (28, 32, 38, 42, 46) sts rem.

ROWS 2, 4, AND 6: Knit.

ROW 3: P2, k2 (3, 4, 5, 6, 7), k2tog, ssk, k10 (10, 12, 16, 18, 20), k2tog, ssk,k2 (3, 4, 5, 6, 7), p2—22 (24, 28, 34, 38, 42) sts rem.

ROW 5: P2, k1 (2, 3, 4, 5, 6), k2tog, ssk, k8 (8, 10, 14, 16, 18), k2tog, ssk, k1 (2, 3, 4, 5, 6), p2—18 (20, 24, 30, 34, 38) sts rem.

ROW 7: P2, k0 (1, 2, 3, 4, 5), k2tog, ssk, k6 (6, 8, 12, 14, 16), k2tog, ssk, k0 (1, 2, 3, 4, 5), p2—14 (16, 20, 26, 30, 34) sts rem; piece measures about 5 (7, 8, 9¼, 10¼, 11¼)" (12.5 [18, 20.5, 23.5, 26, 28.5] cm) from CO.

Cont for your size as foll:

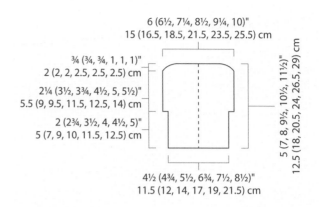

6 (6½, 7¼, 8½, 9¼, 10)"
15 (16.5, 18.5, 21.5, 23.5, 25.5) cm

¾ (¾, ¾, 1, 1, 1)"
2 (2, 2, 2.5, 2.5, 2.5) cm

2¼ (3½, 3¾, 4½, 5, 5½)"
5.5 (9, 9.5, 11.5, 12.5, 14) cm

2 (2¾, 3½, 4, 4½, 5)"
5 (7, 9, 10, 11.5, 12.5) cm

5 (7, 8, 9½, 10½, 11½)"
12.5 (18, 20.5, 24, 26.5, 29) cm

4½ (4¾, 5½, 6¾, 7½, 8½)"
11.5 (12, 14, 17, 19, 21.5) cm

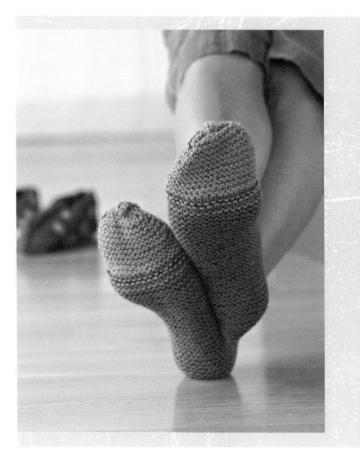

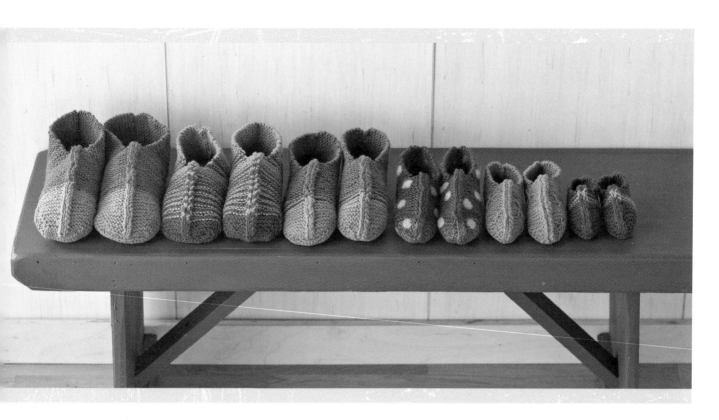

Sizes child small (child medium, child large/adult small) only

BO all sts.

Sizes (adult medium, adult large, adult x-large) only

ROW 8: Knit.

ROW 9: P2, k(2, 3, 4), k2tog, ssk, k(10, 12, 14), k2tog, ssk, k(2, 3, 4), p2—(22, 26, 30) sts rem.

ROW 10: BO all sts—piece measures about (9½, 10½, 11½)" ([24, 26.5, 29] cm) from CO.

Finishing

If desired, add embellishments as described on page 137. Fold slipper in half along dotted line shown on schematic and use the mattress stitch with a 1-st seam allowance (see Glossary) to sew instep seam from toe BO row to edge of foot opening, allowing the 1-st rev St st selvedges to roll to the outside; BO edge of toe will rem open. Turn slipper inside out and use backstitches (see Glossary) with as small a seam allowance as possible (to reduce bulk) to sew the two halves of CO edge tog for heel seam, then sew the two halves of BO edge tog for toe seam.

Weave in loose ends. Block if desired.

embellishment

Make sure to apply embellishments to the right side of the slippers so the decoration will be on the outside.

Needlefelting

Cut a circle, letter, or random shape of the desired size out of a piece of cardboard to make a template. Place template on top of RS of slipper and needlefelt contrasting yarn into the open space of the template until filled. Repeat as often as desired on slipper, in random or orderly arrangement.

Embroidery

With contrasting yarn threaded on a tapestry needle, embroider snowflakes, lightning bolts, flowers, spirals, etc., on RS of slipper as desired. Secure embroidery yarn ends securely on WS.

Other Ideas

Add buttons, crochet flowers, leather soles, etc., as desired.

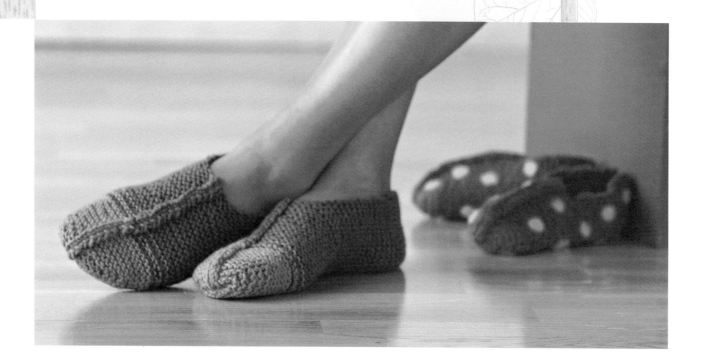

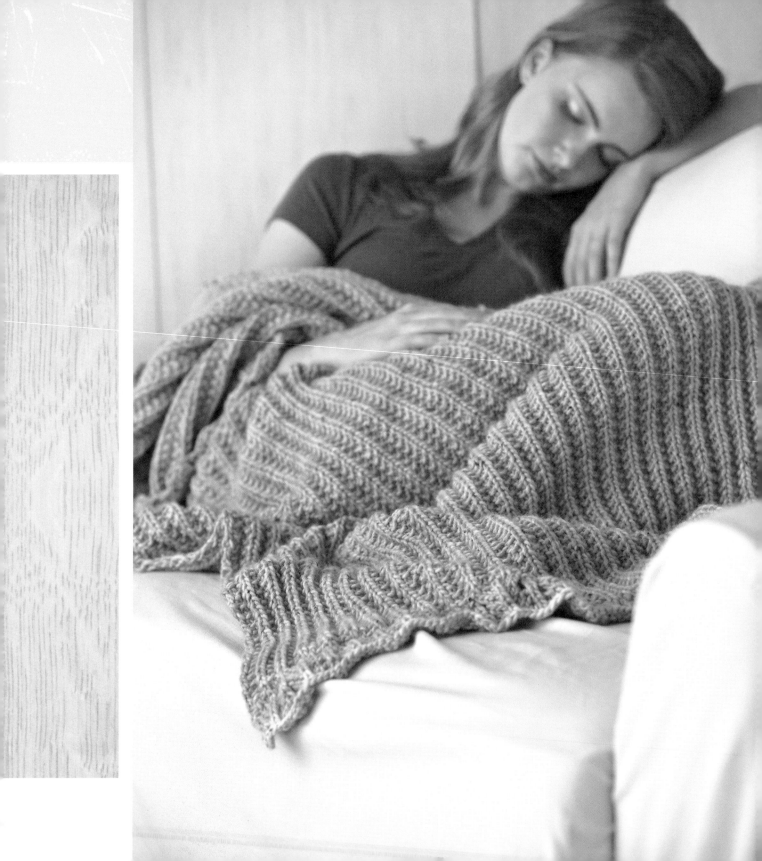

blue cloud
AFGHAN

designed by:
Ann Budd

Instead of turning up the thermostat when the temperature plunges, **Ann Budd** likes to snuggle under a lightweight blanket. The yarn she chose for this afghan is a luxurious handpainted mix of merino, alpaca, silk, and Donegal produced by Araucanía Yarns, a group of artists and designers dedicated to supporting local sustainable job development in Chile. The afghan begins and ends with a simple lace pattern; the center is worked in mistake rib to produce a lofty texture that is extra insulating and has excellent drape.

Finished Size
About 42" (106.5 cm) wide and 54" (137 cm) long. **note:** There is plenty of widthwise and lengthwise stretch in this fabric.

Yarn
Chunky weight (#5 Bulky).

SHOWN HERE: Araucanía Azapa (45% merino, 30% alpaca, 15% silk, 10% Donegal; 197 yd [180 m]/100 g): #804 sky, 9 skeins.

Needles
Size U.S. 11 (8 mm): 24" (60 cm) circular (cir). Adjust needle size if necessary to obtain the correct gauge.

Notions
Tapestry needle.

Gauge
14 stitches and 18 rows = 4" (10 cm) in mistake rib pattern.

Afghan

Use the cable method (see Glossary) to CO 153 sts. Alternate 2 rows each from 2 skeins of yarn throughout (see Note). Work edging as foll:

ROW 1: (RS) *K1, yo, k2, sl 2 sts tog kwise, k1, p2sso, k2, yo; rep from * to last st, k1.

ROW 2: (WS) K1, purl to last st, k1.

Rep these 2 rows 2 more times, then work Row 1 once more—7 rows total.

DEC ROW: (WS) K1, purl to last st and *at the same time* dec 6 sts evenly spaced, k1—147 sts rem.

SET-UP ROW: *K2, p2; rep from * to last 3 sts, k2, p1.

Rep this row for both RS and WS rows until piece measures about 52" (132 cm) from CO, or 2" (5 cm) less than desired total length, ending with a WS row.

INC ROW: (WS) K1, purl to last st and *at the same time* inc 6 sts evenly spaced, k1—153 sts.

Rep Rows 1 and 2 of edging 3 times, then work Row 1 once more. With WS facing, BO all sts.

Finishing

Weave in loose ends. Block lightly, pulling out scallops in edging.

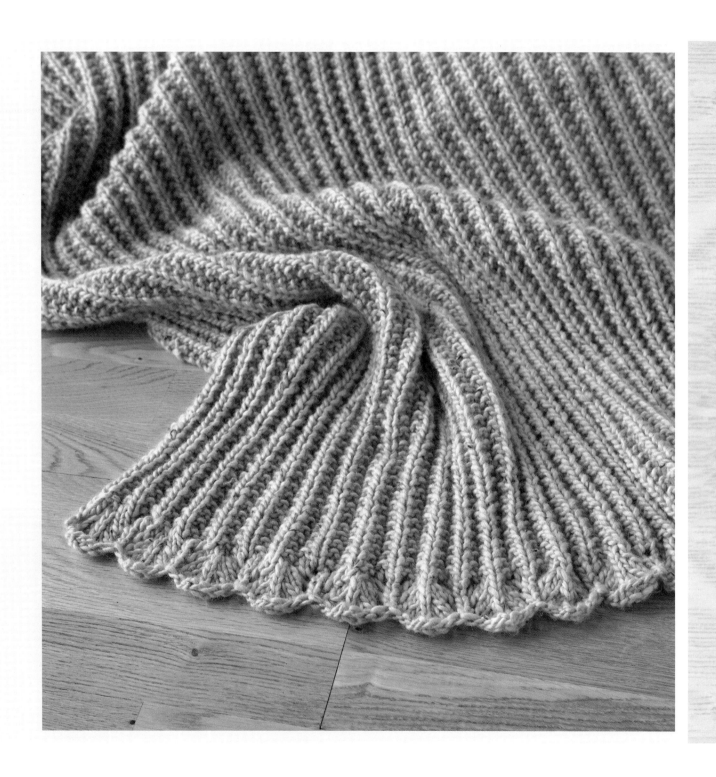

BLUE CLOUD AFGHAN 141

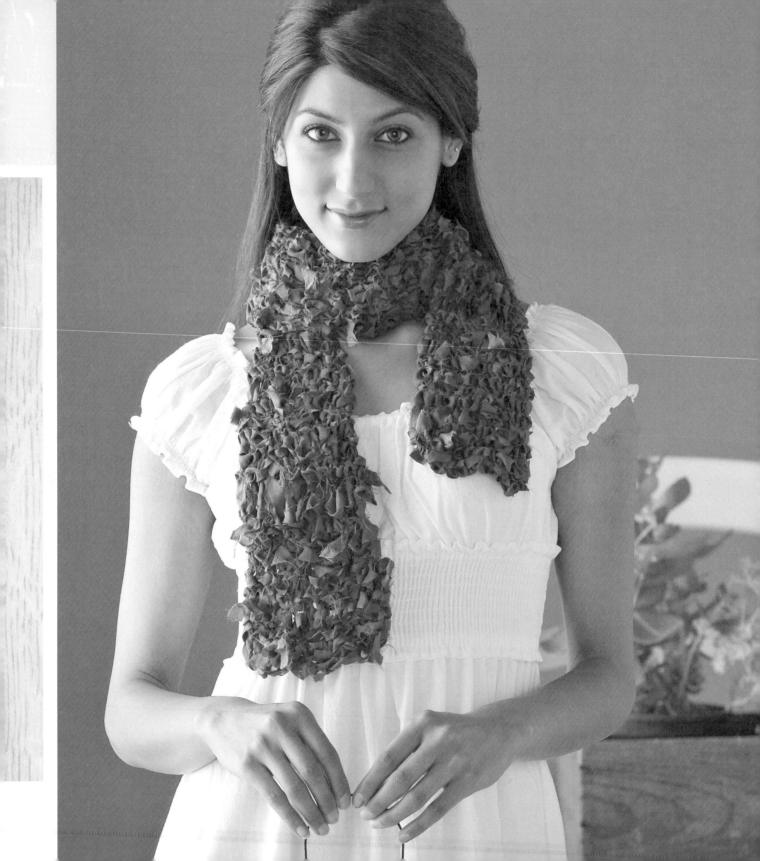

paris
RECYCLED

designed by:
Mags Kandis

For **Mags Kandis,** being green is less about acquiring new things with green labels and more about repurposing and re-creating the things she has already amassed. On her first trip to Paris, Mags purchased a smoky blue silk skirt encircled with tiny knife-edge pleats. But after a few years, the allure of a high-maintenance piece of clothing faded, and Mags tossed it in the wash. Without the pleats, the skirt was never the same. Mags cut the skirt into strips that she tied together and knitted into a scarf that will always remind her of Paris.

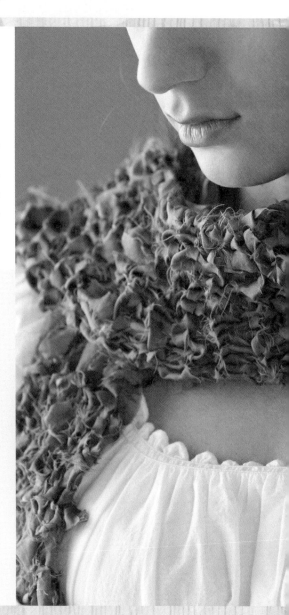

Finished Size

About 5½" (14 cm) wide and 44" (112 cm) long.

Yarn

Lightweight silk fabric cut into strips about ½" to ¾" (1.3 to 2 cm) wide and about 4 to 5 yards (3.75 to 4.5 m) of strips for every 4" (10 cm) of scarf length.

SHOWN HERE: Mags's skirt liberated two lengths of fabric, each measuring about 36" (91.5 cm) long and 45" (114.5 cm) wide with a total weight of 50 grams.

Needles

Size U.S. 15 (10 mm).

Notions

Seam ripper; rotary cutter; metal straight-edge or heavy ruler; self-healing cutting mat; medium-weight fusible interfacing cut to 2½" (6.5 cm) wide and 1½" (3.8 cm) tall for label (optional); sharp-point sewing needle and thread for embroidery and attaching label (optional).

Gauge

About 9½ stitches = 4" (10 cm) in garter stitch. Exact gauge is not critical for this project.

Transform the Garment into Yarn

To begin, remove any details from the garment you do not want to use, such as the waistband, pockets, or zipper. Use a seam ripper to open at least one side of the garment so you have a flat piece from which to cut the strips. Fold the piece widthwise several times so that it is narrower than the length of your straightedge. Place the folded garment on a self-healing mat and lay the straightedge at a 90-degree angle across the fabric. With the straightedge as a guide, use the rotary cutter to cut through all layers to produce strips that vary randomly from ½" to ¾" (1.3 to 2 cm) wide. Knot individual strips together with overhand knots, leaving tails of varying lengths, and roll the knotted strips into a ball.

Scarf

Loosely CO 13 sts. Work in garter stitch (knit all sts every row), inserting 2 rows dropped-stitch patt (see Stitch Guide) randomly every 3" to 6" (7.5 to 15 cm), until piece measures desired length or about 24" (61 cm) of "yarn" strips rem. Loosely BO all sts.

Finishing

Trim the CO and BO ends to lengths similar to the tails of the overhand knots.

Label (optional)

Iron fusible interfacing onto scrap of fabric according to manufacturer's recommendations. Cut the interfaced fabric to the desired size and decorate as desired with embroidery or fabric ink on alphabet stamps. With sharp-point sewing needle and thread, sew label to scarf.

too much of a good thing?

essay by:
Amy R. Singer
Editor of Knitty.com

A skein of yarn is a promise of what might be, and that's what makes it so appealing—potential. It's no mystery, then, why we knitters collect yarn, even with no immediate plan to use it. Some yarn just needs to be in your stash, and you plan to figure out what it wants to be later on.

Except when you don't. Then yarn potential starts to become yarn guilt. Yarn that you can't find a project for, that's leftover from your latest project, or that you've lost interest in turns potential into punishment. How can you buy more yarn if your stash is overflowing? More important, since yarn is a resource that consumes energy in every step of its production, how can you make sure that energy isn't wasted?

It's simple. Expand your yarn framework. Give yarn to a friend, a school, or a community center. Groups such as the Girl Scouts often have knitting projects, or your local guild may know of organizations that would love your castoffs. Or have a yarn swap party. Ask friends to bring their yarny regrets, mistakes, and changes of taste. What looks "blech" to you could be another knitter's dream yarn.

Maybe you like the yarn you have; you just don't want to knit it. Here are a few suggestions:

Braid a rug.

Use the colors you chose for a sweater or afghan and turn them into a braided rug unlike anything you'd find in a store. Better yet, use your needles or an I-cord machine to turn ball after ball into yards of I-cord. Coil the first few inches into a flat circle or oval and secure with strong thread using tiny stitches. Keep making I-cord and stitching it in a spiral until the rug is big enough. And if you have kids, let them make the I-cord!

Weave your cares away.

Invest in a small, affordable 10" to 20" (25.5 to 51 cm) loom and turn your knitting yarn into woven goods. In no time, you'll have cloth for scarves, wraps, rugs, bed coverings, or even garments.

Go back to nature.

For really small amounts of leftover yarn, cut it up into pieces a few inches long. Take your favorite kid for an early spring walk in the woods and drape strands over branches here and there. Then come back a few weeks later and see if the two of you can spot your yarn woven into the nests of birds.

Once you put the needles aside, finding a use for yarn you no longer want to knit becomes an enjoyable challenge, not a curse. And you get to watch the guilt disappear.

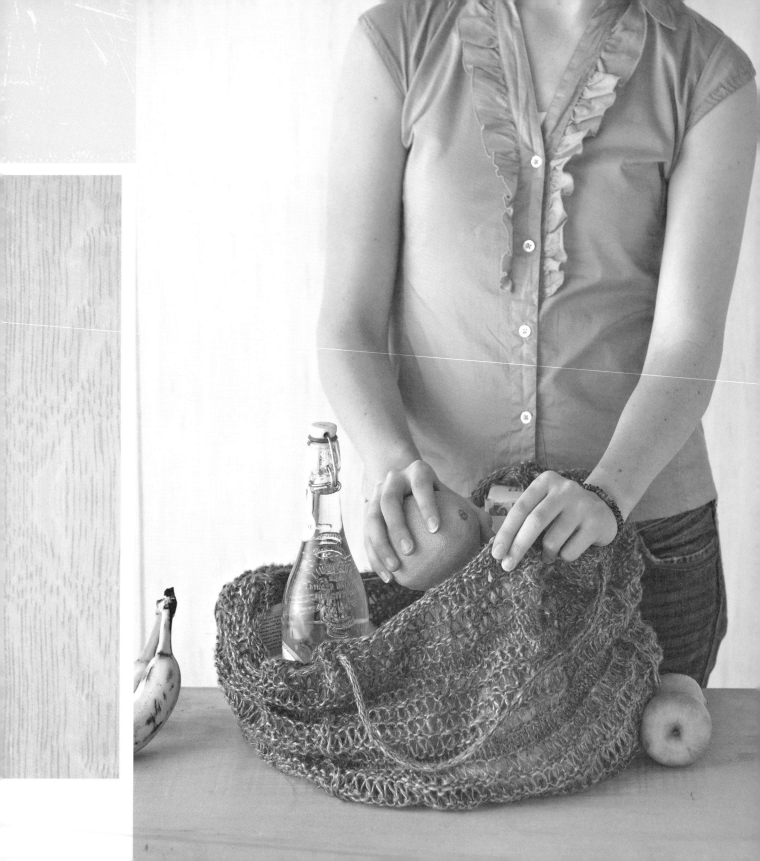

green
GROCERY BAG

designed by:
Ann Budd

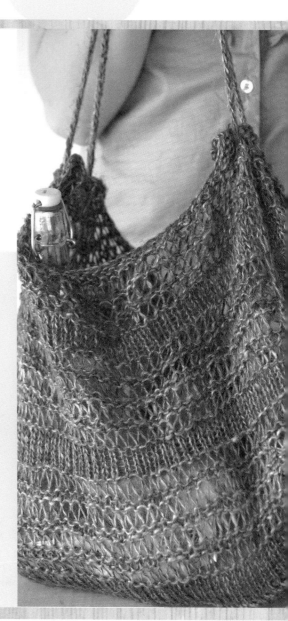

Ann Budd has been reusing shopping bags for years, only recycling them when the bottoms fall out or the sides split. Enter her grocery bag knitted out of durable and renewable linen. Ann began by knitting a garter-stitch rectangle for the base, then she picked up stitches around the edges of the base and knit the sides in the round to the top in drop-stitch pattern on large needles. She threaded I-cord through the uppermost drop-stitches for a drawstring handle that keeps the contents secure.

Finished Size

About 13" (33 cm) wide and 6¾" (17 cm) deep at upper edge, and 13¼" (33.5 cm) tall; rectangular base measures about 6¼" (16 cm) by 11" (28 cm).

Yarn

Chunky weight (#5 Bulky).

SHOWN HERE: Louet Euroflax Chunky Weight (100% linen; 150 yd [137 m]/100 g): #95 bark chips, 2 skeins.

Needles

Size U.S. 9 (5.5 mm): 24" (60 cm) circular (cir) and set of 2 double-pointed (dpn). Adjust needle size if necessary to obtain the correct gauge.

Notions

Markers (m); tapestry needle.

Gauge

13 stitches and 28 rows = 4" (10 cm) in garter stitch; 12 stitches and 16 rounds measures 4" (10 cm) wide and 4¼" (11 cm) high in pattern from Rounds 9–24. **note:** Exact gauge is not critical for this project.

RNDS 1, 3, 5, AND 7: *Sl 1 as if to purl with yarn in back (pwise wyb), knit to m; rep from * 3 more times.

RNDS 2, 4, 6, AND 8: Knit.

RND 9: *Sl 1 pwise wyb, purl to m wrapping yarn twice around needle for each st; rep from * 3 more times.

RND 10: *K1, purl to m dropping extra wraps; rep from * 3 more times.

RND 11: *Sl 1 pwise wyb, knit to m; rep from * 3 more times.

RND 12: *K1, purl to m wrapping yarn twice around needle for each st; rep from * 3 more times.

RND 13: *Sl 1 pwise wyb, purl to m dropping extra wraps; rep from * 3 more times.

RND 14: Knit.

RNDS 15–20: Rep Rnds 9–14 once more.

RNDS 21–24: Rep Rnds 1 and 2 two times.

Rep Rnds 9–24 once, then work Rnds 9–14 once, then work Rnds 9 and 10 once more. Purl 1 rnd, knit 1 rnd, purl 1 rnd—piece measures about 13¼" (33.5 cm) from pick-up rnd. BO all sts kwise.

Finishing

Weave in loose ends.

Cord

With dpn, CO 3 sts. Work 3-st I-cord (see Glossary) until piece measures 42" (106.5 cm) from CO. BO all sts. With yarn threaded on a tapestry needle, weave ends into the center of cord. Beg and end in the middle of a short side, thread cord in and out about every 4 sts along top double-yarnover row on both short sides, leaving an unwoven length of cord about 13" (33 cm) long on the outside of each long side for handles. Tie ends of cord in an overhand knot to secure.

Bag

Base

With cir needle, CO 20 sts. Do not join. Working back and forth in rows, knit 76 rows—38 garter ridges; piece measures about 11" (28 cm) from CO.

Sides

With RS facing, pick up and knit sts around all 4 sides of base as foll: Yo, pick up and knit 38 sts across long side (1 st for each garter ridge), place marker (pm), yo, pick up and knit 19 sts across short side, pm, yo, pick up and knit 38 sts along other long side, pm, yo, k18 sts, k2tog—118 sts total; 39 sts along each long side, 20 sts along each short side. Pm and join for working in rnds.

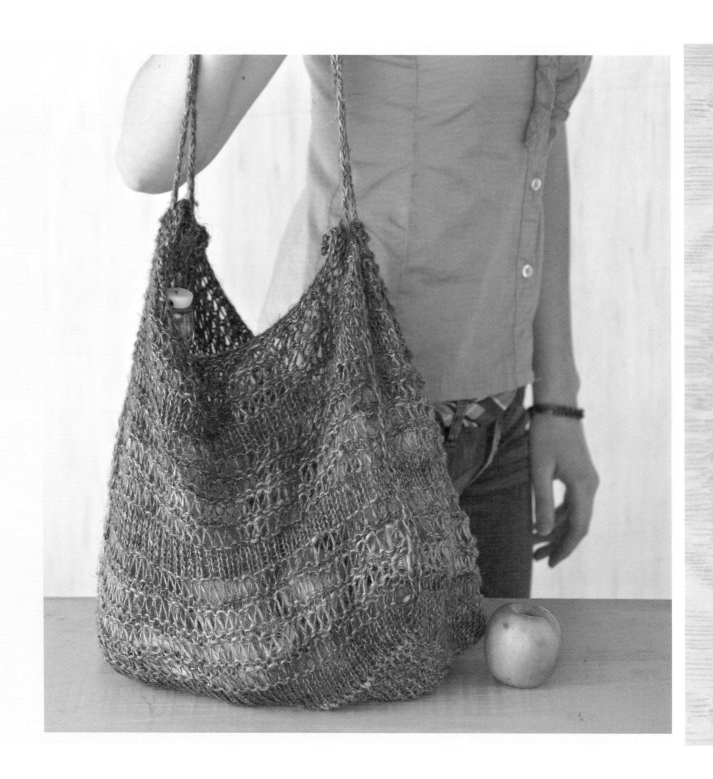

glossary

Abbreviations

beg	begin(s); beginning	M1	make one (increase)	st	stitch(es)
BO	bind off	p	purl	St st	stockinette stitch
CC	contrast color	p1f&b	purl into front and back of same stitch	tbl	through back loop
cm	centimeter(s)			tog	together
cn	cable needle	patt(s)	pattern(s)	WS	wrong side
CO	cast on	psso	pass slipped stitch over	wyb	with yarn in back
cont	continue(s); continuing	pwise	purlwise, as if to purl	wyf	with yarn in front
dec(s)	decrease(s); decreasing	rem	remain(s); remaining	yd	yard(s)
dpn	double-pointed needles	rep	repeat(s); repeating	yo	yarnover
foll	follow(s); following	rev St st	reverse stockinette stitch	*	repeat starting point
g	gram(s)	rnd(s)	round(s)	* *	repeat all instructions between asterisks
inc(s)	increase(s); increasing	RS	right side		
k	knit	sl	slip	()	alternate measurements and/or instructions
k1f&b	knit into the front and back of same stitch	sl st	slip st (slip 1 stitch purlwise unless otherwise indicated)	[]	work instructions as a group a specified number of times
kwise	knitwise, as if to knit	ssk	slip 2 stitches knitwise, one at a time, from the left needle to right needle, insert left needle tip through both front loops and knit together from this position (1 stitch decrease)		
m	marker(s)				
MC	main color				
mm	millimeter(s)				

Bind-Offs

Decrease Bind-Off

Slip the first stitch, knit the second stitch, then *knit these stitches together by inserting the left-hand needle into the front of them from left to right and knitting them together through their back loops with the right needle (Figure 1), then knit the next stitch (Figure 2). Repeat from * for the desired number of stitches.

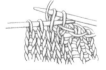

FIGURE 1

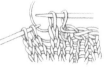

FIGURE 2

Standard Bind-Off

Knit the first stitch, *knit the next stitch (2 stitches on right needle), insert left needle tip into first stitch on right needle (Figure 1) and lift this stitch up and over the second stitch (Figure 2) and off the needle (Figure 3). Repeat from * for the desired number of stitches.

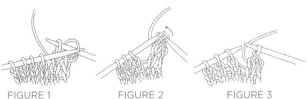

FIGURE 1 FIGURE 2 FIGURE 3

Three-Needle Bind-Off

Place the stitches to be joined onto two separate needles and hold the needles parallel so that the right sides of knitting face together. Insert a third needle into the first stitch on each of two needles (Figure 1) and knit them together as one stitch (Figure 2), *knit the next stitch on each needle the same way, then use the left needle tip to lift the first stitch over the second and off the needle (Figure 3). Repeat from * until no stitches remain on first two needles. Cut yarn and pull tail through last stitch to secure.

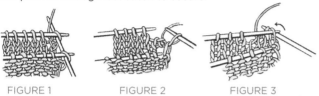

FIGURE 1 FIGURE 2 FIGURE 3

Cast-Ons

Backward-Loop Cast-On

*Loop working yarn and place it on needle backward so that it doesn't unwind. Repeat from *.

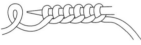

Cable Cast-On

If there are no stitches on the needles, make a slipknot of working yarn and place it on the needle, then use the knitted method to cast-on one more stitch—2 stitches on needle. Hold needle with working yarn in your left hand with the wrong side of the work facing you. *Insert right needle between the first 2 stitches on left needle (Figure 1), wrap yarn around needle as if to knit, draw yarn through (Figure 2), and place new loop on left needle (Figure 3) to form a new stitch. Repeat from * for the desired number of stitches, always working between the first 2 stitches on the left needle.

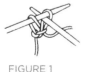 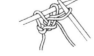 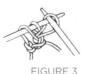

FIGURE 1 FIGURE 2 FIGURE 3

Knitted Cast-On

Make a slipknot of working yarn and place it on the left needle if there are no stitches already there. *Use the right needle to knit the first stitch (or slipknot) on left needle (Figure 1) and place new loop onto left needle to form a new stitch (Figure 2). Repeat from * for the desired number of stitches, always working into the last stitch made.

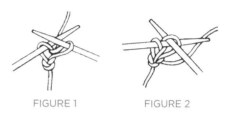

FIGURE 1 FIGURE 2

Long-Tail (Continental) Cast-On

Leaving a long tail (about ½" [1.3 cm] for each stitch to be cast on), make a slipknot and place on right needle. Place thumb and index finger of your left hand between the yarn ends so that working yarn is around your index finger and tail end is around your thumb and secure the yarn ends with your other fingers. Hold your palm upward, making a V of yarn (Figure 1). *Bring needle up through loop on thumb (Figure 2), catch first strand around index finger, and go back down through loop on thumb (Figure 3). Drop loop off thumb and, placing thumb back in V configuration, tighten resulting stitch on needle (Figure 4). Repeat from * for the desired number of stitches.

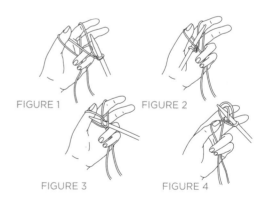

FIGURE 1 FIGURE 2

FIGURE 3 FIGURE 4

Old Norwegian Cast-On

Leaving a long tail (about ½" [1.3 cm] for each stitch to be cast on), make a slipknot and place on right needle. Place thumb and index finger of your left hand between the yarn ends to that working yarn is around your index finger and tail end is around your thumb and secure the yarn ends with your other fingers. Hold your palm upward, making a V of yarn (Figure 1). *Bring needle in front of thumb, under both yarns around the thumb, down into the center of the thumb loop, back forward, and over the top of the yarn around your index finger (Figure 2). Use the needle to catch this yarn, then bring the needle back down through the thumb loop (Figure 3), turning your thumb slightly to make room for the needle to pass through. Drop the loop off your thumb (Figure 4) and place your thumb back in the V configuration while tightening up the resulting stitch on the needle (Figure 5). Repeat from * for the desired number of stitches.

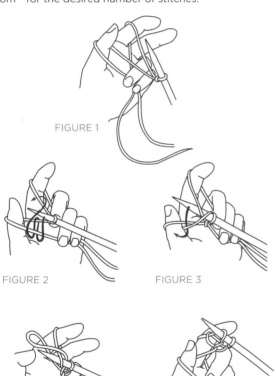

FIGURE 1

FIGURE 2 FIGURE 3

FIGURE 4 FIGURE 5

Invisible Provisional Cast-On

Make a loose slipknot of working yarn and place it on the right needle. Hold a length of contrasting waste yarn next to the slipknot and around your left thumb; hold working yarn over your left index finger. *Bring the right needle forward under waste yarn, over working yarn, grab a loop working yarn (Figure 1), then bring the needle back behind the working yarn and grab a second loop (Figure 2). Repeat from * for the desired number of stitches. When you're ready to work in the opposite direction, place the exposed loops on a knitting needle as you pull out the waste yarn.

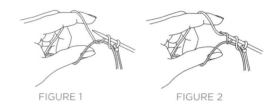

FIGURE 1 FIGURE 2

Crochet

Crochet Chain (ch)

Make a slipknot and place it on crochet hook if there isn't a loop already on the hook. *Yarn over hook and draw through loop on hook. Repeat from * for the desired number of stitches. To fasten off, cut yarn and draw end through last loop formed.

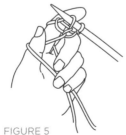

Single Crochet (sc)

*Insert hook into the second chain from the hook (or the next stitch), yarn over hook and draw through a loop, yarn over hook (Figure 1), and draw it through both loops on hook (Figure 2). Repeat from * for the desired number of stitches.

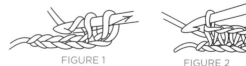

FIGURE 1 FIGURE 2

Slip-Stitch Crochet (sl st cr)

*Insert hook into stitch, yarn over hook and draw a loop through both the stitch and the loop already on hook. Repeat from * for the desired number of stitches.

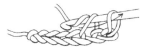

Decreases

Purl 2 Together Through Back Loops (p2togtbl)

Bring right needle tip behind 2 stitches on left needle, enter through the back loop of the second stitch, then the first stitch, then purl them together.

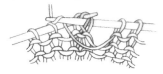

Slip, Slip, Knit (ssk)

Slip 2 stitches individually knitwise (Figure 1), insert left needle tip into the front of these 2 slipped stitches, and use the right needle to knit them together through their back loops (Figure 2).

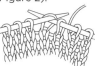 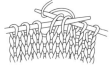

FIGURE 1 FIGURE 2

Slip, Slip, Purl (ssp)

Holding yarn in front, slip 2 stitches individually knitwise (Figure 1), the slip these 2 stitches back onto left needle (they will be twisted on the needle) and purl them together through their back loops (Figure 2).

FIGURE 1 FIGURE 2

Slip, Slip, Slip, Purl (sssp)

Holding yarn in front, slip 3 stitches individually knitwise, then slip these 3 stitches back onto left needle (they will be twisted on the needle) and purl them together through their back loops.

Embroidery

Buttonhole Stitch

Working into the edge half-stitch of the knitted piece, *bring tip of threaded needle in and out of a knitted stitch, place working yarn under needle tip, then bring threaded needle through the stitch and tighten. Repeat from *, always bringing threaded needle on top of working yarn.

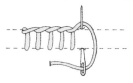

Duplicate Stitch

Bring threaded needle out from back to front at the base of the V of the knitted stitch you want to cover. *Working right to left, pass needle in and out under the stitch in the row above it and back into the base of the same stitch. Bring needle back out at the base of the V of the next stitch to the left. Repeat from * for desired number of stitches.

Grafting

Kitchener Stitch

Arrange stitches on two needles so that there is the same number of stitches on each needle. Hold the needles parallel to each other with wrong sides of the knitting together. Allowing about ½" (1.3 cm) per stitch to be grafted, thread matching yarn on a tapestry needle. Work from right to left as follows:

STEP 1 Bring tapestry needle through the first stitch on the front needle as if to purl and leave the stitch on the needle (Figure 1).

STEP 2 Bring tapestry needle through the first stitch on the back needle as if to knit and leave that stitch on the needle (Figure 2).

STEP 3 Bring tapestry needle through the first front stitch as if to knit and slip this stitch off the needle, then bring tapestry needle through the next front stitch as if to purl and leave this stitch on the needle (Figure 3).

STEP 4 Bring tapestry needle through the first back stitch as if to purl and slip this stitch off the needle, then bring tapestry needle through the next back stitch as if to knit and leave this stitch on the needle (Figure 4).

Repeat Steps 3 and 4 until 1 stitch remains on each needle, adjusting the tension to match the rest of the knitting as you go. To finish, bring tapestry needle through the front stitch as if to knit and slip this stitch off the needle, then bring tapestry needle through the back stitch as if to purl and slip this stitch off the needle.

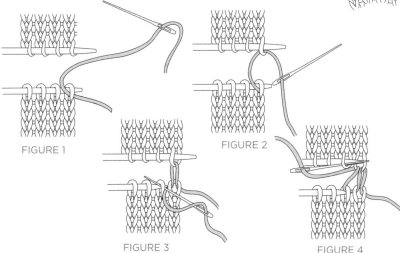

FIGURE 1

FIGURE 2

FIGURE 3

FIGURE 4

I-Cord (also called Knit-Cord)

Using two double-pointed needles, cast on the desired number of stitches (usually 3 to 4). *Without turning the needle, slide stitches to other end of needle, pull the yarn around the back, and knit the stitches as usual. Repeat from * for desired length.

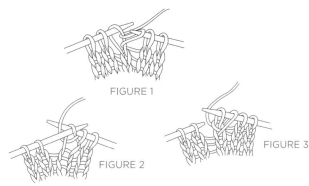

Increases

Bar Increase (k1f&b)

Knit into a stitch but leave it on the left needle (Figure 1), then knit through the back loop of the same stitch (Figure 2) and slip the original stitch off the needle (Figure 3).

FIGURE 1

FIGURE 2

FIGURE 3

Purl Bar Increase (p1f&b)

Purl into a stitch but leave the stitch on the left needle (Figure 1), then purl through the back loop of the same stitch (Figure 2) and slip the original stitch off the needle.

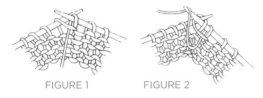

FIGURE 1 FIGURE 2

Raised Make-One

note: *Use the left slant if no direction of slant is specified.*

Left Slant (M1L)

With left needle tip, lift the strand between the last knitted stitch and the first stitch on the left needle from front to back (Figure 1), then knit the lifted loop through the back (Figure 2).

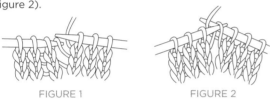

FIGURE 1 FIGURE 2

Right Slant (M1R)

With left needle tip, lift the strand between the needles from back to front (Figure 1). Knit the lifted loop through the front (Figure 2).

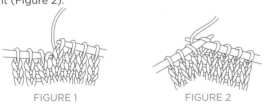

FIGURE 1 FIGURE 2

Purlwise (M1P)

With left needle tip, lift the strand between the needles from front to back (Figure 1), then purl the lifted loop through the back (Figure 2).

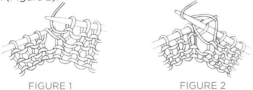

FIGURE 1 FIGURE 2

Pick Up and Knit

Pick Up and Knit Along CO or BO Edge

With right side facing and working from right to left, insert the tip of the needle into the center of the stitch below the bind-off or cast-on edge (Figure 1), wrap yarn around needle, and pull through a loop (Figure 2). Pick up 1 stitch for every existing stitch.

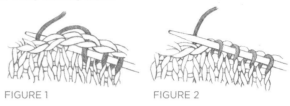

FIGURE 1 FIGURE 2

Pick Up and Knit Along Shaped Edge

With right side facing and working from right to left, insert tip of needle between last and second-to-last stitches, wrap yarn around needle, and pull through a loop. Pick up and knit about 3 stitches for every four rows, adjusting as necessary so that picked-up edge lays flat.

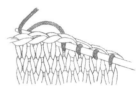

Seams

Backstitch Seam

Pin pieces to be seamed with right sides facing together. Working from right to left into the edge stitch, bring threaded needle up between the next 2 stitches on each piece of knitted fabric (Figure 1), then back down through both layers, 1 stitch to the right of the starting point (Figure 2). *Bring the needle up through both layers a stitch to the left of the backstitch just made (Figure 3), then back down to the right, through the same hole used before. Repeat from *, working backward 1 stitch for every 2 stitches worked forward.

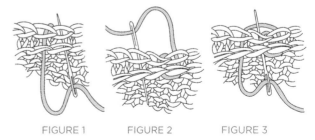

FIGURE 1 FIGURE 2 FIGURE 3

Mattress Stitch

Place the pieces to be seamed on a table, right sides facing up. Begin at the lower edge and work upward as follows for your stitch pattern:

Stockinette Stitch with 1-Stitch Seam Allowance

Insert threaded needle under one bar between the 2 edge stitches on one piece, then under the corresponding bar plus the bar above it on the other piece (Figure 1). *Pick up the next two bars on the first piece (Figure 2), then the next two bars on the other (Figure 3). Repeat from *, ending by picking up the last bar or pair of bars on the first piece.

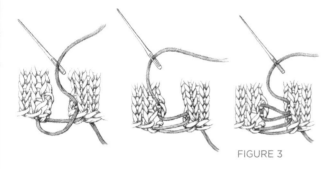

FIGURE 3

Stockinette Stitch with ½-Stitch Seam Allowance

To reduce bulk in the mattress-stitch seam, work as for the 1-stitch seam allowance but pick up the bars in the center of the edge stitches instead of between the last 2 stitches.

Slip-Stitch Crochet Seam

With right sides together and working 1 stitch at a time, *insert crochet hook through both thicknesses into the stitch just below the bound-off edge (or 1 stitch in from the selvedge edge), grab a loop of yarn (Figure 1), and draw this loop through both thicknesses, then through the loop on the hook (Figure 2). Repeat from *, keeping even tension on the crochet stitches.

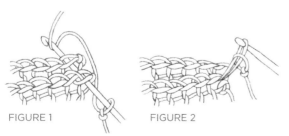

FIGURE 1 FIGURE 2

Short-Rows

Short-Rows Knit Side

Work to turning point, slip next stitch purlwise (Figure 1), bring the yarn to the front, then slip the same stitch back to the left needle (Figure 2), turn the work around and bring the yarn in position for the next stitch—1 stitch has been wrapped and the yarn is correctly positioned to work the next stitch. When you come to a wrapped stitch on a subsequent row, hide the wrap by working it together with the wrapped stitch as follows: Insert right needle tip under the wrap (from the front if wrapped stitch is a knit stitch; from the back if wrapped stitch is a purl stitch; Figure 3), then into the stitch on the needle, and work the stitch and its wrap together as a single stitch.

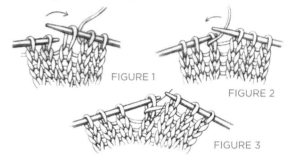

FIGURE 1

FIGURE 2

FIGURE 3

Short-Rows Purl Side

Work to the turning point, slip the next stitch purlwise to the right needle, bring the yarn to the back of the work (Figure 1), return the slipped stitch to the left needle, bring the yarn to the front between the needles (Figure 2), and turn the work so that the knit side is facing—1 stitch has been wrapped and the yarn is correctly positioned to knit the next stitch. To hide the wrap on a subsequent purl row, work to the wrapped stitch, use the tip of the right needle to pick up the wrap from the back, place it on the left needle (Figure 3), then purl it together with the wrapped stitch.

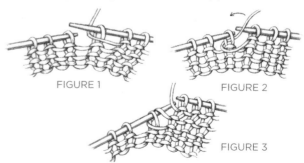

FIGURE 1 FIGURE 2

FIGURE 3

contributors

Pam Allen is the creative director for Classic Elite Yarns and the former editor in chief of *Interweave Knits*. She's the author or *Knitting for Dummies* and *Scarf Style* and coauthor of *Wrap Style*, *Lace Style*, *Bag Style*, and *Color Style*.

An expert at taking a dressmaker's approach to knitwear design, **Véronik Avery** is the author of *Knitting Classic Style* and *Knitting 24/7*. She also has recently introduced her own signature yarn and accompanying magazine, *St-Denis*, distributed by Classic Elite Yarns.

Nancy Bush is the author of *Folk Socks*, *Folk Knitting in Estonia*, *Knitting on the Road*, *Knitting Vintage Socks*, and *Knitted Lace of Estonia*. She teaches workshops in the United States and abroad and is owner of The Wooly West, a mail-order knitting shop (woolywest.com) in Salt Lake City.

Therese Chynoweth is an avid, mostly self-taught knitter. When she's not engineering her designs, she freelances as a technical editor for knitting publications.

Cecily Glowik MacDonald has a BFA in painting, but knitting is her passion. She has been designing handknits for little more than five years and has had numerous designs featured in books, magazines, and Classic Elite Yarns collections.

Kristeen Griffin-Grimes is the author of *French Girl Knits*. She lives in Seattle, Washington, where she designs knitwear and organizes knitting excursions to France. Follow her adventures at frenchgirlknits.com.

Carmen S. Hall has gradually abandoned a career as a water-rights attorney to spend more time with her family and fiber habit. She lives in Evergreen, Colorado, with her husband and three children.

A designer, modern dancer, and all-around maker, **Kim Hamlin** lives in Brooklyn, New York. She is the author of *Posh Pooches* and has contributed designs to several books. Visit her blog at inspiredliving-keepitmoving.blogspot.com.

Darlene Hayes left the corporate world to start Hand Jive (handjiveknits.com), a source for naturally dyed wools and silks. She lives in Sebastopol, California.

Katie Himmelberg is the former assistant editor of *Interweave Knits* and style editor of *Knitscene* magazines. When she's not tending to her infant son, she knits, sews, makes jewelry, and cooks gourmet vegan meals.

Mags Kandis is a maker of stuff, designer of things, and author of *Folk Style*, as well as seventeen pattern books for Mission Falls Yarns. She lives in Consecon, Ontario.

Lisa R. Myers is the owner of Rosie's Yarn Cellar in Philadelphia and Fairmount Fibers (distributor of Manos del Uruguay yarns). She is the author of *The Joy of Knitting* and *The Joy of Knitting Companion* and coauthor of *Knit So Fine* and regularly designs knitwear for RosieKnits pattern line.

Deborah Newton of Providence, Rhode Island, designs all kinds of knitwear for magazines and yarn companies, as well as fabrics for Seventh Avenue. She is the author of *Designing Knitwear*.

When she's not tending to her sheep, **Kristin Nicholas** paints, stitches, knits, and write books about the crafts she loves. Visit her website at kristinnicholas.com.

Michele Rose Orne has been designing for more than twenty years in the garment and handknitting industry and was a design director of a large sweater importer. She is the author of *Inspired to Knit* and has had designs published in many books and magazines.

Clara Parkes is the publisher of *KnittersReview.com* and author of *The Knitter's Book of Yarn* and *The Knitter's Book of Wool*. She is also a frequent contributor to *Interweave Knits* and *Twist Collective*. Clara lives in a rambling farmhouse on the coast of Maine.

Amy R. Singer is the editor of *Knitty.com*, an online knitting magazine, and several knitting books, including *No Sheep for You*. She lives in Toronto, Canada.

Vicki Square is the author of several books, including *The Knitter's Companion*, *Folk Bags*, *Folk Hats*, and *Knit Kimono*. Vicki lives in Fort Collins, Colorado.

Kristen TenDyke is a part-time knit/crochet designer and fulltime tech editor, graphic designer, etc., at Classic Elite Yarns. She also self-publishes knit and crochet designs for her website at kristentendyke.com.

A professional member of the Association of Knitwear Designers, **JoLene Treace's** designs have appeared in a number of publications, and she also self-publishes patterns leaflets through her business, Kristmen's Design Studio.

Sandi Wiseheart is the founding editor of *Knitting Daily* (knittingdaily.com) and now works as a freelance writer and designer. She lives near Toronto, Canada, with her husband, rescue dog, and several cats. Learn more at What's on Sandi's Needles at knittingdaily.com/blogs/needles.

sources for supplies

Blue Sky Alpacas Inc.
PO Box 88
Cedar, MN 55011
blueskyalpacas.com

Buffalo Gold Premium Fibers
11316 C.R. 604
Burleson, TX 76028
buffalogold.net

Cascade Yarns
PO Box 58168
1224 Andover Park E.
Tukwila, WA 98188
cascadeyarns.com

Classic Elite Yarns/St-Denis
122 Western Ave.
Lowell, MA 01851
classiceliteyarns.com

Diamond Yarn
9697 St. Laurent, Ste. 101
Montreal, QC
Canada H3L 2N1
and
155 Martin Ross, Unit 3
Toronto, ON
Canada M3J 2L9
diamondyarn.com

Green Mountain Spinnery
PO Box 568
Putney, VT 05346
spinnery.com

Hand Jive Knits/Nature's Palette Fingering Weight
handjiveknits.com

Himalaya Yarn
149 Mallard Dr.
Colchester, VT 05446
himalayayarn.com

Jojoland International
5615 Westwood Ln.
The Colony, TX 75056
jojoland.com

Knitting Fever Inc./Araucanía
PO Box 336
315 Bayview Ave.
Amityville, NY 11701
knittingfever.com

LaLana Wools
136-C Paseo del Pueblo Norte
Taos, NM 87571
lalanawools.com

Lanaknits Designs
320 Vernon St., Ste. 3B
Nelson, BC
Canada V1L 4E4
lanaknits.com

Louet North America
3425 Hands Rd.
Prescott, ON
Canada K0E 1T0
louet.com

O-Wool
52 Seymour St.
Middlebury, VT 05753
o-wool.com

Plymouth Yarn Company Inc.
500 Lafayette St.
Bristol, PA 19007
plymouthyarn.com

Skacel/Schulana
PO Box 88110
Seattle, WA 98138
skacelknitting.com

Southwest Trading Company
918 S. Park Ln., Ste. 102
Tempe, AZ 85281
soysilk.com

Westminster Fibers/Nashua
165 Ledge St.
Nashua, NH 03060
westminsterfibers.com
in Canada:
Diamond Yarn

index

Looking for more ways to knit naturally?

TRY THESE ESSENTIAL GUIDES FROM INTERWEAVE

**The Complete Guide
to Natural Dyeing**
*Techniques and Recipes
for Dyeing Fabric, Yarn,
and Fiber at Home*

Eva Lambert and
Tracy Kendall

ISBN 978-1-59668-181-1
$24.95

**Natural Knits for
Babies and Moms**
*Beautiful Designs
Using Organic Yarns*

Louisa Harding

ISBN 978-1-59668-010-4
$21.95

No Sheep For You
*Knit Happy with Cotton,
Silk, Linen, Hemp, Bamboo
& Other Delights*

Amy R. Singer

ISBN 978-1-59668-012-8
$22.95

Are you knitting daily?
Join KnittingDaily.com, an online
community that shares your passion for
knitting. You'll get a free e-newsletter, free
patterns, projects store, a daily blog, even
updates, galleries, tips and techniques,
and more. Sign up for *Knitting Daily* at
knittingdaily.com.

INTERWEAVE KNITS

From cover to cover, *Interweave Knits*
magazine presents great projects for
the beginner to the advanced knitter.
Every issue is packed full of captivating
smart designs, step-by-step instructions,
easy-to-understand illustrations, plus
well-written, lively articles sure to inspire.
Interweaveknits.com

INTERWEAVE
interweavestore.com